THE SPARKFUN GUIDE
TO PROCESSING

THE SPARKFUN GUIDE TO PROCESSING

CREATE INTERACTIVE ART WITH CODE

BY DEREK RUNBERG

no starch
press

SAN FRANCISCO

Printed in USA

First printing

19 18 17 16 15 1 2 3 4 5 6 7 8 9

ISBN-10: 1-59327-612-5
ISBN-13: 978-1-59327-612-6

Text stock is SFI certified

Publisher: William Pollock
Production Editor: Alison Law
Cover Illustration: Pete Holm
Interior Design: Beth Middleworth
Developmental Editor: Jennifer Griffith-Delgado
Technical Reviewer: Andres Colubri
Copyeditor: Rachel Monaghan
Compositor: Susan Glinert Stevens
Proofreader: James Fraleigh

For information on distribution, translations, or bulk sales, please contact No Starch Press, Inc. directly:

No Starch Press, Inc.
245 8th Street, San Francisco, CA 94103
phone: 415.863.9900; info@nostarch.com
www.nostarch.com

Library of Congress Cataloging-in-Publication Data:
Runberg, Derek.
 The SparkFun guide to Processing : create interactive art with code / by Derek Runberg.
 pages cm
 Includes index.
 Summary: "A project-based guide for beginners that teaches how to use the programming language Processing. Covers digital artwork and hardware topics including pixel art, photo editing, video manipulation, 3D design, and using Processing to control an Arduino"-- Provided by publisher.
 ISBN 978-1-59327-612-6 -- ISBN 1-59327-612-5
 1. Processing (Computer program language) 2. Computer art. 3. Digital video. 4. Arduino (Programmable controller)--Programming. I. SparkFun Electronics. II. Title.
 QA76.73.P75.R86 2015
 776--dc23
 2015024859

THIS BOOK IS DEDICATED TO
THE EDUCATORS ACROSS THE UNITED STATES
WHO ARE WORKING DILIGENTLY TO BRING
COMPUTER SCIENCE AND ELECTRONICS
TO THE FOREFRONT
OF THEIR CLASSROOM PRACTICE.

ABOUT THE AUTHOR

Derek Runberg is the educational technologist at SparkFun Electronics, a position dedicated to creating outstanding curriculum for electronics and computer science education. Before joining SparkFun, Derek was a middle school technology and engineering educator for five years. During this time, he ran a number of after-school and summer programs on both programmable electronics and Processing. Derek's time as an educator has culminated in this book, which takes computer science concepts and breaks them into digestible chunks that everyone can understand.

Derek documented his work with Processing in the middle school classroom as the author of the website Processing and Interactivity for Educators.

This website focused on developing curricula for teachers using Processing in the mainstream classroom. Derek's Processing activities were focused on getting students to be creative with code, for the sake of creating.

In his free time, Derek likes to spend time with his two children, Bear and Bridge, and his wife, Zondra. If you ever run into Derek, he will talk your ear off about either food or technology; choose wisely. He enjoys the outdoors, writes code when it's raining, and has been known to do both at the same time!

ABOUT SPARKFUN ELECTRONICS

SparkFun is an online retailer that produces and sells the widgets and parts that end up in a lot of maker projects, prototypes, and even the International Space Station. Nathan Seidle started the company after blowing a circuit board in 2003, while he was an undergraduate at Colorado University. At the time, circuit boards were really hard to get; you had to fax your credit card to another country and hope that you got your hardware in six to eight weeks. Nathan felt he could do better, and he did. SparkFun.com was born, and it now sells over 3,000 different parts of all shapes and sizes for your digital electronic needs. From a basic Arduino to GPS modules, you can find them and all of the documentation you need to get up and running at SparkFun.

SparkFun's Department of Education develops curricula and runs professional development programs for educators of all kinds. The department is at the forefront of a number of computer science and maker initiatives that are making headway in the classroom. Processing is an everyday tool in the department and is a foundational part of SparkFun's professional development workshops around the country. You can learn more about SparkFun and the Department of Education at *https://www.sparkfun.com/* and *https://learn.sparkfun.com/*.

ABOUT THE TECHNICAL REVIEWER

Andres Colubri is an active contributor to the Processing project, as the main developer of the OpenGL renderer and the Video library in Processing 2 and 3. He studied physics and mathematics in Argentina and later received an MFA from UCLA's Design Media Arts program. He uses Processing as the main tool to bridge his interests in computer graphics, visualization, and statistical modeling. You can see some of his work at *http://andrescolubri.net/*.

CONTENTS

CONTENTS IN DETAIL

FOREWORD

THREE HUNDRED YEARS AGO, books were limited to a select few: members of the clergy and the upper class. Then, as access to education increased dramatically and the printing industry took off, the world struggled to change the educational system to teach students the fundamentals of reading. Today, we take for granted that every student will learn how to read—it's a necessary skill to operate in the modern world. But it's interesting to note that we have the same anxieties now about how to teach every student the fundamentals of programming as people had about reading so long ago. We all know it needs to happen; the devil is in the details.

I learned to program by getting a bootlegged copy of Visual Basic from one of my parent's friends and spending countless hours re-creating a board game called Stratego. I even made it work over a modem so I could play against friends who lived across town. This wasn't part of a class that I took in seventh grade; it was raw, unguided determination. I learned a tremendous amount, but it was a slow process and I often programmed in very wrong ways. I would design what should happen when a piece was placed on a player square and then copy and paste that

code 72 times across 72 different player squares. I distinctly remember the day I discovered what a function call was and thinking, Whoa! That's how that works?! Overnight, my code got a lot smaller and easier to modify, and I learned something I now use every day of my life. I seriously love writing code.

Based on this experience, I am of two minds about the learning process. There is part of me that believes every person needs to have the experience of trying to build something, to design something, to sculpt something before they discover the tips and tricks of their profession. That way we will truly understand just how beneficial those tools are. There is, however, an equally loud part of me that thinks no one should waste time fumbling around getting frustrated. We should instead stand on the shoulders of others and reach for the stars. There is no end to this debate, but the good news is that no matter how you learn the tools, they have gotten much easier to learn for two reasons: the Internet and open source.

When I was learning how to program, I struggled to find a book, a friend, or a teacher that could answer my questions. Today there are over

158 million how-to videos on YouTube. There are countless communities on the Internet that want nothing more than to share and to help other members have a positive experience learning something new. There are dozens of large nonprofit entities creating free online courses on art history, genetics, fundamentals of music theory, and yes, even an "Intro to Programming." When I was a kid, my determination to learn something nonstandard was frowned upon; my parents were worried I needed to spend more time outdoors or playing with friends. I think I ended up just fine, but if I were growing up today, with the resources that are available to beginners now, I think a small amount of determination would lead to much larger success than I ever experienced.

If I were in seventh grade, I'd want to learn Processing. It has a huge Internet community and countless how-tos. Thanks to the power of open source, the community has flourished, creating apps and plug-ins that extend Processing into environments that its creators Ben Fry and Casey Reas probably never expected. I've seen Processing run on point-of-sale cash registers in a local coffee shop, and I've used it to design an app for my mobile phone. You can't walk through a museum or public space without interacting with an installation that is running Processing. It's everywhere once you know what to look for. Processing is one of

those languages that's easy to learn and just keeps going. It can do amazing things if you just dig in and start hacking it.

Now I must give a shout-out to Derek. To author a technical book is difficult. It takes intimate knowledge of how things work coupled with the language skills to express concepts in a way that readers can absorb. We call this interaction "teaching" and "learning," and we often take it for granted. *The SparkFun Guide to Processing* is an excellent example of modern teaching. Through Derek's writing and lessons, you will gain the knowledge you need to use Processing.

Once you open the box and master the tool, Processing can lead you to some truly awe-inspiring projects. I am constantly enjoying hair-raising experiences from artists, performers, and creators who have all used Processing to create their work. I hope you find inspiration in Derek's amazing book to continue exploring the interaction between the digital and physical worlds. Where these worlds collide, humanity is improved and expanded.

But enough talking—let's build some fun stuff!

NATHAN SEIDLE • **FOUNDER OF SPARKFUN ELECTRONICS**
BOULDER, COLORADO • **JUNE 23, 2015**

INTRODUCTION

In my teaching career and during my time at SparkFun, I've used Processing to make computational thinking approachable, and this book is the culmination of that work. Many of the projects you'll create here come directly from my experience teaching middle school technology classes. Others come from my experience running workshops for a wide variety of participants, from young children to seasoned web developers. But all of them will teach you something and hopefully inspire you to dig more deeply in to making.

WHY START MAKING WITH PROCESSING?

Processing was developed to make it easy for anyone to create interactive art, so by design, it makes programming accessible for the masses. That alone makes Processing a great place to start your journey into DIY, but there's another good reason: Processing has a close connection to Arduino. The programming language and development environment for the Arduino platform are based on Processing, so when you're ready to transition from software to hardware, you'll feel right at home.

Early in my endeavors to learn and teach programming, I started my students out with Arduino. I quickly found, however, that learning how to build circuits and program at the same time was overwhelming for students who had no experience with either. I needed to separate the two issues and let my students focus on each independently. That's when I met Jeff Branson, who works in the SparkFun Department of Education. We got to talking about Processing, and he ran a 45-minute workshop in my classroom right before spring break. By the end, he had my students running code like the examples you'll see in the first two projects of this book.

My students and I were hooked, and I think you will be, too.

WHO THIS BOOK IS FOR

This book is for anyone interested in making dynamic, interactive art and learning to program along the way. It's designed with beginners in mind, so you definitely don't need to have a background in computer science. You just have to want to make something awesome,

and badly enough to get some simple code working. This book will teach you basic programming, but it's focused on making something cool in an approachable way.

If you're driven to learn on your own, this book will be extra fun for you. You'll finish with a portfolio of interesting, creative, and useful Processing applications that you can incorporate into your everyday life—a web page, your phone, and even print. I'll walk you through experiences, tools, and concepts that will be useful across a number of disciplines and applications, including art and engineering. For example, it wouldn't be hard to combine a few of these projects into a program that collects data from the Web and visualizes it as part of an interactive art installation.

In the end, this book is for doers and makers. It's for those who like getting their hands dirty, who love to explore through creating both physically and digitally. It's for those who are curious about programming but might be a little intimidated by the math or the science of it. In fact, if you have read this far without putting the book down, you'll do well getting through it.

A NOTE TO TEACHERS

First and foremost, I love you and thank you for doing what you do. In a lot of ways, I designed this book to emulate the experience my students and I had of learning Processing through doing. You could easily use each chapter as a project for your class. The instructional content for each chapter is written to be detailed and concise enough that you can hand it to a student on its own. I've also designed the projects to be open-ended so that each student's project should come out differently and can be personalized. The projects introduce new concepts on a need-to-know basis, which is great for someone just starting out with programming. It filters the background noise and allows you to focus on what is important: making a cool project, for yourself and with your students.

WHAT'S IN THIS BOOK

This book is project-driven, and each project walks you through building example sketches that demonstrate specific Processing concepts and functions, complete with diagrams and screenshots to help you learn more effectively. Once you understand those concepts, you can tackle the larger project for the chapter. Each project aims to offer a good balance of direct instruction and plenty of opportunities to inject

your own personal flair and personality. I want your projects to look and feel different from any other reader's.

Following that approach, this book is broken into 14 projects:

- **Project 0: Getting Started with Processing** shows you how to install Processing and helps you write your first program to draw a simple line.

- **Project 1: Pixel Art** teaches you how to draw actual shapes in Processing. You'll draw rectangles and translate some graph-paper pixel art to the computer screen.

- **Project 2: Holiday Card** gives you more basic drawing practice. You'll draw ellipses and triangles, play with stroke weight, and make a digital snowman.

- **Project 3: A First Dynamic Sketch** covers the if() statement, a basic building block in programming, and explains how you can use it to move shapes around in your sketches.

- **Project 4: Interactive Time-Based Art** shows you how to use the clock and calendar in your computer to control a drawing's color and position over time, and introduces the idea of rotating and scaling shapes.

- **Project 5: Enter the Matrix** teaches you to manipulate entire groups of shapes as if they were a single image, and covers how to translate multiple shapes across the screen at the same time.

- **Project 6: Image Processing with a Collage** teaches you how to use photographs and other image files in Processing to make a photo collage, add some pretty cool filters, and do some simple photo manipulation. In this project, I also give you a brief introduction to object-oriented programming.

- **Project 7: Playing with Text** introduces drawing text in a Processing sketch. I cover how to use fonts, change the font size in your program, and create a dashboard that displays your mouse position in the sketch window.

- **Project 8: Two Drawing Programs** explores more ways users can interact with your Processing sketches. You'll create a pair of simple paint programs that let you use your mouse to draw pictures freehand, either in random or controllable colors.

- **Project 9: A Maze Game** shows you how to make a video game in Processing! You'll make a simple maze-navigating game and learn how to replace your keyboard with a custom controller built on the wonderful MaKey MaKey board.

- **Project 10: Manipulating Movies and Capturing Video** shows you how to put your webcam to good use with Processing to build a photo booth. This will be your first foray into libraries in Processing, and you'll get a deeper look at object-oriented programming.

- **Project 11: Audio Processing with Minim** teaches you how to add, record, and trigger different sounds in Processing sketches, as well as access all of the amazing background data that comes with MP3 files.

- **Project 12: Building a Weather Dashboard with JSON Data** levels up your skills as you use the Web to find and extract data in JSON format to build a simple weather dashboard application and keep its information up to date.

- **Project 13: Using Sensors with Processing and Arduino** gives you another taste of using hardware with Processing. You'll gather sensor data with an Arduino, send that data to Processing over a serial connection, and graph it. At the end, I'll show you how to control an RGB LED on an Arduino with Processing.

These projects focus not on teaching every programming concept, but on the concepts you need to create something beautiful and cool. That doesn't mean you won't learn some programming along the way: I just explain any necessary programming concepts contextually on a need-to-know basis. My hope is that having a concrete application for what you're learning will help that knowledge sink in. The projects are numbered because they build on one another in terms of complexity and your understanding, but you should feel free to circle back and take another swing at a project or apply more advanced concepts to previous projects. Throughout the book, I point out particularly good opportunities to go back and hack previous projects with your newfound skills, but I hope you'll revisit any project you like, as much as you want, at any time.

For each step of the way, I'm there to help you. I explain what's going on in the code, how everything comes together, and even some of the pitfalls within a given project. At the end of each project is a "Taking It Further" section to encourage you to explore that project's theme on your own and personalize the project. Sometimes, I'll ask you to take the concept in a whole new direction; other times, I'll just discuss how you can improve what you already have.

NOTE

Several of the projects in this book are based on SparkFun's HotSheets, single-page projects meant to help you get started with new technologies. You can check out these and other SparkFun tutorials at https://learn.sparkfun.com/resources/.

THE PROCESSING COMMUNITY

As you work through this book, I highly encourage you to visit the official Processing forums at Processing.org and share your own projects through OpenProcessing.org, because the Processing community is full of wonderful people and inspiring projects. Processing was my first major experience with the open source community, after Arduino. It floored me that I could jump on a forum and find example code and discussions about problems or ideas just like mine, and I'm sure you'll find the community just as welcoming.

The first time I posted to OpenProcessing.org to share programs, I received comments on my code and it was forked. That was a powerful moment: it was so cool to know that someone liked my code enough to think it useful! You'll have similar moments, and as you learn and gain experience with different tools and plug-ins for Processing, you can even give back to the community by writing your own libraries.

On top of that, it's fun to find others using Processing to create both beautiful art (like museum installations or insane data visualizations) and utilitarian projects (like control systems, user interfaces, and mapping applications). Whatever they're working on, everyone I encounter is just as excited that I'm using Processing as I am that they are. In my time working at SparkFun so far, I've found a number of companies that use Processing for everything from creative endeavors to sensitive control and feedback systems. You never know what you'll find!

ONLINE RESOURCES

If you get stuck on something or you're just looking for a concrete example to compare to your project, you can find all of the example code from the book at *https://nostarch.com/sparkfunprocessing/* for download. The programs are organized into folders by project, so you can find all the source code easily. Within each folder, you'll find the sketches for any output shown in that project. (For example, if you wanted to open the sketch for Figure 2-10, you'd download the source code, open the *Project 2* folder, open the *fig_2_10* folder, and open *fig_2_10.pde* in Processing.) When a sketch includes external files such as images, sounds, and so on, you can find them in a *data* folder within the sketch's folder, too.

Now, grab your artist's hat and your engineer's hat, because for the rest of this book, you'll learn to think like both. Get ready to program a masterpiece!

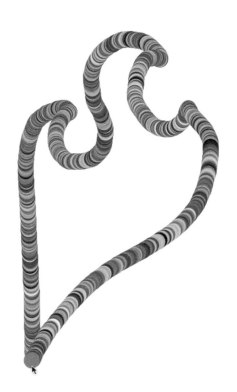

GETTING STARTED WITH PROCESSING

THIS PROJECT COVERS EVERYTHING YOU NEED TO GET PROCESSING UP AND RUNNING BEFORE YOU DIVE IN TO THE FIRST PROJECT; THAT'S WHY IT'S CALLED PROJECT 0. I'LL INTRODUCE YOU TO PROCESSING, TELL YOU HOW TO INSTALL IT, AND HELP YOU MAKE SURE IT WORKS. AT THE END OF THE PROJECT, YOU'LL HAVE A WORKING PROCESSING ENVIRONMENT AND, HOPEFULLY, A SENSE OF ACCOMPLISHMENT. HERE WE GO!

ABOUT PROCESSING

So you bought this book about Processing, perhaps after hearing that you could use it to make art with code. But where did Processing come from, and what exactly can you do with it?

A Programming Language

First and foremost, Processing is a *programming language*, which means it provides a way for you to interface with a computer and give it instructions. You can use programming languages like Processing to teach a computer to do some pretty cool tricks! But just like learning Spanish, English, or Swahili, learning Processing takes time and patience. You'll make mistakes, and some programs will act oddly at first. You'll have burning questions, and you'll need to look up answers. And that's all okay!

A Tool for Art and Design

Processing was created to make computers and programming more accessible as creative tools for artists and designers. It was developed in 2001 at the Massachusetts Institute of Technology (MIT) by Casey Reas and Ben Fry, while they studied under John Maeda in the Aesthetics and Computation research group. Since then, Processing has developed quite a following, and it even has its own foundation to manage and continue the good work Casey and Ben started.

Before Processing, the few people who wrote programs to generate artwork mostly had backgrounds in computer science, not art. Today, artists, designers, and engineers have embraced Processing for creating graphics, modeling physical objects (see Figure 0-1), designing architecture, building electronics, and more. Processing can communicate with hardware and with other software packages, which has also made it useful in performing arts, lighting, and other physical installations (see Figure 0-2).

Processing's role as a creative tool is summed up in the Processing Foundation's mission statement.

> Processing seeks to ruin the careers of talented designers by tempting them away from their usual tools and into the world of programming and computation. Similarly, the project is designed to turn engineers and computer scientists to less gainful employment as artists and designers.

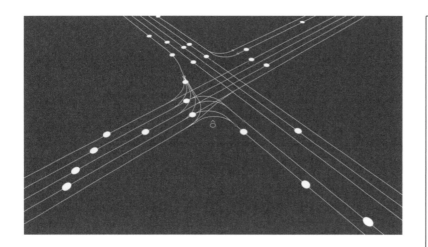

FIGURE 0-1:
City Symphonies, created by Mark McKeague, is a simulation in which traffic patterns and vehicle movement dictate sounds.

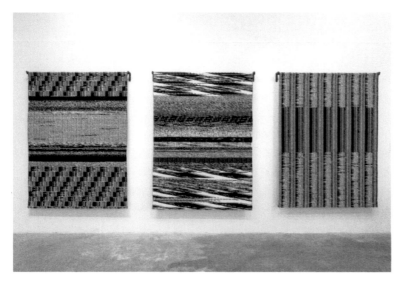

FIGURE 0-2:
In his piece *Fragmented Memory*, Phillip Stearns created the pattern for this triptych of woven tapestries using Processing and data dumped from his computer's physical memory.

An Open Source Project

The Processing language and its environment are free to download and use, but Processing is so much more than a free tool. It's an *open source* project, which means that you are free to modify it. You can remix the base code that makes up the language and the programming environment, add new tools to improve it, or even use the platform as a basis for an entirely new project! In fact, others have done this already. If you've ever programmed an Arduino microcontroller board, you'll feel right at home when you start up Processing, because Arduino—another open source project—adopted Processing's programming language and environment.

The catch is that when you use or modify open source material in a project, you agree to give credit to the original owner of that material. You can find out more about open source licenses, such as Creative Commons, at *http://www.opensource.org/*.

Since its inception, Processing has been adapted for a number of applications, including a JavaScript library called Processing.js (developed by John Resig) and an Android mode, which ports Processing sketches over to Android applications for phones and tablets. In the future, you might even see versions of Processing that support other programming languages, such as Ruby or Scala.

Now that you have a better idea of what Processing is, it's time to download and install it.

INSTALLING PROCESSING

Visit *http://www.processing.org/download/* to download and install Processing. The website will ask if you want to donate to the Processing Foundation; I'll let you decide how to answer that. Next, click **Donate & Download** to reach the download page, and download the latest stable release of Processing.

Once you have downloaded your version of Processing, unzip or unpack the compressed folder to a safe location that you'll remember, and don't remove any files from it. In Windows, I usually place this unzipped folder in my *Programs* or *Documents* folder to keep it handy; in OS X, you might put yours in the *Applications* folder. You could also leave it on the Desktop.

Unzip the folder, and your installation should be complete! Processing doesn't require a full installation process, unlike many other applications, so you don't have to deal with an installer program or be the administrator of the machine.

In Linux, your downloaded file will be a *.tar.gz* file instead of a .zip file. Place this in your home directory, and open a terminal. Then enter the following command, where *processing-xxxx.tgz* is a placeholder for the name of the file you just downloaded:

```
$ tar xvfz processing-xxxx.tgz
```

Now, if you move to the newly created directory, you should be able to enter **./processing** to run Processing.

If you want to make Processing more accessible, you can always create a shortcut in Windows or drag it to your Dock if you are using OS X.

Now that you have Processing installed, you're ready to get it up and running.

THE IDE

Open the Processing 2.2.1 folder (the unzipped folder you just downloaded) and double-click the Processing executable. This should launch Processing, and after a splash screen, you should see the *integrated development environment (IDE)*, which looks something like Figure 0-3.

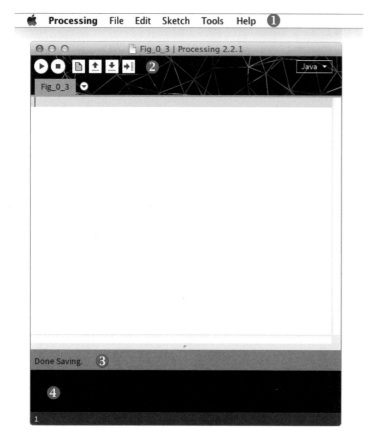

FIGURE 0-3:

The Processing IDE

An IDE is simply a place for you to write code and test it out; it is really nothing more than a word processing tool that allows you to write instructions for your computer. Just like a word processing

application, the IDE has tools for making corrections, formatting, and entering text, but its focus is on the Processing language rather than the English language. What separates an IDE from the word processing program I am using to write this book is that an IDE allows me to *run* the set of instructions as a program on my computer.

A Quick Tour

Take a look around the IDE now. The majority of the area is whitespace; this is where you'll write your code. At the top of the interface is a menu bar ❶, where you can save and open files, export your code, and more. Underneath the menu bar, you'll find a set of graphic buttons ❷; from left to right, those buttons are Run, Stop, New, Open, Save, and Export. You'll explore the menu bar and those six buttons throughout this book.

Before you write any code, go ahead and click the **Run** button. Processing will work a bit and then display a window with a gray square in it, as shown in Figure 0-4. Not very cool, is it? Don't worry—you'll fix that soon!

FIGURE 0-4:

The sketch window

For clarity, I'll refer to the window where that square appeared as your *sketch window*, and I'll refer to the IDE as your *code window*. Close the sketch by clicking the **Stop** button.

You can click New to create a blank sketch, Open to work on previously saved sketches, and Save to save your current sketch. The final button, Export, is for exporting the application when you're done developing your sketch. You can export your sketch to a number of different formats depending on your operating system and how you plan to use it.

When you save your sketch, it is placed in your sketchbook. The *sketchbook* is a set folder where your sketches are automatically saved. By default, on a computer with multiple users set up, your sketchbook is placed in the *Documents* folder for your specific user.

Below the code window, you should see the alert bar ❸ and the console ❹. Type your name in the code window and then click **Run**.

You'll get an error, and your alert bar will turn red. In my case, I saw the error message Syntax error, maybe a missing semi-colon? in my alert bar, and my console printed expecting SEMI, found 'Runberg' (see Figure 0-5).

This is how Processing displays errors—without frills. Processing tells you what you are probably missing and where the error occurred by highlighting the error's location in your code.

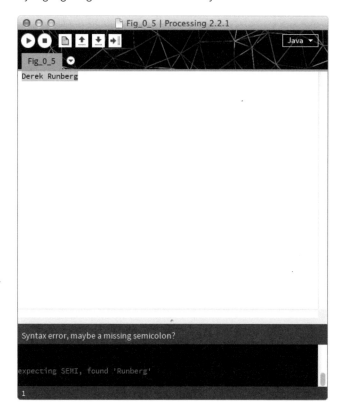

FIGURE 0-5:
Syntax error displayed in the console and alert bar

The Preferences Window

You can make a few changes to the Processing IDE by opening the Preferences window (Figure 0-6) under the File drop-down menu. Within Preferences, you can change the location of your sketchbook folder, the font and font size of the text editor window, and many other options.

You can see from my Preferences window that my font size is much larger than the default and that I increased the maximum amount of memory allocated to Processing to 1GB (1,024MB). Depending on your changes here, you may have to close and restart Processing before they take effect.

FIGURE 0-6:

The Preferences
window

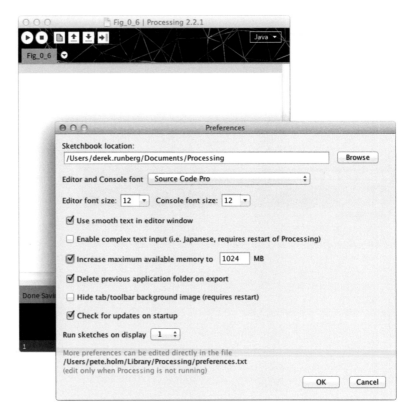

That concludes your brief Processing IDE tour. Now you'll create
your first Processing sketch!

HELLO WORLD

Programmers who are just learning a new language usually write
a little test program after installing any necessary software, just to
make sure that everything is set up correctly. Such a program is often
called *Hello World*.

Processing has a number of basic functions you could use in a
Hello World program, but I like to draw a simple line. Type the follow-
ing in the code window, and click the **Run** button.

```
void setup()
{
  size(250,250);
}

void draw()
{
```

```
  line(0,0,200,200);
}
```

Congratulations: you've written and run your first Processing sketch! You should see a sketch window that is larger than the one in Figure 0-4, and it should contain a diagonal line from the upper-left corner to the lower-right corner, as shown in Figure 0-7.

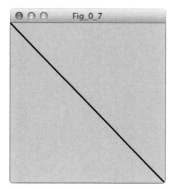

FIGURE 0-7:
Hello World sketch

Next I'll walk you through this Hello World sketch in a bit more detail.

ANATOMY OF A SKETCH

Go back to your code window and take a closer look. The Hello World sketch contains three functions: `setup()`, `size()`, and `line()`. A *function* is a named set of instructions that accomplishes a task. These three functions were written by the designers of Processing, but later in the book, you'll write your own. You can find the basic structure, or *syntax*, of a Processing sketch in the Hello World program.

A Two-Part Recipe

In the Hello World code, there are two structural functions (functions that every Processing sketch has): `setup()` and `draw()`. To visualize how these functions work, imagine making a batch of cookies. When you bake cookies, you have a recipe, and a recipe has two parts. The first part covers everything you need to prepare: ingredients, equipment, and even the time you need to set aside. The second half contains the step-by-step instructions to make a single batch of cookies. In a Processing sketch, `setup()` and `draw()` are just like those two parts of a recipe. These two functions make up the

organizational order of the sketch and dictate how the sketch runs. You can play around with the code that goes under setup() and draw() to achieve different outcomes.

```
void setup()❶
{

}
void draw()❷
{

}
```

The setup() function ❶ is the first part of the recipe: it includes all the things that you will do to prepare to make the cookies. This function runs the functions inside it (between the curly brackets) only once at the beginning of the sketch. The draw() function ❷ is the second part: the act of making the cookies. In Processing, the draw() loop repeats over and over again, 60 times a second. The main difference between these two functions is that your draw() function is a *loop*—a piece of code that repeats itself—and setup() runs only once. In essence, you are telling Processing to make batches of cookies at 60 times per second until you tell it to stop. That is really fast baking!

In every sketch you create, you'll include a setup() function because leaving it out would be like baking cookies without any ingredients or tools—you just can't! You can, however, have a sketch without a draw() loop and place all of your functions inside setup(), but then they would all run only once. That's fine, but only one batch of cookies is no fun, so for most of this book, you will make use of the draw() loop.

Syntax

Processing knows which parts of your code are functions only if you follow the correct syntax. *Syntax* is a set of rules that describes the correct way to put together a program, like the grammar rules that dictate the right way to construct a sentence. For example, in the English language, you capitalize the first letter of a sentence and put a punctuation mark at the end. And just like written languages, all programming languages have their own syntax.

In the Hello World sketch, the pair of curly brackets, { }, groups all of the functions or commands that should be executed as part of the preceding function, so setup() contains size(), and the draw()

function contains `line()`. All function names are followed by a pair of parentheses, `()`, and depending on the function, you'll often include *parameters* inside those parentheses. Parameters contain information that functions need to do their jobs.

For example, `size()` specifies the size of your sketch window, but you have to use parameters to tell it how big to make the window. In this project, you set the window size to 250 pixels wide (the first parameter) by 250 pixels high (the second parameter). The `line()` function draws a line between two points, and you told it to draw from point (0,0) to point (250,250). But not all functions take numbers as parameters, and some (such as the `setup()` function) don't need parameters at all!

The semicolon, `;`, is another important part of the Processing syntax: all functions should end with a semicolon. Don't forget it, or Processing won't know where your function stops. This is a common error, even among veteran programmers. Just like a period at the end of a sentence, a semicolon denotes the end of a function and tells the computer to go to the next one.

These basic syntax structures should be enough to get you started. As you work through more projects, I'll address other parts of the syntax as necessary. The major thing to focus on is the error messages; they tell you what you are missing and where!

Data Types

Just like a good cookie recipe, any program you want to produce meaningful results needs ingredients—that is, data to manipulate. You've already seen one type of data that you can use in Processing; just look at the parameters in `line(0,0,200,200)`. Processing classifies each number there as an `int`, short for *integer*, which is just a whole number without a decimal point.

You can also work with *floating-point* numbers (those with a decimal point); Processing would recognize a number like 3.14 as the `float` data type. Processing has several more data types, which I'll introduce as needed throughout this book.

Now that you understand the structure of a sketch, it's time to explore the sketch window on which it's drawn in more detail.

CARTESIAN COORDINATE PLANE

Your sketch window is measured in *pixels*. A pixel is a single dot of color on your monitor or TV. In fact, if you have a magnifying glass, you can see individual pixels on your monitor. In Processing,

pixels are the unit of measurement. Anything that has a dimension—including the width and height you gave the `size()` function, as well as length, depth, and so on—is given in pixels.

Processing treats the sketch window like a Cartesian coordinate plane, and every pixel corresponds to a coordinate in that plane (see Figure 0-8). In two dimensions, you'll work with x-coordinates (width) and y-coordinates (height).

Click **Run** on your sketch again. Recall that the line goes from (0,0) to (250,250). The upper-left corner is the *origin* of the sketch window, or (0,0). As you move to the right, the x-value (or the width) increases. As you move down the sketch window, the y-value (or the height) increases. You might remember from math class that the y-axis usually increases as you move up in a graph. Processing flips that graph concept upside-down, as shown in Figure 0-9.

To sum up the Cartesian coordinate plane in Processing:

- The origin, (0,0), is in the upper-left corner.
- Distance and position are given in pixels.
- The y-axis increases as you move down the sketch window.

In the next project, you'll put this new knowledge to good use!

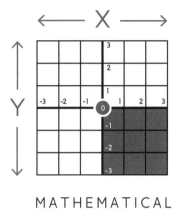

MATHEMATICAL

COMPUTER

FIGURE 0-9:
Mathematical Cartesian coordinate plane vs. computer Cartesian coordinate plane

PIXEL ART

YOU'VE ALREADY DRAWN YOUR FIRST LINE IN PROCESSING, BUT THAT WAS JUST THE BEGINNING. IN THIS PROJECT, YOU'LL USE BASIC RECTANGLES TO CREATE SOME AWESOMELY LOW-RESOLUTION GRAPHICS, SO LOOK TO YOUR FAVORITE RETRO VIDEO GAME SPRITE (OR ANY SIMPLE, BLOCKY IMAGE) FOR INSPIRATION. WE'RE MAKING PIXEL ART!

GATHER YOUR MATERIALS

- Graph paper
- Colored pencils
- Felt-tip pen

DRAFTING YOUR PIXEL ART

First, you'll draft your pixelated masterpiece in the physical world. Using your colored pencils, draw a square that is 20 boxes by 20 boxes on a piece of graph paper to represent your sketch window in Processing, and create your image inside that square. Follow these rules to make your image easier to translate into code:

Rule 1 Use only full squares of color—no angles, arcs, or partial squares!

Rule 2 Start by creating something simple, like a smiley face or a house.

Rule 3 Try to use contrasting colors at first. Some subtler shades may not be noticeable when transferred to the computer.

To spark your creativity, Figure 1-1 shows an example of the "unplugged" version of this project that follows the rules just given.

FIGURE 1-1:

A sketch of my pixel art, ready to be programmed in Processing

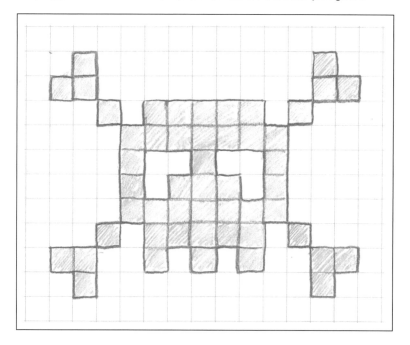

Once you've drawn your rough draft, you have some planning to do. Remember the Processing version of the Cartesian coordinate plane from Project 0? That coordinate plane (Figure 1-2) is going to be your best friend from here on out, because Processing uses this plane for specifying locations.

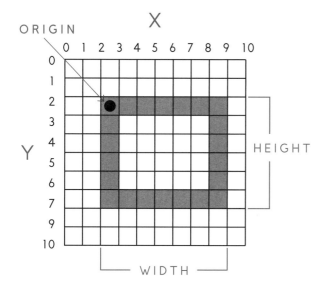

FIGURE 1-2:

Processing's coordinate plane

In Processing, a rectangle has an *origin* just like the sketch window does, as well as a width and height. On your screen, a rectangle's origin and dimensions will be given in pixels, but for now we'll count in graph paper squares. Mark the origin of your 20×20 graph paper drawing, and then, using a felt-tip pen that will contrast well against the colors you've already used, break up your drawing into the largest rectangles of solid color possible. These larger rectangles will make your drawing much easier to translate into code. In Processing, you must be able to break down a drawing into smaller shapes, and since you're making pixel art, you'll use rectangles to draw your image. The great thing is that you don't have to draw each individual pixel: grouping pixels into the largest possible rectangles means you'll write less code in the long run!

Now mark the upper-left corner of each rectangle in your pixel art, as shown in Figure 1-3. The upper-left corner is that rectangle's origin, and you'll need to know this location for each shape you want to draw.

FIGURE 1-3:

The upper-left corner of
a rectangle is its origin.

The number of rectangles you end up with depends on how many colors you used and the complexity of your design. Usually, the more complex the drawing, the more rectangles you'll have and the smaller those rectangles will be in size; the inverse usually holds true for simple drawings.

Once you have all of your rectangles outlined and their origins marked, you're just about ready to translate the image into code. To draw your pixel art in Processing, you need four values from each rectangle: the x- and y-coordinates of the rectangle's origin with respect to the origin of your 20×20 Cartesian coordinate plane, and the width and height of the rectangle, measured in graph paper squares.

I usually create a table to hold the values for each rectangle, as I've done in Table 1-1 for the skull drawing (Figure 1-1). Be sure to group all the rectangles of the same color in your table. Sorting the rectangles by color now will help you avoid further sorting and rearranging when you start translating them into code.

TABLE 1-1:

Rectangles to draw,
sorted by color,
for skull image

X-COORDINATE	Y-COORDINATE	WIDTH (IN SQUARES)	HEIGHT (IN SQUARES)	COLOR
4	5	1	1	Pink
2	6	2	1	Pink
3	6	2	1	Pink

X-COORDINATE	Y-COORDINATE	WIDTH (IN SQUARES)	HEIGHT (IN SQUARES)	COLOR
5	7	1	1	Pink
7	7	5	2	Pink
13	7	1	1	Pink
14	6	2	1	Pink
14	5	1	1	Pink
6	8	1	3	Pink
12	8	1	3	Pink
9	9	1	1	Pink
8	10	3	1	Pink
6	11	3	1	Pink
10	11	3	1	Pink
5	12	1	1	Pink
5	12	1	1	Pink
7	12	5	1	Pink
13	12	1	1	Pink
3	13	2	1	Pink
4	14	1	1	Pink
14	13	2	1	Pink
9	13	1	1	Pink
11	13	1	1	Pink

When you have all of the rectangles mapped in the manner shown in Figure 1-2 and Table 1-1, it's time to jump back into Processing and take your pixel art to the screen!

TRANSLATING YOUR SKETCH INTO CODE

Start with a blank code window in the Processing IDE, and write the two main functions of every sketch: setup() and draw(). Recall from Project 0 that the setup() function runs once and only once. The draw() function, on the other hand, runs over and over again in a loop.

```
void setup()
{
  //setup code goes here and runs once
}

void draw()
{
  //draw code goes here and runs over and over again
}
```

NOTE

Use comments to label functions, colors, shapes, and so on, or to leave notes to help guide friends who might read your sketch later!

The grayed-out lines of code starting with // are called *comments*. Processing won't execute any code that is *commented out*. Comments are normally used to leave information or notes for other people that won't be read by the computer. We can use comments to "hide" functions from the computer instead of deleting them. It's a way to turn functions on and off but keep them in place. Here, I've included the comments to remind you how the setup() and draw() functions work.

Tackle the setup() function first: type **void setup()** followed by an open brace and closed brace, **{}**. Inside those braces, set the size of your sketch window by calling size() with a width and height of 20 pixels.

```
void setup()
{
  size(20,20);
}
```

Now for the draw() loop, which will house all of the code you'll use to draw your rectangles. Processing has several functions you can use to draw specific shapes, and in this project, you'll use the rect() function to create rectangles.

As noted earlier, you need to pass four values, or *parameters*, to the rect() function, and you must place them in a specific order: the x-coordinate of the top-left corner, the y-coordinate of that corner, the rectangle width, and the rectangle height. For example, calling rect(100,100,20,30) would draw a 20×30-pixel rectangle starting 100 pixels to the right and 100 pixels down from the sketch origin.

Start by drawing a basic rectangle before you jump into drawing rectangles from the table you used to break down your pixel art. Create a draw() loop function, and add a rect() function inside

the loop. Make sure you don't forget to add a semicolon! Your code should look something like this:

```
void draw()
{
  rect(50,85,150,75);
}
```

Click the **Run** button, and your sketch window should display a white rectangle outlined in black (Figure 1-4). Success!

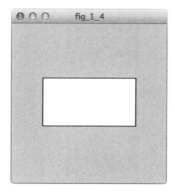

FIGURE 1-4:

Rectangle drawn by Processing sketch

But your pixel draft probably includes colors other than white, so how do you change the color of a rectangle?

ADDING COLOR

Processing provides a number of ways to change the color of a drawing, including a function called fill() that fills shapes with color, like the paint bucket tool in many graphic design applications.

There are a few ways you can specify color to a computer, but I'll focus on just one for now: RGB. *RGB* stands for *red green blue*, and in this format, each color intensity is represented by a number from 0 to 255, where 0 is no color and 255 is full intensity. The fill() function accepts three different parameters, which also range from 0 to 255 and represent amounts of red, green, and blue (in that order). You could pass 255, 0, and 0 to the fill() function to fill a shape with only the highest intensity of red. The two zeros tell Processing not to use blue or green.

If you use a single 0–255 number, you'll get a grayscale value, where 0 is black and 255 is white (see Figure 1-5).

FIGURE 1-5:

Grayscale values in
Processing

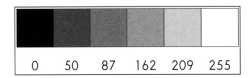

| 0 | 50 | 87 | 162 | 209 | 255 |

Any function that manipulates a shape's appearance is called a *modifier*, and all modifiers must appear above the shapes being altered in your Processing code. So to color your rectangle red, add the `fill()` function above the `rect()` function and pass the three values representing full-intensity red without green or blue (see Figure 1-6).

```
void draw()
{
  fill(255,0,0);
  rect(50,85,150,75);
}
```

FIGURE 1-6:

Color shapes with
full-intensity red using
`fill(255,0,0)`.

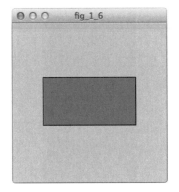

Play around with more number combinations in `fill()` to see what colors you get! Figure 1-7 shows a purely green rectangle using `fill(0,255,0)`. How would you make a blue one?

FIGURE 1-7:

Color shapes with full-
intensity green using
`fill(0,255,0)`.

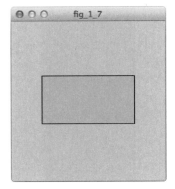

Processing also includes a tool that lets you select a specific color. In the menu bar at the top of the code window, click **Tools** to access a menu of add-ons that make certain tasks easier. Click **Color Selector** to launch the Color Selector tool in a dialog, as shown in Figure 1-8.

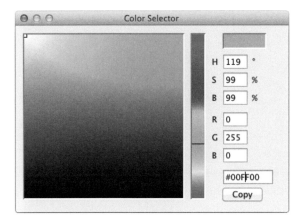

FIGURE 1-8:
The Color Selector tool

Note the RGB values for red, green, and blue. You can use this interface to find the exact color you're looking for. Select the color you want with your mouse, and the Color Selector displays the color's RGB value on the right side of the window. Using the Color Selector tool, you can create very detailed images with appropriate colors without having to play an RGB guessing game.

ORDER MATTERS

Remember how you sorted your list of rectangles by color, as shown in Table 1-1? I had you organize them that way to make using the `fill()` function easier.

When you add a `fill()` function to your code, it fills all shapes below it with the color you specify. If you don't group your rectangles by color, then you might have to call a `fill()` function for each rectangle! When you call the `rect()` functions for all rectangles of a particular color in a group, you only have to call `fill()` once for each color, as in this `draw()` function for the sketch shown in Figure 1-9.

```
void setup()
{
  size(250,250);
}

void draw()
```

NOTE

The other popular way to specify color in Processing is with hex values, which are also often used to specify color in websites and other digital content. The Color Selector shows a hex value in the very last text field. Use hex values in your code if you'd prefer, but I'll use the RGB setting throughout this book to keep explanations simple.

```
{
  fill(0,0,255);          //blue rectangles
  rect(5,5,25,25);
  rect(55,55,25,25);

  fill(0,255,0);          //green rectangles
  rect(30,30,25,25);
  rect(105,105,25,25);

  fill(255,0,0);          //red rectangles
  rect(80,80,25,25);
  rect(130,130,25,25);
}
```

You called the fill() function only three times, even though the sketch window shows six colored rectangles. Grouping elements of the same color helps to keep your code nice and clean, especially if you leave some whitespace between your color groupings.

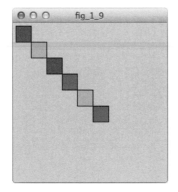

Now that you have some experience with creating a rectangle and filling it with color, you can tackle your table of colored rectangles from your pixel art drawing. Start with one color from your drawing, use the Color Selector tool to find the fill color that best matches it, draw all of the rectangles of that color at one time, and then move on to the next color. Click the **Run** button every so often to check the progress of your image, see if everything is lining up correctly, and confirm that you like the colors you've chosen. Continue working this way until you've drawn all of your rectangles.

REMOVING OR MODIFYING YOUR OUTLINES

Each rectangle in your picture probably still has a black outline, which may make your drawing look funny. The outline of a shape is called a

stroke, and Processing applies a single black stroke to every shape by default. If you don't like the current stroke, you can modify it or get rid of it completely.

When creating a pixel art image, you really don't want every rectangle outlined; it ruins the look of using individual pixels! Use the function noStroke() at the top of your draw() loop, as shown here, to remove the stroke from all of the shapes in your sketch, just as I did for the red square in Figure 1-10.

```
void draw()
{
  noStroke();      //no outline
  fill(255,0,0);   //red fill
  rect(75,75,100,100);
}
```

FIGURE 1-10:
A red square with no stroke

If you want a stroke for some shapes, use the stroke() function to add it back to a particular shape or group of shapes. Notice that the stroke() function works just like the fill() function, but it's for coloring outlines rather than filling entire shapes. You can use an RGB or hex value if you want a specific color; the red square specified here and shown in Figure 1-11 has a blue stroke.

```
void draw()
{
  stroke(0,0,255);  //blue outline
  fill(255,0,0);    //red fill
  rect(75,75,100,100);
}
```

FIGURE 1-11:

Outlining a single shape

Remember, if you don't specify the stroke() of groups of code lines or specify noStroke(), then one stroke() value will be applied to all geometry functions.

SCALING YOUR SKETCH TO EPIC PROPORTIONS

You've learned to draw basic rectangles, placed them on a Cartesian coordinate plane, filled them with color, and removed their outlines. You should have the coolest tiny pixel art image ever! Your Processing code should look something like Listing 1-1.

LISTING 1-1:

Rectangle sizes with a sketch window of 20×20 pixels

```
void setup ()
{
  size(20,20);
❶ background(0,0,0);
}
void draw()
{
  noStroke();
❷ fill(188,13,168);
  rect(4,5,1,1);
  rect(3,6,2,1);
  rect(5,7,1,1);
  rect(7,7,5,2);
  rect(13,7,1,1);
  rect(14,6,2,1);
  rect(14,5,1,1);
  rect(6,8,1,3);
  rect(12,8,1,3);
  rect(9,9,1,1);
  rect(8,10,3,1);
  rect(6,11,3,1);
  rect(10,11,3,1);
  rect(5,12,1,1);
```

```
  rect(7,12,5,1);
  rect(13,12,1,1);
  rect(3,13,2,1);
  rect(4,14,1,1);
  rect(14,13,2,1);
  rect(14,14,1,1);
  rect(7,13,1,1);
  rect(9,13,1,1);
  rect(11,13,1,1);
}
```

This sketch draws the skull shown in "Drafting Your Pixel Art" on page 18 and in Figure 1-12. The background() function ❶ takes three parameters that represent red, green, and blue, just like fill(), and I used it to color my background black. All of the rectangles in the skull are pink ❷, just as I defined them in Table 1-1.

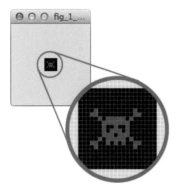

FIGURE 1-12:

Skull image at 20×20 pixels

But that sketch is *awfully* small. Don't worry—you can make it bigger.

In Processing, size is all about scale. If you multiply all of the values in your rectangle functions as well as your sketch window size by a factor of 10, your image will come out much larger—in fact, 10 times larger! Check out Listing 1-2 for an example.

```
void setup ()
{
❶  size(200,200);
  background(0,0,0);
}

void draw()
{
  noStroke();
  fill(188,13,168);
❷  rect(40,50,10,10);
```

LISTING 1-2:

Rectangle sizes with a sketch window of 200×200 pixels

```
  rect(30,60,20,10);
  rect(50,70,10,10);
  rect(70,70,50,20);
  rect(130,70,10,10);
  rect(140,60,20,10);
  rect(140,50,10,10);
  rect(60,80,10,30);
  rect(120,80,10,30);
  rect(90,90,10,10);
  rect(80,100,30,10);
  rect(60,110,30,10);
  rect(100,110,30,10);
  rect(50,120,10,10);
  rect(70,120,50,10);
  rect(130,120,10,10);
  rect(30,130,20,10);
  rect(40,140,10,10);
  rect(140,130,20,10);
  rect(140,140,10,10);
  rect(70,130,10,10);
  rect(90,130,10,10);
  rect(110,130,10,10);
}
```

Starting with the sketch window size ❶ and moving on to the rectangle locations and dimensions ❷, I've made each value in this sketch 10 times larger. The actual pixel art image (Figure 1-13) is much easier to see now!

FIGURE 1-13:

Skull image at
200×200 pixels

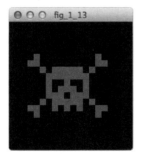

TAKING IT FURTHER

If you really like your image and want to share it with others, I highly recommend visiting *http://openprocessing.org/*. OpenProcessing allows you to upload your sketches to the Web and share not only how they look but also the code that you used to create them. Other people can then check out your projects and even fork your code

and modify it. Modifying other users' code to see how your changes affect the original image is also a great way to learn how to program in Processing.

If you want to try your hand at more complex pixel art, then instead of creating an image off the top of your head, try reproducing a pixelated version of an existing image by printing it out and placing it underneath your graph paper. Using the same pixel art rules for your original pixel masterpiece, try to trace the print out with squares of colors to pixelate it. You should end up with an elaborate, pixelated version of what you printed out. Dare I suggest attempting the *Mona Lisa*? And it's always fun to pixelate a friend!

HOLIDAY CARD

NOW THAT YOU'RE A RECTANGLE-DRAWING CHAMPION, YOU'LL DRAW SOME OTHER SHAPES AND PUT THEM TO GOOD USE. WHAT BETTER WAY TO PRACTICE BASIC DRAWING THAN BY CREATING A HOLIDAY CARD?

Through the metaphor of a paper collage, you'll learn how to compose an image using shapes and lines in Processing. I'll also give you a deeper look at the line() function and how you can modify lines in different ways. Put on your artist's hat, because here we go!

GATHER YOUR MATERIALS

- Colored pencils
- Graph paper

DRAWING MORE SHAPES!

You can draw a number of basic shapes in Processing, and each shape is always defined by points on the Cartesian coordinate plane. Here is a rundown of the basic geometric shapes and the parameters that you need to pass to them.

Ellipses

An *ellipse* is an oval or circle, and you can draw one in Processing with the ellipse() function. Pass ellipse() four values, just like you would rect(), in this order:

```
ellipse(X,Y,W,H);
```

X and Y give the x- and y-coordinates of the ellipse's position; W and H indicate the width and height, respectively. If you make W and H the same value, you'll draw a circle, as in this example.

```
void setup()
{
  size(250,250);
  background(150);
}

void draw()
{
❶  ellipse(125,125,100,100);
}
```

In this sketch, I've used ellipse() ❶ to draw a circle with a diameter of 100 pixels at the center of the sketch window (see Figure 2-1).

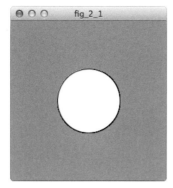

FIGURE 2-1:
Drawing an ellipse in
Processing

The difference between drawing a rectangle and drawing an ellipse is that the rectangle's origin is its upper-left corner, while the ellipse's origin is its center. You can see this clearly in Figure 2-2, where both a rectangle and an ellipse have been passed the same parameters.

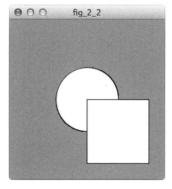

FIGURE 2-2:
This ellipse and
rectangle were both
passed the parameters
(100,100,100,100). Try it!

Lines

The second common shape you'll draw in Processing is the line. You used the `line()` function in Project 0, but I'll cover it in a little more detail here. The `line()` function requires two points, (*X1,Y1*) and (*X2,Y2*). The order of parameters in the `line()` function is as follows:

```
line(X1,Y1,X2,Y2);
```

The first point, (*X1,Y1*), indicates where your line should start. The second, (*X2,Y2*), indicates where it should end. So in this example, I've drawn a line from (25,25) to (175,175):

```
void setup()
{
  size(250,250);
  background(150);
```

```
}

void draw()
{
   line(25,25,175,175);
}
```

This line should run from the top left to the bottom right of the sketch window, as shown in Figure 2-3.

FIGURE 2-3:

Drawing a line

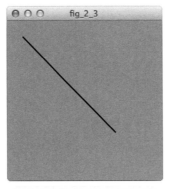

Line Color

The stroke() function, which you learned about in Project 1, doesn't just change shape outlines; it modifies the line() function, too. So to change the color of a line, use the stroke() function and pass it a set of RGB values. The noStroke() function also hides all lines as well as outlines. Keep that in mind for later!

```
stroke(R,G,B);
noStroke();
```

You can change the stroke color as many times as you want in your sketch:

```
void setup()
{
   size(250,250);
   background(150);
}

void draw()
{
❶  stroke(255,0,0);
   line(0,0,200,200);

❷  stroke(0,255,0);
```

```
    line(50,0,200,150);

❸   stroke(0,0,255);
    line(100,0,200,100);
}
```

In this example, I've drawn a red line ❶, a green line ❷, and a blue line ❸ on a gray background. Check out the result in Figure 2-4.

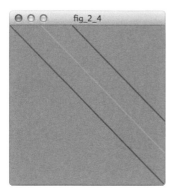

FIGURE 2-4:
Pick a color, any color!

Line Thickness and End Shapes

More useful, line-specific modifiers include strokeWeight() and strokeCap(). strokeWeight() controls the thickness of a line, and you pass it one parameter—the line thickness in pixels:

```
strokeWeight(width in pixels);
```

There is no limit to your strokeWeight() value, but past a certain weight, it would probably be easier to use the rect() function. I've shown a few examples here:

```
void setup()
{
  size(250,250);
  background(150);
}

void draw()
{
  stroke(255,0,0);
❶ strokeWeight(5);
  line(0,0,200,200);

  stroke(0,255,0);
❷ strokeWeight(15);
  line(50,0,200,150);
```

```
    stroke(0,0,255);
❸   strokeWeight(30);
    line(100,0,200,100);
}
```

In this sketch, the red line ❶ has the smallest stroke weight, so its line is the thinnest. The green line ❷ and the blue line ❸ are progressively larger, as shown in Figure 2-5.

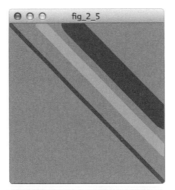

strokeCap() deals with the shape of the end of a line. You have three different shapes to choose from: ROUND, SQUARE, and PROJECT. (You must capitalize these parameters for the function to accept them; this formatting denotes that they are a known and preset parameter within Processing.)

```
strokeCap(ROUND);
strokeCap(SQUARE);
strokeCap(PROJECT);
```

As their names indicate, ROUND rounds off the end of a line, and SQUARE gives your line a squared-off end. Both terminate the line at exactly the point specified by line(). PROJECT is a squared line that projects a distance beyond the point, for some extra style. Look at these stroke caps in action:

```
void setup()
{
  size(250,250);
  background(150);
}

void draw()
{
```

```
     stroke(255,0,0);
     strokeWeight(10);
❶   strokeCap(ROUND);
     line(25,25,175,25);

     stroke(0,255,0);
     strokeWeight(10);
❷   strokeCap(SQUARE);
     line(25,75,175,75);

     stroke(0,0,255);
     strokeWeight(10);
❸   strokeCap(PROJECT);
     line(25,125,175,125);
}
```

These three lines all start and stop at the same x-positions, but they look a bit different. The red line ❶ is rounded, while the green line ❷ is squared off. The blue line ❸ looks like another square-capped line, but it projects a bit farther than the green line. You can see this output in Figure 2-6.

FIGURE 2-6:
Each line uses a different strokeCap() type.

Quadrilaterals

Quadrilaterals are another shape you'll see used frequently in Processing. While the rect() function is great for drawing rect-angles and squares, quad() is much more flexible. It also produces a shape with four sides, but those sides don't need to be parallel to one another, as they do in a rectangle or square. You pass the quad() function eight parameters, which represent the four corner points of the shape:

```
quad(X1,Y1,X2,Y2,X3,Y3,X4,Y4);
```

Make sure you specify the points of the quadrilateral in sequential order, because Processing will draw from point to point. You can go around the shape either clockwise or counterclockwise, starting from (*X1*,*Y1*).

```
void setup()
{
  size(250,250);
  background(150);
}

void draw()
{
  fill(255,0,0);
  quad(25,25,150,50,100,175,25,200);
}
```
❶

To draw the shape in Figure 2-7, I started with the point closest to the top left (25,25) and went clockwise to (150,50), and so on ❶.

FIGURE 2-7:

A proper quadrilateral has four sides, but they don't have to be parallel.

If you don't enter your points in order, you may get an odd-looking shape instead of a quadrilateral. Figure 2-8 shows an example where I swapped the last two points around. Not quite what I was looking for!

FIGURE 2-8:

Swapping two points actually produced two triangles!

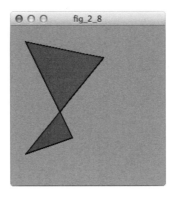

Triangles

The final common Processing shape I'll cover here is a triangle. The `triangle()` function requires three points, so it takes six different parameters:

```
triangle(X1,Y1,X2,Y2,X3,Y3);
```

As with the `quad()` function, you need to pick a direction and follow it around the shape as you pass in those points:

```
void setup()
{
  size(250,250);
  background(150);
}

void draw()
{
  fill(0,255,0);
  triangle(25,25,150,50,25,200);
}
```

This sketch should draw the triangle in Figure 2-9, starting at (25,25) and moving clockwise around the shape.

If you have trouble thinking in terms of points in space and then connecting those points, I recommend keeping graph paper and a pencil on hand as you get started with Processing. When you use `quad()` and `triangle()`, it helps to sketch out your drawing on graph paper to get your points straight before typing the parameters.

PROGRAMMING A DIGITAL COLLAGE

Time to start drawing! As I mentioned in the introduction, you can think of the sketch window as a collage. Remember cutting out paper circles and gluing them to a piece of construction paper to create a card before winter break when you were a kid? You're going to do the same thing in Processing, but with a lot less mess. In this project, you'll make a snowman like the one in Figure 2-10, but once you have a sense of how shapes and lines work together, you can draw anything you want!

FIGURE 2-10:

A snowman created using shapes and lines in Processing

Setting the Stage

Your code window is probably full of practice code, so click
File ▸ New to open a clean window now.

Going back to that collage metaphor, the first thing you need is a piece of digital construction paper. You've seen the size() and background() functions already in Project 1, and you'll use them here to create a light blue sky background.

```
void setup()
{
  size(1100,850);
  background(25,220,252);
}
```

This setup() function gives you a big, blue canvas on which you can draw your snowman scene.

Gluing Down the Pieces

With the setup() function in place, you can start to add shapes. I suggest drawing the snowman from the bottom layer up, as if you were building a real one. First, create the body of the snowman by adding the following after your setup() code:

```
void draw()
{
  fill(255);
  noStroke();
  rect(0,700,1100,150);

  ellipse(550,600,225,225);
  ellipse(550,425,175,175);
  ellipse(550,300,100,100);

  //accessorize your snowman here!

  noLoop();

}
```

① In this code, I added the ground as a rectangle ❶ and stacked three white ellipses on top of one another, as shown in Figure 2-11. I also placed the example snowman in the center of the sketch window, as indicated by the fact that all three ellipses have an x-coordinate of half the total sketch width.

FIGURE 2-11:
The body of your snowman uses three different-sized ellipses.

Also, notice the noLoop() function at the end of the draw() loop. Normally, draw() repeats over and over again, but once you glue shapes to your paper, your physical collage is static, so that's how you'll approach the digital one, too. The noLoop() function prevents draw() from repeating.

I played around with the sizes of the different ellipses until I found a size and scale I liked for each. If you have trouble visualizing the different components of the sketch at this point, rough out a snowman on your graph paper first. Be sure to note where the origins of your circles fall and the rough endpoints of your lines. If you lack time or patience, graph paper will help you conserve both.

With the snowman's body in place, you can add some distinguishing features. A standard snowman has three buttons, two eyes, and a carrot nose. Those will be our next phase of programming, so add the following just before the closing bracket of your draw() loop, underneath the three ellipses:

NOTE

I went with the standard three-ball snowman, but if you have other ideas for your snowman's body shape, try them out! You'll find drawing a graph paper sketch first invaluable there, too. Then you can draw as many trial snowmen as you want before you decide which to plug into Processing.

```
fill(0);
ellipse(530,280,10,10);            //eyes
ellipse(550,280,10,10);

ellipse(550,400,10,10);            //buttons
ellipse(550,450,10,10);
ellipse(550,500,10,10);

fill(255,150,0);
triangle(525,300,530,310,485,310);  //carrot nose
```

In my code, I grouped the eyes and buttons together under the black fill() function and drew the carrot nose last. As you learned in Project 1, grouping the shapes and lines by color reduces the number of fill() and stroke() functions you have to use. See the output in Figure 2-12. That's progress!

For the arms of my snowman, I used a number of lines to create sticks. To draw arms like the ones I used, add the following immediately after the code for your snowman's nose:

```
❶  stroke(100,15,15);
❷  strokeWeight(5);
   line(475,390,400,315);  //right arm
   line(419,333,430,300);

   line(625,440,700,530);  //left arm
   line(668,494,660,525);
```

FIGURE 2-12:
It's clear that you're making a snowman, but this holiday card isn't done yet.

I changed the stroke color to brown ❶ and increased the stroke weight ❷ to make the sticks thicker. You could also play with the strokeCap() of your lines to get the look you want; I stuck with the standard cap, as you can see in Figure 2-13.

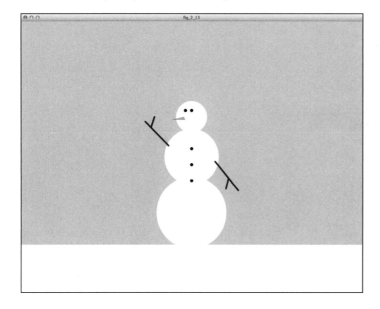

FIGURE 2-13:
Your snowman is complete!

PRINTING TO THE CONSOLE

Review the snowman code so far and look over all of the geometric shape functions and their modifiers. I used a lot of exact numbers in my points, and the trick to figuring those points out lies in this line of code:

```
println(mouseX + "," + mouseY);
```

The `println()` function prints information in the console window below the code window. It prints any string of characters—letters, numbers, punctuation, and other symbols—that you tell it to. A single character has the data type `char` in Processing, and a group of characters is a `String`; you will learn more about them both in coming chapters. You use the + operator to combine groups of strings and characters.

The values `mouseX` and `mouseY` are both *variables* built into Processing, and they contain the x- and y-coordinates of my mouse. A variable is any value that can change, or vary.

This particular line of code prints the x- and y-coordinates of the mouse cursor while the cursor is inside the sketch window; Figure 2-14 shows this happening in my console. If your sketch window is open, click **Stop** to close it. Then, comment out the `noLoop()` function to let `draw()` run continuously, add that `println()` function to the end of your `draw()` loop, click **Run**, and watch the bottom of the Processing window.

FIGURE 2-14:

The console window for the x- and y-coordinates of my mouse

The coordinates of your mouse should print in the console, and as you move your mouse around the sketch window, those numbers should change. So to find the exact values for start points and endpoints of lines and determine where you want to place shapes (such as a button on the snowman), just run this line of code inside the `draw()` loop and note the coordinates you want to use! This handy piece of code can reduce the amount of trial, error, and frustration for you.

TAKING IT FURTHER

As you draw your own images, look for creative ways to use the different shapes available in Processing. You could use a combination of lines and quadrilaterals to make a snowflake, or perhaps you could use ellipses and rectangles to make a car. Try different modifiers to achieve different effects, and be sure to share your work with your friends!

A FIRST DYNAMIC SKETCH

IN YOUR SKETCHES UP TO THIS POINT, YOU'VE MADE THE DECISIONS, AND YOU'VE DONE THE MATH. BUT COMPUTERS ARE MUCH FASTER THAN YOU ARE AT BOTH OF THOSE TASKS. IT'S TIME TO SET UP VARIABLES, TACKLE SOME LOGIC, AND GET THE COMPUTER TO DO THE HEAVY LIFTING RATHER THAN DOING IT YOURSELF.

MORE ON VARIABLES

In Project 2, I showed you how to use some of Processing's built-in variables (mouseX and mouseY) to figure out exactly where to put the pieces of your snowman. In this project, you'll take variables a step further: you're going to create your own!

Anatomy of a Variable

First, let's crack open a variable and see what it's made of. This variable, called x, contains the number 23.

```
int x = 23;
```

A variable has three parts, and the first is the data type. There are a whole slew of data types in Processing, but I'll use only a handful in this book. Here are the primary data types you'll use and a quick definition of each.

int An integer (whole number), for example 35
float A number with a decimal point, for example 3.5
char An alphanumeric character, for example 'a'
String A group of characters bound by quotation marks (""), for example "This is a string"
boolean A value of true or false, or 1 or 0

Think of data types as different types of dishes. Each dish has its own use and designated function. For example, you eat soup out of a bowl. If you tried to eat soup off a plate, you would make a mess! The same is true of data types: if you try to store a String in an int, it just won't work. Processing doesn't like messes, so it is really picky about data types.

The second part of a variable is its name. You could use generic letters, as in algebra, but some situations call for more descriptive names. For example, the x-coordinate of a shape might be named shapeX. A good variable name gives a clue as to what that variable is used for so that your code makes sense not just to you, but also to anyone else who might read it.

The final part of a variable is its initialization value. *Initializing* a variable is essentially giving it a starting value.

```
int x = 3;    //initialized with the value 3
int x;        //to be initialized later
```

You don't have to initialize right away unless the variable needs a value when the sketch makes its first cycle through the `draw()` loop. If you are going to initialize the variable somewhere else in the code, you can give it a data type and a name at the beginning, and give it a value later.

Where to Use a Variable

You can create a variable anywhere you want in your code; however, that doesn't mean that variable is accessible everywhere in your sketch. When you create a variable outside the `setup()` function or the `draw()` loop—say, at the top of your code window—it is called a *global variable*. A global variable can be used and accessed anywhere in the sketch, by any function.

If you create a variable inside a separate function, it is called a *local variable*, and it can be used and referenced only within that function. If you try to use that variable within a different function, Processing will throw an error telling you the variable doesn't exist.

```
int G = 29;    //G is a global variable

void setup()
{
  int L = 300; //L is a local variable
  size(100,L);
}

void draw()
{
  background(G,200,0);
}
```

In this example, the global variable G is initialized at the very top of the sketch, outside the `setup()` and `draw()` functions. The variable L is a local variable that you can use only inside the `setup()` function, where it was initialized inside the `setup()` function itself.

MATH IN PROCESSING

There are several ways to work with variables in Processing. For example, you can perform different math functions on them. You can multiply, subtract, and so on in your head, but fortunately, you can

also let Processing handle the math for you using the *mathematical operators* listed here.

+ Addition
- Subtraction
* Multiplication
/ Division

In your first dynamic sketch, you'll use basic math to manipulate variables, but first, take a look at how logic works in Processing.

LOGIC

In programming, the basic level of logic is the `if()` statement. You probably even used this construct as a kid without knowing it! Have you ever played Simon Says? The rules are basically an `if()` statement. Players should follow Simon's commands only *if* Simon says the words "Simon says" first. The `if()` statement works the same way, but your computer will never lose.

Inside if() Statements

`if()` statements begin with `if()`, where the parentheses contain a condition that can be true or false, such as x > 100.

```
if(x > 100)
{
  //execute if statement inside parentheses is true
}
else
{
  //execute if statement inside parentheses is false
}
```

If the value of x is greater than 100, Processing will implement the code between the curly brackets just below the `if()` statement. If the statement is false (that is, if x is less than or equal to 100), Processing will implement the `else` portion of this code. The `else` is not required; if it is not present, Processing just moves to the next line of code.

CODE CONVENTIONS

If you have previous programming experience, you may have noticed that I place my curly brackets differently than the standard convention. I give each curly bracket its own line, whether the brackets are used in an `if()` statement or for a `draw()` loop.

```
//standard convention for bracket placement
if(statement) {
  //your awesome code here!
}

//my unconventional brackets
if(statement)
{
  //your awesome code here
}
```

I position my brackets this way so that when I'm debugging, I can easily find each one. Both placements are correct, and you can use whichever style you're more comfortable with. You'll often find that there are multiple ways to structure your code, so don't worry too much about following convention if you find a style that works for you!

My preferences for how I structure my code stem from being a teacher and wanting to check for correct structure and quickly be able to debug a student's sketch. The style has stuck with me ever since and has become the standard way we structure code here at SparkFun.

The `if()` statement is the basis for how your sketch starts to make decisions, but its power is all in the *conditional argument* that you give it. In the previous example, x > 100 was a conditional argument, and the code inside the `if()` statement would have run only if that condition were true, as shown by the branches in Figure 3-1.

FIGURE 3-1:

Flowchart of an

if() statement

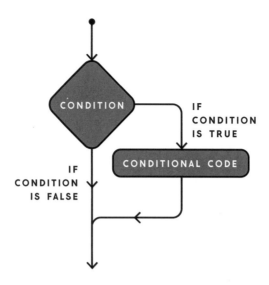

A Refresher on Relational Operators

Notice the greater-than sign in x > 100. If you haven't used *relational operators* such as greater than and less than in a while, here's your chance to brush up on them and put them to good use!

In Processing, you'll use relational operators to create conditional arguments. These allow you to test if something is greater than a value, less than a value, and so on. You can harness the power of these statements to make events happen only if a value equals a certain number or falls within a specified range of numbers.

Relational operators are at the heart of computational thinking and logic. If you take just one skill away from this book, it should be the concept of computational logic with an if() statement. As a refresher, here's a list of relational operators and how they are stated in Processing.

a > b Greater than

a >= b Greater than or equal to

a < b Less than

a <= b Less than or equal to

a != b Not equal

a == b Equal to

Logical Operators

After a while, you'll start to see that you may need more than one argument for a piece of logic to really work. In Simon Says, there's usually a number of people who will never mess up if you stick with

one instruction at a time. You want to be able to combine arguments to create compound logical arguments.

Compound logic uses more than one conditional argument and combines those arguments into *logical operators*. Processing includes three logical operators: OR, AND, and NOT.

a || b OR
a && b AND
!a NOT

The compound argument a || b resolves to true if either a or b is true; a && b is true only if both a and b are true. The last statement, !a, is true only if a is false.

To combine logical arguments, just place each argument on one side of a logical operator, as in this example.

```
if((x > 100) && (x < 200))
{
   //true argument code
}
else
{
   //false argument code
}
```

If the variable x is greater than 100 and less than 200, Processing should execute whatever code is in the `if()` statement. If the variable falls outside of those values, then Processing will execute the `else` statement code.

FOLLOWING THE BOUNCING BALL

With those fundamentals in mind, let's get coding! For this project, I'll teach you to create some basic animations using `if()` statements to manipulate variables. First, create two global variables: one for the starting x-position of an ellipse you'll draw (x), and one to control how fast the ellipse moves (grow).

```
int x = 400;
int grow = 5;
```

Next, create your `setup()` code, and specify the size of your sketch window and background. Also add a call to a function named `smooth()`, which simply smooths the edges of shapes. The resulting effect looks nice, especially when a shape is moving.

```
void setup()
{
    size(800,800);
    background(150);
    smooth();
}
```

My `background()` function paints a black backdrop to set the stage for the real magic, which happens inside the `draw()` loop. In Project 2, your snowman remained static, but that's not where the true power of `draw()` lies. It's time to unshackle your `draw()` loop to create animations.

Moving in One Direction

You added `noLoop()` to the end of the `draw()` loop in Project 2 to prevent the loop from repeating, which created a completely static sketch. But `draw()` really shines when you want to create a dynamic sketch.

First, add a `draw()` loop to your sketch, after the `setup()` code. Select a fill color and draw an ellipse, using the x variable for the ellipse's x-coordinate.

```
void draw()
{
    fill(255,0,0);
    ellipse(x,400,100,100);
❶  x++;
}
```

I created my ellipse with a y-coordinate of 400 and a 100-pixel diameter, but you could use any values you like for the other three parameters. At the end of the loop, add 1 to x ❶.

Most of the code elements at this point should look familiar. The one part that may be new to you is the x++, which is shorthand for x = x + 1. Every time Processing reads that line of code, it increases the value of x by 1. So every frame, or every time the `draw()` loop is run, x increases by 1, and the ellipse should move to the right. Figure 3-2 shows my ellipse in action.

FIGURE 3-2:
This bright red ellipse
leaves a pretty obvious
trail at the moment.

Notice the trace following my ellipse in Figure 3-2. Since you're
drawing the background in `setup()` rather than in `draw()`, every
version of the ellipse that Processing adds to your sketch remains
visible. To remove the trace, cut the line `background(150);` from your
`setup()` function and paste it into the `draw()` loop. Click **Run** to see
the outcome.

Creating Walls

The ellipse should move to the right of the sketch window, eventually
moving outside your specified sketch area. But why just let the ellipse
disappear? You can make it bounce off the edge of the window and
change directions instead. Enter the `if()` statement!

```
void draw()
{
  background(150); //drawing the background after every loop
  fill(255,0,0);
  ellipse(x,400,100,100);
❶  x = x + grow;    //assigning x

❷  if(x >= width)
  {
❸    grow = grow * -1;
  }
}
```

Instead of just incrementing x by 1, this `draw()` loop now increments x by grow (with x = x + grow ❶). I've also added an `if()` statement ❷ that basically reads, "if x is greater than or equal to width, then multiply grow by –1." The value width is built into Processing, and it always equals the width of your sketch window; in this case, it's 800 pixels. If the statement is true, grow will become negative ❸, changing the direction in which the ellipse moves. Your ellipse should bounce off the right side of the screen. Success!

But keep watching that ellipse. Eventually, you'll see it zoom straight out of the window on the left side. The problem is that the argument you pass the `if()` statement accounts only for the right side of the sketch window. The conditional statement x >= width establishes the boundary for the right side of the window but not the left side. You need to add another conditional statement to the argument using an OR logic operator, as shown in Listing 3-1.

LISTING 3-1:

A bouncing ellipse

```
void draw()
{
  background(150);
  fill(255,0,0);
  ellipse(x,400,100,100);
  x = x + grow;

if((x >= width - 50) || (x <= 50))
  {
    grow = grow * -1;
  }
}
```

The new conditional statement, x <= 50, checks the left boundary of the sketch window. Thanks to the || operator, the code inside the `if()` statement will execute if either of those two conditionals is true. I could have left it at x <= 0, but I changed it to x <= 50; note that I've also subtracted 50 from the width in the first argument. I've done this to compensate for the distance between the origin of the ellipse, which is the center, and the edge of the ellipse, which has a radius of 50 (100/2 = 50). If you make these modifications to your sketch, you should have a satisfying bouncing ellipse.

The `if()` statement is really powerful for getting your sketch to make decisions. Once you get the hang of it, you will be thinking in terms of `if()` in no time at all. You can use it to change colors, sizes, shapes, and, as you have done already, motion. Try tackling these options with an `if()` statement on your own!

For a challenge, try to create an ellipse that grows in diameter and then shrinks again in a pulsing manner. How could you increase or decrease the speed at which it grows or shrinks? Could it grow faster and shrink slower? A pulsating shape has a number of different applications in programming, so once you get it working, keep it in your coder tool belt.

TRAILS OF COLOR AND MULTIPLE VARIABLES

A single ellipse moving back and forth can teach you a lot, but you can extend this project to make something more colorful without too much extra work. It's time to add more bouncing ellipses! I'll only show you how to get them bouncing horizontally (as in Figure 3-3), but if you're looking for a bit of a challenge, create a few more and make them bounce vertically.

FIGURE 3-3:
Final version of the multiple ellipse bounce

Reusing Code

Of course, I'm all about working smart and not hard . . . so let's use cut and paste!

Each ellipse needs its own set of x and grow variables, so create those now. You can type these out or cut them from Listing 3-1, paste them, and make changes. The important part is that each variable needs to be different from the others. I just gave each copy a number that represented which ellipse it would be assigned to. Here is my list of variables; delete the original x and grow, and add these (or your own!) to the top of your sketch.

```
int x1 = 400;    //x-coordinate for ellipse 1
int x2 = 300;    //x-coordinate for ellipse 2
int x3 = 200;    //x-coordinate for ellipse 3

int grow1 = 1;   //grow variable for ellipse 1
int grow2 = 1;   //grow variable for ellipse 2
int grow3 = 1;   //grow variable for ellipse 3
```

All three x variables are assigned different numbers, but the `grow` variables all start at the same value. You may think that you could get away with using just one variable for `grow`, but that's not the case. Since each ellipse will collide with the edge of the sketch window at a different time, each needs its own variable for direction; otherwise, one ellipse would trigger the other two to change direction early.

Manipulating Individual Shapes

Once you've taken care of all of the variables, your code will pretty much stay the same for your `setup()`; the only difference is that you'll set the background there again. But you do have some big changes to make in your `draw()` loop.

```
void setup()
{
  size(800,800);
  background(150);
  smooth();
}

void draw()
{
  stroke(255,0,0);
  ellipse(x1,200,50,50);

  stroke(0,255,0);
  ellipse(x2,400,50,50);

  stroke(0,0,255);
  ellipse(x3,600,50,50);
}
```

First, write three `ellipse()` functions to create two more ellipses than you had before. To spice up the visuals, I also changed the stroke color of each ellipse; make those anything you like. With the background placed in `setup()`, the ellipses will leave streaks of color across

the screen. Make sure that you test your code at this point to see if you like where you've placed your ellipses. Move their starting positions or vertical placement around as you see fit.

When you get everything where you want it and the colors suit you, move on to the `if()` statements and the increment equations. Replace `x = x + grow;` and the original `if()` statement (as shown in Listing 3-1) with the following:

```
x1 = x1 + grow1;
x2 = x2 + grow2;
x3 = x3 + grow3;

if(x1 >= width - 25 || x1 <= 25)
{
  grow1 = grow1 * -1;
}
if(x2 >= width - 25 || x2 <= 25)
{
  grow2 = grow2 * -1;
}
if(x3 >= width - 25 || x3 <= 25)
{
  grow3 = grow3 * -1;
}
```

Just as you did with the single bouncing ellipse, you need to modify the `if()` statement to account for the width of the ellipse. The origin of the ellipse is at the center, so you have to use the radius value to find the edge of the ellipse. Here, the radius is 25 for all of the ellipses. As you can see, I have already added the math to the bounding `if()` statements for each ellipse. If you use a different-sized ellipse, just swap out the 25 for whatever your radius is.

Each ellipse needs not only its own equation but also its own `if()` statement so that you can control where your ellipses go and how fast they get there. I have each shape at a different starting point, which means they hit the edge of the window at different heights and different times.

If you think you might want to change each shape individually, then build that into your sketch from the beginning. For example, you could change the speed of an individual ellipse by making a single value change at this point. If you had one equation to control all of the motion, you'd have to rewrite or add a bunch of code later.

Once you get your code in place, run it, and as you watch those colored circles bounce, think about how you can remix the code. What change would you make to control the speed of each ellipse? What about its direction of travel? What if you use the x variables as more than one parameter, as I did to create Figure 3-4?

FIGURE 3-4:

Which parameters would you replace with x variables to create an image like this?

TAKING IT FURTHER

You've successfully created shapes that bounce in a single direction—along the x-axis. How might you go about getting a shape to bounce along the y-axis? Once you figure out how to get a shape bouncing in both directions, try making multiple shapes that bounce in different directions! How could you get them moving diagonally?

INTERACTIVE TIME-BASED ART

IN THIS PROJECT, YOU'LL EXPLORE TIME AS A VARIABLE AND PUT IT TO USE AS A DRIVING FORCE IN SOME TIME-BASED ART—THAT IS, ART THAT DEVELOPS OVER TIME. AT FIRST, THIS CONCEPT MAY SEEM A BIT ABSTRACT. IT'S MEANT TO! YOUR FINAL SKETCH WILL BE A CLOCK, AND ITS APPEARANCE WILL BE BASED ON WHAT THE CODE YOU WRITE DOES OVER TIME.

By now, you've learned and used many of the basic structures and functions in Processing. Think of this as a chance to just play with and explore variables within your current knowledge and understanding. For example, with what you know now plus what you'll learn in this project, you'll be able to draw shapes at different angles, to impressive effect. I created the sawblade pattern in Figure 4-1 by rotating a rectangle every second and using a time-based variable to change the color from black to red.

Since your creation will be constantly changing, I'll forgo the paper and pencil this time and jump right into the code. Go ahead and get lost for a bit, but never lose track of time as a variable!

BUILT-IN VALUES

To change a shape's dimensions, color, or other properties while your sketch is running, you need to be able to change the values you pass to your Processing functions without adjusting the sketch and restarting. You created variables to automate such changes in Project 3, but say you want a shape to respond to the passage of time or even to a mouse click.

In that case, you also have at your disposal a powerful set of system variables that are built into Processing, as well as several useful system functions. Both let you harness values from your computer to use in your projects, and you can use them in any part of your Processing sketch. Your system functions return values from your computer, such as the date, time, and so on, and for all intents and purposes, you can treat them the same as system variables.

You'll explore system variables and functions in this project as you create dynamic and time-based art. Let's take a quick look at a few particularly useful system variables now.

Finding the Mouse and Keypresses

You've already played around with two of the system variables I'll describe. Remember mouseX and mouseY? Those are mouse, or cursor, system variables. Here are the mouse system variables and the values they contain.

mouseX The x-coordinate of the mouse cursor while it is in your sketch window

mouseY The y-coordinate of the mouse cursor while it is in your sketch window

pmouseX The x-coordinate of the mouse cursor from the previous frame

pmouseY The y-coordinate of the mouse cursor from the previous frame

key The ASCII numerical value of a letter or number being pressed

The mouseX and mouseY variables store your mouse's current position, while pmouseX and pmouseY store its previous position. The key variable stores any letter or number key you're currently pressing!

Telling Time

Your computer has a built-in clock, and Processing can access it and store certain time-related values for you to use with certain functions. You can access all sorts of time- and date-based information for your sketches. Here are a few time-related functions that you'll find useful.

millis() The number of milliseconds since the sketch started

second() The seconds value on your computer's clock

minute() The minute value on your computer's clock

hour() The hour value on your computer's clock

day() The day value of the date on your computer's calendar

month() The numeric value of the current month on your computer's calendar

year() The year from your computer's calendar

All of these functions return a time-related number. Use them to represent the passing of time—from the number of milliseconds since you clicked Run to the current calendar year—in your sketch!

Putting Built-in Values into Action

You can use the values I've described in this section anywhere you would normally pass a number. For example, you can use `second()` to change a rectangle's shade of red based on how many seconds have passed in the current minute:

```
void setup()
{
  size(200,200);
}

void draw()
{
  fill(second(),0,0);   //shade of red based on
                        //the value of second()
  rect(50,50,100,100);
}
```

Just pass `second()` as the red value of the rectangle's `fill()` function!

If you run that code as a sketch, it probably isn't the most exciting thing to watch. It takes 60 seconds to get to a measly 59 out of 255 for our red value. But you can up the ante a bit and give a possible range of 0 to almost 255. Enter math!

EXTENDING YOUR RANGE

In the color example in the previous section, the red value will only go up to 59 because I used the value returned by `second()`. If you want a wider range of values, you can multiply the `second()` variable by, say, 4. When you choose a multiplier for any value you want to pass into a function, think about the range of values the function will actually accept. The `fill()` function accepts only a number between 0 and 255 for any color value. Your computer won't explode if you go over; it just caps out at 255.

The highest value you'll get from second() is 59, so when you multiply that by 4, the highest value you'll pass to fill() is 236, which is still within the fill() function's limits. Try this as a comparison to the previous example:

```
void setup()
{
  size(200,200);
}

void draw()
{
  fill(second() * 4,0,0);
  rect(50,50,100,100);
}
```

As shown in Figure 4-2, the red value of the rectangle changes every second. When you start the sketch, the value passed from second() is 0, and the rectangle is black; as the second() value increases, so does the red value in the fill() function, and the rectangle becomes redder. After the second() value hits 59 and the red value peaks at 236, the second() function starts over again at 0—a black rectangle.

RESET!

FIGURE 4-2:

This rectangle's shade of red changes according to the value of the second() function, as if second() were a variable.

Notice that the syntax of the fill() function didn't change, even though you're using an equation within the parameter for the red value. If you moved or removed the comma, you would get an error when you tried to run the sketch.

The value of second() is small and changes slowly, so I multiplied it to increase the rectangle's range of redness and speed up the color shift. A similar concept applies to values that change quickly or

grow large, like those obtained from `millis()` or `mouseX`. Just sub-tract or divide to get a smaller or steadier value! If you want a value in your sketch to be based on time or some other variable, but the variable changes at a speed you don't like, amplify or reduce it using mathematical operators.

TRANSFORMATION FUNCTIONS

When you manipulate a shape's dimensions, coordinates, and so on, you're *transforming* the shape. Geometric transforms include scaling, rotating, and translating, and you may see some similarities between transforms of the same name in graphic design software and what you learn in this project. Here are a few transformations that you'll use in this book:

scale(S) Scales the entire sketch by a percentage (S) in decimal form (for example, 80% = .80)

rotate(R) Rotates the sketch by R radians (3.14 radians = 180 degrees)

translate(X,Y) Moves the sketch X pixels along the x-axis and Y pixels along the y-axis

For now, use the transformation functions sparingly, as they'll be applied to everything in your sketch. For example, look at the `translate()` function in action.

```
void setup()
{
  size(400,400);
  translate(100,100);
  fill(255,0,0);
  ellipse(0,0,100,100);
}
```

Normally, you'd expect `ellipse(0,0,100,100)` to draw an ellipse at the origin of the sketch window. But because `translate(100,100)` is called before the `ellipse()` function is called, the ellipse will be shifted by 100 pixels on both axes, as shown in Figure 4-3.

Later, I'll show you how to apply a transformation to a specific shape or group of shapes, but for now, time to dive in and make a clock!

WITH TRANSLATE() FUNCTION **WITHOUT TRANSLATE() FUNCTION**

AN ABSTRACT CLOCK

Up to this point, I've just talked about time-based values, but now you'll get your hands dirty and actually use those values in code. Any time you learn a new Processing concept, I recommend running parts of the code in small sketches that look like the example code from this book. When you're practicing, the goal is to quickly understand the function or concept, rather than create something elaborate and beautiful.

Comparing the Major Time Functions

First, I'll compare four of the major functions that return time values. The following example uses `second()`, `minute()`, `hour()`, and `day()` to create an abstract clock, where rectangles move according to the time on your computer's clock. I replaced some `fill()` function and shape parameters with these built-in values. Since time-based functions change over time, you will have to rewrite the code on your own machine, as shown in Listing 4-1.

LISTING 4-1:

An abstract clock with three moving rectangles

```
void setup()
{
  size(240,240);
  background(150);
}

void draw()
{
❶  fill(second() * 4,0,0);
❷  rect(second() * 4,160,50,50);
```

```
    fill(0,minute() * 4,0);
    rect(minute() * 4,100,50,50);

    fill(0,0,hour() * 4);
    rect(hour() * 4,40,50,50);
}
```

This chunk of code uses the second, minute, and hour hands of the clock on your computer. Since there are 60 seconds in a minute and 60 minutes in an hour, I set the width of the sketch window to 240, which is 60 multiplied by 4.

For the first rectangle, I multiplied second() by 4 to give both its red value ❶ and x-coordinate ❷ a minimum of 0 and maximum of 240. The second and third rectangles follow that pattern, using minute() and hour(), respectively. I replaced the x-coordinate with a time-based value in both cases, but in one, the minute() value controls the green fill() argument, and in the other, the hour() value controls the blue fill() argument.

You can see the results in Figure 4-4. If you want to expand on this sketch, add a fourth rectangle that uses millis(). I will leave it up to you to figure out the equation to have the rectangle track across the screen properly and change color.

FIGURE 4-4:

An abstract clock using Processing. The top rectangles represent hours, the middle rectangles represent minutes, and the bottom rectangles represent seconds.

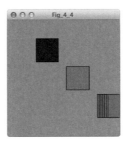

These values are really useful for triggering events at specific times, having shapes move on their own (as demonstrated here), or changing color over time. Now you can put all this into practice and make your clock more stylish.

Spicing It Up!

In this section, I'll show you how to create another abstract clock that is a little more intricate than the previous one. The clock isn't really useful for getting to work or school on time, but since I designed the project I've become accustomed to looking at it, and I'm actually

pretty good at telling what time it shows. Practice reading your clock, and you can impress your friends by being able to tell time from a group of shapes that move and change color!

First, think about what you want your clock to do. You know that you want it to react to time, so you'll be using the `millis()`, `second()`, `minute()`, and `hour()` functions.

I started with the example code from Listing 4-1 and changed it for this project. The original abstract clock sketch has good potential, but I wanted to make the clock a little more creative. I also wanted to include either `scale()` or `rotate()` in the sketch.

Start by creating a `setup()` and `draw()` loop. Then add some shapes that move and leave trails as they change color and move across the screen. Let's also include shapes that stand alone, without trails; you'll be able to tell that these shapes move only if you actually watch them over time.

Listing 4-2 shows the complete code for the project.

LISTING 4-2:

A more intricate abstract clock

```
void setup()
{
  size(240,240);
}

void draw()
{
❶  //background(150);
❷  rotate(millis());

   fill(second() * 4,0,0);
❸  rect(20,160,second(),second());

   fill(0,0,minute() * 4);
❹  triangle(100,100,80,40,minute(),minute());

   fill(0,hour() * 10,0);
❺  ellipse(0,0,hour() * 5,hour() * 5);

❻  if(second() >= 59)
   {
     background(150);
   }
}
```

First I played with the size of the seconds-based rectangle and tried rotating the sketch as well. I also commented out the `background()` function ❶ from the `draw()` loop so my sketch would leave a trail of shapes.

This modified abstract clock uses three different shapes: our original rectangle ❸, a triangle ❹, and an ellipse ❺.

The biggest difference in the sketch itself is probably that the shapes are rotating around the sketch origin (0,0). I created this effect using the `rotate()` function at the top of the `draw()` loop ❷. The `rotate()` function accepts a single parameter, and I've used `millis()`. I wanted something that changed relatively quickly, and the number of milliseconds since the sketch started fit the bill nicely. Since the value of `millis()` is not connected directly to your system clock, but rather internally within your sketch, it also gives you a good source of time that is independent from your system clock for future applications.

The `if()` statement at the end of the `draw()` loop redraws the background to clear the shape trails any time `seconds()` is greater than or equal to 59 ❻, which would be roughly the end of a minute. Run the code and watch it for a bit. At the end of each minute, you should see everything disappear as the background is redrawn, and the clock should start over again.

Of course, you could redraw the background whenever you want. For example, try changing the number in the statement from 59 to 10. This would redraw the background when the second hand was at 10 seconds and higher. How long do the shape trails stay visible?

As you move through the code it should look pretty familiar compared to the earlier example sketch. Feel free to change things and make this your own! Play around with using a combination of your mouse variables and your time variables to change color, shape, or position within your code.

I ran this piece of code around noon and saw the colors shown in Figure 4-5. It would be interesting to see this sketch at the time you run it! The colors your sketch will produce while you're reading this book will probably be different from mine.

FIGURE 4-5:
The new abstract clock, starring three different shapes

SHARING YOUR PROJECT!

Now that you've tried my version of this project, make it your own, make it beautiful, and make it a piece of art. When you're done, you could even share it on OpenProcessing.org, so everyone can benefit from your work and creativity.

First go to *http://openprocession.org/* and follow the instructions there to register an account. Once you have an account, you'll land on your dashboard, which should look similar to Figure 4-6.

FIGURE 4-6:
OpenProcessing dashboard

From your dashboard, you can access sketches you've recently uploaded or created using OpenProcessing's web-based IDE. You can click create new sketch to try out the IDE, but for this book you should stick to the original Processing IDE for consistency and functionality.

You can also upload sketches you created with the normal IDE, so try it with your abstract clock project (Listing 4-2). Click **upload from processing** to reach the screen in Figure 4-7, which gives basic instructions and, perhaps more importantly, the limitations on what you can upload to OpenProcessing. You can't upload anything over 10MB, but the abstract clock file is well below that limit.

FIGURE 4-7:

Upload instructions from OpenProcessing

Save your sketch if you haven't already done so. You now need to install JavaScript mode for Processing, which is a short and painless process. Click the Mode drop-down menu (highlighted in Figure 4-8); you should see only Java and an Add Mode option. Select **Add Mode** to bring up the Mode Manager window. From here you can select which modes to add to Processing. At the time of writing, there are a number of available modes, which you will explore later in the book. For now, find JavaScript mode and click **Install**. The installation will take a few minutes, and then you are done!

FIGURE 4-8:

The Mode drop-down menu is currently set to Java.

Click the Mode drop-down menu again, and you should now see two mode choices: Java and JavaScript. Select **JavaScript**. Your sketch should disappear and reappear quickly with a different-looking control bar at the top of your sketch, shown in Figure 4-9. The Mode drop-down menu now says JavaScript. Congratulations! You're ready to send your code to the Web.

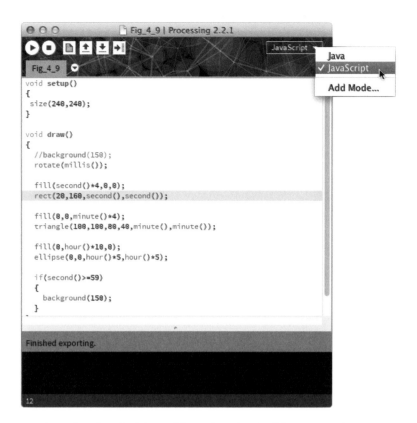

FIGURE 4-9:
The Processing control
bar changes for
JavaScript mode.

Learning JavaScript would require a book of its own, so for now, all you need to know is that Processing's JavaScript mode allows you to create JavaScript programs using the Processing language and export your sketches to a web-friendly format. Just click the **Export for Web** button; it's the last button in your toolbar and looks like an arrow pointing to the right, as shown in Figure 4-10. This creates a folder called *web-export* inside your sketch folder. This new folder should contain three files: a copy of your sketch, the *processing.js* file, and *index.html*, which is the web page of your sketch.

Now, compress or zip the *web-export* folder so you can upload it to OpenProcessing. In Windows, right-click the folder and select **Send to ▸ Compressed (zipped) folder**. Then return to OpenProcessing, click **Choose File**, navigate to your sketch folder, and select the zipped *web-export* folder. Click **Upload**, shown in Figure 4-11, to send your sketch to OpenProcessing.

FIGURE 4-10:

Exporting your sketch
for the Web

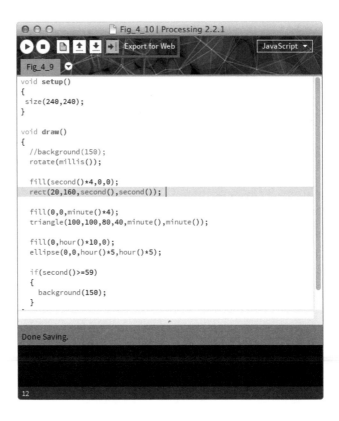

FIGURE 4-11:

Uploading the
web-export folder to
OpenProcessing

OpenProcessing should take you to a new page to add a name, thumbnail, and description to your sketch. The website will also show your sketch below this interface, as in Figure 4-12.

Fill out all of the content you want to include, click **Save**, and you should have a web-based version of your Processing application that you can share. Other OpenProcessing users can also fork your work, modify it, comment on it, and view it. Figure 4-13 shows what a sketch page looks like on OpenProcessing.

I touched on a few OpenProcessing basics to get you started with sharing and webifying your sketches, but I encourage you to explore this awesome tool further. Checking out other users' code and tweaking it to see how it works is one of the best learning tools. Have fun!

FIGURE 4-12:

Adding descriptive
information to
your sketch

FIGURE 4-13:

A basic sketch that
changes color over
time uploaded to
OpenProcessing

TAKING IT FURTHER

A great way to take this project further would be to build time-based
applications that are a little less creative but a bit more useful. You
could incorporate the larger time-based variables by creating a
calendar that draws something specific on a given day. Looking to
the short term, you could also build a stopwatch for timing tasks, or
you could even create a custom alarm clock by combining hour()
and minute() with an if() statement! When you look not only at the
system clock–based variables, but also millis(), the possibilities are
endless.

ENTER THE MATRIX

YOU'VE CREATED A NUMBER OF WONDERFUL THINGS FROM SHAPES AND LINES, AND EVEN MOVED SHAPES AROUND USING AN if() STATEMENT. NOW I'LL COVER HOW TO COMBINE THE CONCEPTS YOU'VE LEARNED TO CREATE IMAGES AND TRANSFORM ALL THE PIECES OF YOUR SKETCH AT ONCE, RATHER THAN TRANSFORMING INDIVIDUAL SHAPES.

WHAT IS A MATRIX?

When you create individual shapes with Processing, you're actually placing them on a *matrix*. In simple Processing projects, you can think of a matrix as a way to group a lot of shapes and treat them as a single object. It's a bit like drawing on a piece of paper: if you wanted to move the picture, you could erase it and redraw it—or you could simply move the whole piece of paper.

Without a matrix, you'd have to move every single shape, one at a time, whenever you wanted to move your picture, as shown in Figure 5-1.

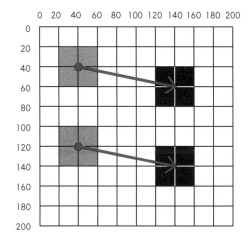

But if you use a matrix, you can just move the whole picture all at once instead, as Figure 5-2 shows.

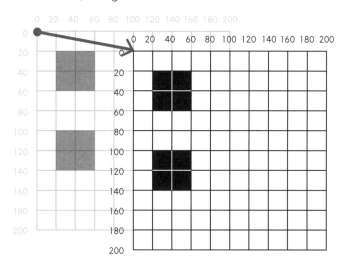

To be clear, this definition of a matrix is not mathematically correct. Matrices are actually much more complicated, but this simplified definition corresponds to the one you'll find on the Processing website, and it should give you just enough information to build some cool projects. If you're eager to dig in to the math behind matrices, then read more about them at Wolfram MathWorld (*http://mathworld.wolfram.com/*) or Khan Academy (*https://www.khanacademy.org/*).

For now, think back to your snowman from Project 2. If you wanted it to bounce back and forth, writing all of the `if()` statements needed to get each shape (let alone the lines) bouncing correctly would drive you crazy! With a matrix, you can capture the whole snowman and treat it as one single shape, and then move it with a single `if()` statement.

You'll use two functions to define a matrix. The first function, `pushMatrix()`, defines the start of a matrix. Any shapes or lines that you want to group together go in between `pushMatrix()` and the terminating function, which is called `popMatrix()`.

```
void setup()
{
  size(250,250);
}

void draw()
{
  pushMatrix();
  fill(255,0,0);
  ellipse(0,0,25,25);
  ellipse(0,25,25,25);
  ellipse(0,50,25,25);
  popMatrix();
}
```

In this program, I created a single matrix, set the fill to bright red, drew three ellipses stacked on top of each other, and *popped* the matrix when I finished. You can see the resulting sketch in Figure 5-3.

These ellipses are partially hidden at the moment, which is okay; they're supposed to be. Note that the top ellipse is centered on the origin of the sketch, (0,0). Now, you can move the entire matrix that holds the ellipses when you want to change their position.

FIGURE 5-3:

These ellipses may look
normal, but they're
really in the matrix!

THINKING WITH MATRICES

To create sketches with matrices, you'll have to change how you
approach the drawing process. The origin of a matrix is the same as
the origin of your sketch, which affects how and where you should
draw a shape with a matrix.

For example, if you just draw a rectangle in a matrix and then
rotate the matrix as shown on the left in Figure 5-4, the rectangle
will rotate in a wide arc around the origin of the sketch because the
rotate() function rotates around the origin. If you want that rectangle
to spin around its *own* origin, as shown on the right in Figure 5-4, you'll
need to make the rectangle and matrix origins the same ❶ and then
rotate the matrix ❷. Your rectangle's final position is shown at ❸.

FIGURE 5-4:

Shape transformations
work differently when
you use a matrix!

This principle applies to all of the transformations you've seen so
far, so let's explore how that works.

Translation Revisited

If you apply the `translate()` function to a matrix, it'll move the entire matrix, which is exactly what you need to do to give the matrix and a particular shape the same origin. For example, Listing 5-1 uses `translate()` on the matrix you created to move all of the ellipses to the center of the sketch.

❶
```
pushMatrix();
translate(width/2,height/2);
fill(255,0,0);
ellipse(0,0,25,25);
ellipse(0,25,25,25);
ellipse(0,50,25,25);
popMatrix();
```

LISTING 5-1:

Translating a matrix to move ellipses to the center of the sketch

The values `width` and `height` are both system variables, and they contain the respective dimensions of your sketch window. Add the `translate()` function to the matrix inside your `draw()` loop ❶, and pass it half the height and width of the sketch to move the matrix to the center of the screen. Figure 5-5 shows the result.

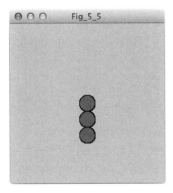

FIGURE 5-5:

Now the program draws the first ellipse at the center of the sketch and continues from there.

The power of the matrix is much clearer with one small change to your `translate()` function. Instead of using `width/2` and `height/2` for the coordinates, change them to `mouseX` and `mouseY`.

```
translate(mouseX,mouseY);
```

Click **Run**, move your mouse around, and watch the entire group of ellipses follow your mouse! Check out Figure 5-6 for the result.

That's the simplistic power of a matrix, and you can add other transformational functions to this entire group of ellipses, too.

FIGURE 5-6:

Drawing with a matrix of three stacked ellipses

Rotation Revisited

If you add `rotate()` to your matrix and pass it the value of `second()`, all of the ellipses will rotate around the mouse cursor. For example, wrap your matrix in an `if()` statement as follows:

```
if(mouseX == pmouseX || mouseY == pmouseY)
{
  pushMatrix();               //create matrix
  translate(mouseX,mouseY);   //follow mouse
  rotate(second());           //rotate over time
  fill(255,0,0);              //fill red
  ellipse(0,0,25,25);
  ellipse(0,25,25,25);
  ellipse(0,50,25,25);
  popMatrix();                //end matrix
}
```

The `if()` statement looks for when you stop moving your mouse, and then it rotates and draws the group of ellipses over time, forming the flower pattern shown in Figure 5-7. If you move your mouse continuously, nothing happens, but if you keep it still, the drawing starts again.

FIGURE 5-7:

When Processing draws these three ellipses repeatedly in a circle, it creates a flower pattern.

If you haven't clicked Run yet, please do! The group of ellipses will still follow your cursor, but now they should rotate around it, too.

You can further see the usefulness of a matrix when you add something outside of the matrix. Copy the ellipse code from inside your matrix and paste it after `popMatrix()` as follows:

```
pushMatrix();
translate(mouseX,mouseY);
rotate(second());
fill(255,0,0);
ellipse(0,0,25,25);
ellipse(0,25,25,25);
ellipse(0,50,25,25);
popMatrix();

fill(0,0,255);
ellipse(0,0,50,50);
ellipse(0,50,50,50);
ellipse(0,100,50,50);
```
❶

To make the ellipse groups distinct, change the fill color for the set you pasted outside the matrix to blue ❶. Click **Run**, and you'll see that the blue ellipses stay put and the red ones still follow your mouse, as Figure 5-8 shows.

Scaling Revisited

If you create a second matrix around the blue group, you can transform those ellipses separately from your original matrix. Add a matrix around the blue ellipse group, translate it to the center of the window just like you did in Listing 5-1, and then try out the `scale()` function.

NOTE

Try changing your logic operators within the `if()` statement. Instead of ==, try >= or <=. How could you tell Processing to draw the flower only when your mouse is on the right side of the sketch window?

FIGURE 5-8:
The blue ellipse matrix stays in place, but the red matrix moves with the mouse.

```
pushMatrix();
translate(width/2,height/2);
scale(second()/3);
fill(0,0,255);
ellipse(0,0,25,25);
ellipse(0,25,25,25);
ellipse(0,50,25,25);
popMatrix();
```

Recall from Project 4 that you can pass a percentage in decimal form to the scale() function. I passed in the second() value divided by 3, which will result in scales between 0 and 2; that is, either the ellipse group will be normal sized, or it will be blown up to 200 percent of its usual size, as shown in Figure 5-9.

FIGURE 5-9:

The blue ellipse group at left is normal sized, while the one at right is twice as big.

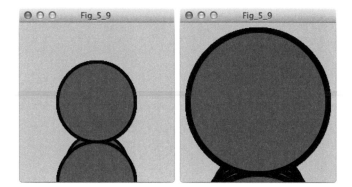

You should now have two different groups of ellipses: one that changes size over time, and one that rotates over time and follows your mouse. As you practice using matrices, you'll be able to make great use of them in future sketches. They're handy for organizing your code as well: I tend to group characters or groups of shapes together and manipulate them as a matrix. Now let's tackle some more complex sketches!

HACKING YOUR PREVIOUS PROJECTS

In Project 3, you learned how to bounce a shape back and forth or up and down. The goal of this project is to animate your sketch from Project 2 by using if() statements and a matrix to keep your holiday image intact. Then you can add more elements to your image and animate them as well. For example, you could add snowflakes that fall as your snowman slides back and forth.

Here's one way to combine the concepts from Projects 2 and 3 using the matrix concepts from this project. My code draws a

snowman similar to the one from Project 2 (it's not identical, but it
should give you an idea of what yours should look like).

```
int x = -300;              //necessary integers from Project 3
int grow = 5;              //variable to increment by

void setup()
{
  size(900,900);           //900x900 window
}

void draw()
{
  background(0,255,0);     //green background; it's spring!

  pushMatrix();            //beginning of matrix
❶ translate(x,0);
  noStroke();              //hack your "holiday image" snowman into
                           //the matrix!
  fill(255);               //white fill
  ellipse(400,350,125,125);
  ellipse(400,500,200,200);
  ellipse(400,700,300,300);

  fill(255,141,0);
  triangle(340,345,300,350,347,354);
  fill(0);
  ellipse(350,325,10,10);
  ellipse(375,325,10,10);
  ellipse(400,500,20,20);
  ellipse(400,550,20,20);
  ellipse(400,600,20,20);

  stroke(121,85,17);
  strokeWeight(10);
  line(300,500,200,400);
  line(500,500,300,600);
  line(223,423,228,398);
  line(336,585,337,605);

  x = x + grow;                    //x-coordinate code from Project 3

  if(x >= width || x <= -300) //keep x between 0 and width
  {
    grow = grow * -1;
  }
  popMatrix();                     //end of matrix
}
```

The holiday image in Project 2 was a basic snowman. Just wrap your original code inside a matrix: place a `pushMatrix()` on the line before the snowman code starts, and place a `popMatrix()` at the end. This will retain your snowman but allow you to manipulate it. Since the snowman is inside a matrix, it should move left and right across the sketch window as a single shape when you apply the `translate()` function ❶, using the *x* value from Project 3.

TAKING IT FURTHER

Matrices are key when you want a specific group of shapes to do something without manipulating other parts of your picture. Start a new image (or open any other project you've made so far) and put a matrix or two to good use!

An interesting mashup of projects would be to combine your pixel art project with your time-based art to make a *Space Invaders*–themed abstract clock. You could draw each shape of the abstract clock as an alien and then translate each one in a matrix at certain time intervals. Now that's a clock I would want! Here's some skeleton code for you to fill in when you take on this challenge.

```
void draw()
{
  pushMatrix();
  translate();

  //write the code for your first space invader drawing here

  popMatrix();

  pushMatrix();
  translate();

  //write the code for your other space invader drawing here

  popMatrix();
}
```

As you move forward in this book, always be looking for opportunities to use a matrix to simplify your code and its functionality. When it makes sense, I will use a matrix by default, as it tends to reduce the total amount of code I need to get something working.

IMAGE PROCESSING WITH A COLLAGE

UP TO THIS POINT, YOU'VE USED PROCESSING AS A CANVAS OR DIGITAL COLLAGE OF SORTS, BUT YOU CAN ALSO USE IT TO MANIPULATE IMAGES. ADDING PREEXISTING IMAGES TO PROCESSING LETS YOU CREATE MULTIMEDIA PROJECTS THAT CAN INCLUDE SCANS OF HAND-DRAWN ILLUSTRATIONS, CUSTOMIZED BUTTONS, OR EVEN COMPLETE BACKGROUNDS.

Using photographs in Processing adds a few steps, but it is well worth the extra legwork. After you've added a photograph to your sketch, I'll show you how to modify it with filters and change the tint.

FINDING AN IMAGE TO USE

If you're like me, you probably have hundreds (if not thousands) of images on your computer, tablet, or smartphone. To add images to a Processing sketch, you need to do some preparation.

Start a new Processing sketch, and in the code window, click the **Sketch** drop-down menu and select **Add File**. This option should bring up the file dialog shown in Figure 6-1.

FIGURE 6-1:

Find an image and place it in the *data* folder using the Add File option.

NOTE

You can add images to your Processing sketch at any time, which allows for flexibility in your sketch design. However, if you know you'll be using an image in your project, I suggest adding it at the very beginning, for simplicity and clarity.

Find an image you want to use; this can be any *.jpg*, *.bmp*, or *.png* file. If your image has a crazy name, rename it something simple and descriptive. You'll use that filename in your sketch, and long, random names leave opportunities for spelling errors. Once you're happy with the filename, select the image and click **Open**.

Next, go back to the code window, click the **Sketch** drop-down menu, and select **Show Sketch Folder**. This folder is where your sketch resides when you save it, but it also includes all of the other assets that your sketch needs to run properly. There shouldn't be much there right now, but your projects will have more files as they become more complicated.

Open the folder named *data*, and you should see a copy of the image file you just added. I will be using the photograph of my friend Jeff in Figure 6-2. I named the file *jeff.jpg*. Take note of the file format (mine is *.jpg*, for example).

FIGURE 6-2:
The original photo of my friend Jeff. It will look pretty different when I'm done!

THE PIMAGE DATA TYPE

You've seen a few different data types in this book already, including float, which is a number with a decimal point, and int (integer), which is a whole number. In this project, I introduce PImage, which is an advanced data type used for storing an image file.

PImage is considered advanced because when you create a PImage variable, you have to go through an extra step to initialize or assign an image to it. Here, I create a global variable (although a PImage can be a local variable as well) at the top of the sketch called img with a data type of PImage. Notice that I only create the variable and don't initialize it with a value.

```
PImage img;

void setup()
```

```
{
  size(800,600);
❶ img = loadImage("jeff.jpg");
}
```

To assign a value to `img`, you have to load your image ❶. Using the `loadImage()` function tells Processing to literally load, or pack, the `img` variable with every single pixel of the image.

To specify which image to pack, just pass `loadImage()` the file-name as a string in quotes; I passed it `"jeff.jpg"`. Since `img` is global, after you initialize it you can use the image it contains anywhere in your `draw()` loop or in any other function that follows the initialization.

USING YOUR IMAGE IN A SKETCH

Now that you have a variable holding your image, you need to put it to good use in the `draw()` loop by using the `image()` function. Think of an image as a rectangle that you can manipulate. The `image()` function accepts three parameters.

```
void draw()
{
  image(img,100,100)
}
```

The first parameter is the image variable—in our case, `img`. The other two parameters indicate the location, (*x*,*y*), where you want to place the image origin. If you pass only these three parameters, the image adopts its original size. If you want to stretch and skew your image, you can add two more parameters, the width and height of the image, after the x- and y-coordinates.

When you use images in Processing, resolution really matters, because resolution is essentially the size of your image in pixels. Once you pull an image into Processing, you may notice that it is larger or smaller than you thought, and that can throw off your program. Be sure to check the original resolution of the images you are using under your image file properties before you use them in a project.

You should also think about *aspect ratio*—the ratio of height to width—when you choose images for your projects. If you are looking to scale or change the width or height of an image, that scaling will also stretch or contort the image. You may need to crop or edit some images to make them work for your project.

With that in mind, let's explore the image modes available to you in Processing.

Image Modes

By default, the origin of an image is the same as that of a rectangle—the top-left corner. You can change this using a function called imageMode(). For example, if you want the origin to be the center of the image, you can pass the mode CENTER to imageMode(), and it will move the origin for you.

```
void draw()
{
    imageMode(CENTER);
    image(img,width/2,height/2);
}
```

Thanks to imageMode(), it takes only a couple of lines of code to place *jeff.jpg* in the center of my sketch window, as shown in Figure 6-3. To place the image using the image() function, I passed it img, which is the image I want to show, and the x- and y-coordinates of the center of the sketch (width/2 and height/2).

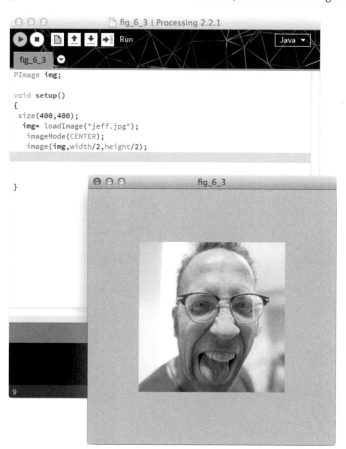

FIGURE 6-3:

An image drawn in CENTER mode

NOTE

These three modes are also options for rectangles and ellipses, courtesy of the rectMode() and ellipseMode() functions. Rectangles and ellipses have another available mode, too, called RADIUS.

The imageMode() function lets us choose from two other modes. Passing CORNER sets the origin back to the default (the top-left corner). Calling imageMode(CORNERS) will let you draw based on where you want the top-left and bottom-right corners of the image to fall in your sketch. In CORNERS mode, just pass image() the filename and two coordinates.

Since an image can be treated like a rectangle, you can even pass the mouseX and mouseY system variables to set its origin.

```
void draw()
{
❶   background(150);
    imageMode(CENTER);
    image(img,mouseX,mouseY);
}
```

You should now have an image that follows your mouse! Of course, just like any rectangle, an image leaves tracers behind by default, as shown in Figure 6-4. If you don't want to see them, add a background() function ❶ to your draw() loop. Pretty cool, huh?

FIGURE 6-4:

There are so many Jeffs! Get rid of that tracer so there's only one.

Transformation

You can translate, scale, and rotate your image just as you did for the basic shapes in previous chapters. All you need to do is set up a matrix in your `draw()` loop, and then you can transform the image as much as you want! For example, it's always fun to play with scale.

```
void draw()
{
  background(150);
  imageMode(CENTER);
  pushMatrix();
  translate(width/2,height/2);  //center image in your sketch
❶ scale(map(mouseX,0,width,.5,2));
  image(img,0,0);
  popMatrix();
}
```

Notice that I've passed a *mapped* value of `mouseX` to `scale()` ❶. Processing's `map()` function maps a value onto a different range of values. Here, I've told Processing to map the range of `mouseX`—which would normally be from 0 to the width of your sketch—to values ranging from .5 to 2, resulting in scales from 50 to 200 percent. This should turn your mouse movements into a zoom control, as shown in Figure 6-5.

FIGURE 6-5:
The farther you move the mouse along the x-axis, the more you'll zoom in on your image.

Now that you've played with one image, let's up the ante and move on to this chapter's project. You can add as many pictures as you want to your Processing sketch, and you can also assemble

them into a collage, just as you did with the basic shapes to create a holiday image in Project 2. I'll show you a few other useful tools on the way to finishing your photo collage, too.

A PHOTO COLLAGE

The main reason for using matrices is so you can group individual or sets of objects together and manipulate them independently from the rest of your sketch. In a photo collage, you may want to modify a specific image or group of images while keeping others intact. I recommend placing each image on its own matrix so that you can work with it freely. If you want to apply the same effects to multiple images, you can place them within the same matrix, but at some point you may want to separate them.

I'm going to use images of my other teammates at SparkFun to create a photo collage in Processing. You could create a scrapbook page from your last family trip, a collage of scans of your favorite doodles, or, really, anything you can imagine.

Multiple Images

To use multiple images in a project, first you need to add those images to your *data* folder. Click **Sketch ▸ Add File** and add the first new file to your *data* folder, and then repeat those steps until you've added all the images you need. When you're finished, I recommend clicking Sketch ▸ Show Sketch Folder to access the *data* folder and changing the names of the images to something simple.

Next, create a variable for each image, with the data type PImage. Since you have more than one image, use descriptive variable names to keep them all straight. I named each image variable after the person in the photo I plan to load into that variable.

```
PImage jeff;
PImage amanda;
PImage lindsay;
PImage ben;
PImage brian;
PImage angela;

void setup()
{
  size(1000,800);
```

NOTE

You can download the images I used for this project from https://learn .sparkfun.com/about/. *Use those images for this collage if you'd like, but to make it your own, search your library for six that have the same resolution as mine (200 pixels by 200 pixels) and use those instead!*

```
❶   jeff = loadImage("jeff.png");
    amanda = loadImage("amanda.png");
    lindsay = loadImage("lindsay.png");
    ben = loadImage("ben.png");
    brian = loadImage("brian.png");
    angela = loadImage("angela.png");
    }

    void draw()
    {
❷   image(jeff,20,20);
    image(amanda,600,400);
    image(lindsay,300,20);
    image(ben,20,400);
    image(brian,600,20);
    image(angela,300,400);
    }
```

The final step of preparing your images is loading the files to variables. Call the loadImage() function ❶ inside the setup() code and assign the image files to the variables you created at the top of your sketch. Now you can draw them onto your sketch window, as shown in Figure 6-6, by calling the image() function ❷ and supplying your desired coordinates.

FIGURE 6-6:
Placing multiple images on a sketch

I'm going to continue using these images throughout the project, so for reference, in Figure 6-6 the filenames are (clockwise from top left) *jeff.png*, *lindsay.png*, *brian.png*, *amanda.png*, *angela.png*, and *ben.png*.

If you know where you want your images within your sketch and you're not looking to move them around or to transform them in any way, you're finished. But you're probably looking to do more than just place your images in clean, straight rows. This is where the strength of the matrix comes in.

Returning to the Matrix

Whenever you're working with multiple images, I recommend getting into the habit of using matrices. You can give each image its own matrix and then manipulate those matrices independently of one another. As an example, I'm going to tweak the draw() loop from the previous section to get each image ready for using a matrix.

```
void draw()
{
  pushMatrix();
  translate(20,20);
  image(jeff,0,0);
  popMatrix();

  pushMatrix();
❶ translate(300,20);
❷ image(lindsay,0,0);
  popMatrix();

  pushMatrix();
  translate(300,400);
  image(angela,0,0);
  popMatrix();

  pushMatrix();
  translate(600,400);
  image(amanda,0,0);
  popMatrix();

  pushMatrix();
  translate(600,20);
  image(brian,0,0);
  popMatrix();
```

```
  pushMatrix();
  translate(20,400);
  image(ben,0,0);
  popMatrix();
}
```

All you have to do is place each image in its own matrix and
translate that matrix to the position at which you were drawing the
image before. Remember how each matrix has its own origin? I
placed all of the images at (0,0) and moved the matrices—not the
images. To move the matrices, give each a `translate()` function at
the top. For example, I drew the `lindsay` picture at (300,20) originally,
but here, I translate the matrix to that point ❶ and draw the image at
the origin of its matrix ❷, which is at (300,20). Follow the same pat-
tern for your own collage, and when you click Run, all of the image
locations should be the same as before.

Now you can manipulate each image within its matrix. So to
move one of your images, you'll use the `translate()` function to
move the matrix rather than the image itself. This may seem like a lot
of work, but trust me: it's worth the effort. Now, let's make your col-
lage a bit more interesting.

Scattered Photos

Straight and true images are a little boring. Since each image is in its
own matrix you can add some transformation functions to give your
sketch a little more depth and interest. You can also rotate, scale,
and otherwise manipulate each image as you see fit once they're all
inside matrices. Give it a try! Mix up that perfectly aligned collage to
make the pictures look like they've been strewn on the sketch.

```
PImage jeff;
PImage amanda;
PImage lindsay;
PImage ben;
PImage brian;
PImage angela;

void setup()
{
  size(1000,800);

  jeff = loadImage("jeff.png");
  amanda = loadImage("amanda.png");
  lindsay = loadImage("lindsay.png");
  ben = loadImage("ben.png");
```

NOTE

*In my setup code, I didn't
set an imageMode(), so if
you're using CENTER, your
sketch may act differently.*

```
    brian = loadImage("brian.png");
    angela = loadImage("angela.png");
    background(200,0,200);              //purple background
    imageMode(CENTER);
}

void draw()
{
  pushMatrix();
  translate(500,20);
  rotate(1.6);
  scale(1.5);
  image(angela,0,0);
  popMatrix();

  pushMatrix();
  translate(200,200);
  rotate(.5);
  image(jeff,0,0);
  popMatrix();

  pushMatrix();
  translate(600,600);
  rotate(1.3);
  scale(1.5);
  image(amanda,0,0);
  popMatrix();

  pushMatrix();
  translate(150,500);
  rotate(.15);
  image(brian,0,0);
  popMatrix();

  pushMatrix();
  translate(800,200);
  rotate(-1);
  image(ben,0,0);
  popMatrix();

  pushMatrix();
  translate(500,400);
  scale(.75);
  rotate(.2);
  image(lindsay,0,0);
  popMatrix();
}
```

In this version of my collage code, I added the imageMode() and background() functions to the setup() section. In the draw() loop, I scaled or rotated some images, with the scale() and rotate() functions, respectively. These changes offer more appeal than just static images, as you can see in Figure 6-7.

FIGURE 6-7:

This collage is much more dynamic.

It's great that you can handle multiple images and modify them individually using the transformation functions you learned in previous chapters, but now I'll introduce you to a few image-specific modifiers so you can give your collage even more creative depth.

APPLYING TINTS

First we'll explore the tint() function, which allows you to add a colored tint to an image. tint() is a modifier, so just like fill() or stroke(), it must be placed before the image that you're tinting.

Changing the tint of your image is as simple as passing tint() red, green, and blue values, but I think the coolest part of the tint() function is that it allows you to set the transparency value of the image as well. To set the transparency, pass a fourth argument ranging from 0 to 255, where 0 is completely invisible and 255 is completely opaque, or solid.

Try it out now! In my collage, I added a tint to all of my images except the one of Lindsay, which I explicitly removed the tint from with noTint(), as shown in Listing 6-1.

LISTING 6-1:

Applying tints to the collage

```
PImage jeff;
PImage amanda;
PImage lindsay;
PImage ben;
PImage brian;
PImage angela;

void setup()
{
  size(1000,800);

  jeff = loadImage("jeff.png");
  amanda = loadImage("amanda.png");
  lindsay = loadImage("lindsay.png");
  ben = loadImage("ben.png");
  brian = loadImage("brian.png");
  angela = loadImage("angela.png");
  background(200,0,200);
  imageMode(CENTER);
}

void draw()
{
  Background(150);
  pushMatrix();
  translate(500,20);
  rotate(1.6);
  scale(1.5);
❶  tint(second() * 4,second() * 4,second() * 4);
  image(angela,0,0);
  popMatrix();

  pushMatrix();
  translate(200,200);
  rotate(.5);
❷  tint(255,mouseY/4);
  image(jeff,0,0);
  popMatrix();
```

```
pushMatrix();
translate(600,600);
rotate(1.3);
scale(1.5);
tint(100,150,0);
image(amanda,0,0);
popMatrix();

pushMatrix();
translate(150,500);
rotate(.15);
tint(mouseX/4,mouseY/4,0);
image(brian,0,0);
popMatrix();

pushMatrix();
translate(800,200);
rotate(-1);
tint(255,255,255,mouseX/4);
image(ben,0,0);
popMatrix();

pushMatrix();
translate(500,400);
scale(.75);
rotate(.2);
noTint();
image(lindsay,0,0);
popMatrix();
}
```

Try adding variables to the tint() function so that you can make
your work feel interactive. The tint for Angela's image ❶ changes
color over time, and the images of Jeff ❷, Brian ❸, and Ben ❹ all
change if you move the mouse. The image of Ben fades in and out of
the foreground depending on the mouseX value, Brian changes color
depending on both mouse positions, and Jeff actually changes trans-
parency, but not color. (If you don't look carefully at the beginning of
the sketch, you may miss the change in Jeff's picture!) Check out the
result in Figure 6-8.

FILTER BASICS

You can accomplish a lot with the `tint()` function, but you can extend image manipulation and modification even further by using the `filter()` function, which has filters similar to those available in photo editing software.

The `filter()` function doesn't work exactly like other image modifiers. The filter is placed over the image, like a mask that you're looking through. The `filter()` function also requires a filter name, rather than numeric values. Table 6-1 lists Processing's seven default filters along with examples of what each does to an image. To compare against the original image, flip back to the photo in Figure 6-1.

FILTER	RESULT
filter(THRESHOLD); (Range: 0–1)	
filter(GRAY);	
filter(INVERT);	
filter(POSTERIZE,4); (Range: 2–255)	
filter(BLUR,1); (Range: ≥1)	
filter(ERODE);	
filter(DILATE);	

TABLE 6-1:

Processing's default filters

A few of these filters are *stand-alone*, meaning there is only one setting. A few of them—THRESHOLD, POSTERIZE, and BLUR—allow you to pass an additional value to change a setting or intensity. For those, I have provided the range of numbers that you can pass to the filter.

There are two different techniques for applying a filter. The simplest way is to place the filter over the entire sketch. This is helpful when you want to use a general filter, such as a blur, or when you want to make everything grayscale. For example, at the very end of your photo collage, add the line filter(GRAY); to produce a grayscale sketch like the one in Figure 6-9.

You can also stack image filters by adding a second filter function after the first one. For example, add a BLUR filter with a level of 7 after your initial GRAY filter:

```
filter(GRAY);
filter(BLUR,7);
```

This combination should produce a blurry black-and-white image like the one in Figure 6-10.

To apply a filter to a single image rather than to the whole sketch, you'll need to use a different approach that breaks from how we've been writing code up to this point. But before we dive in to that, I'll explain a little more about advanced data types.

PROCESSING OBJECTS

Advanced data types have two faces. The first, and the most apparent, is that they're data types, just like an int or a float. But unlike a variable with an int or float value, variables that have advanced data types like PImage are considered *objects*. In *object-oriented programming (OOP)*, you create an object, which is an instance of a *class.* A class has certain properties that it passes on to every object of that class type.

Let's go through an example of how classes and objects work. Start by thinking about a dog. A dog has a weight, a color, and other properties; dogs also greet you when you come home and sit and stand on command. Those aspects form a template that applies to all dogs, and a class is like that template. In a dog class, properties like weight and color are called *fields*; while actions like greet() or sit() can be stored as *methods*, which are just functions defined in a class.

Now, consider an adorable dog named Fluffy. Fluffy is a specific instance of the dog class, so she's an object. Figure 6-11 shows some fields and methods that our `Fluffy` object might have if she were part of a program.

FIGURE 6-11:

Fluffy is an instance of dog, so she has the same fields and methods as any other dog object.

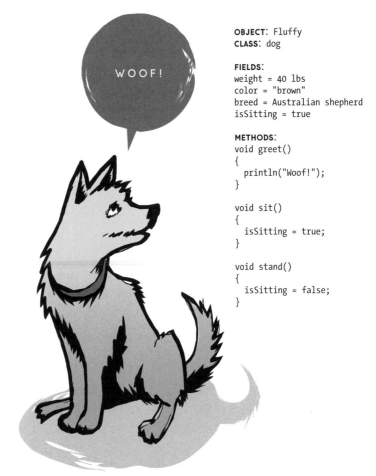

```
OBJECT: Fluffy
CLASS: dog

FIELDS:
weight = 40 lbs
color = "brown"
breed = Australian shepherd
isSitting = true

METHODS:
void greet()
{
  println("Woof!");
}

void sit()
{
  isSitting = true;
}

void stand()
{
  isSitting = false;
}
```

`Fluffy` displays a friendly `"Woof!"` string when you call her `greet()` method. `Fluffy` is also currently sitting because `isSitting` is true; if you called the `stand()` method on `Fluffy`, she'd stand up and `isSitting` would change to false.

In Processing, photos can take actions and change fields based on your commands, too. They can change filters, width, height, and so on. Those actions would be methods on a photo object. `PImage` is a built-in class, and its preset methods actually include the `filter()` function you've already encountered.

You don't need to take a deep dive into OOP to complete this project, but if you're curious, check out the "More on Object-Oriented Programming" box.

When you think about your images as objects, you can start to consider different aspects of the image that you can either use as variables or change. For example, the filter of an image is something that you can change by calling a method on an image object:

```
lindsay.filter();
```

For this example, I used an image of Lindsay stored in a `PImage` object named `lindsay`. I then applied the `filter()` method to `lindsay` by adding a period after the object name followed by a call to the method.

Follow the same rule any time you want to apply one of the class's methods to any object of that class. But a word of warning: you can't just use any old function in this way! The function must actually be a method, which means it must exist as part of the object's class. I can apply `filter()` to `lindsay` because `lindsay` is an instance of the `PImage` class, which includes that function.

This object-oriented approach is what allows you to apply a specific filter to a specific image, rather than applying it to all of the images in your sketch. If you want to apply specific filters to certain images, add the functions in the `setup()` of your sketch rather than in the `draw()` loop. For example, add the following object-oriented function calls to your `setup()` function from Listing 6-1.

```
jeff.filter(BLUR,7);
lindsay.filter(GRAY);
ben.filter(POSTERIZE,3);
angela.filter(ERODE);
brian.filter(INVERT);
amanda.filter(THRESHOLD,.8);
```

NOTE

I placed the individual filter functions in setup() because some of them act oddly when placed in the draw() loop. For example, the INVERT filter will alternate between being inverted and not. You can play around with where you place these filter functions to get the effect you're looking for, but for now I am placing them in setup().

Working with the same code and images as in previous examples, I gave each image its own filter by calling the image object followed by a period and then the `filter()` function that I wanted to apply to that image.

Adding those filters produces the sketch in Figure 6-12, where you can see that each image has its own individual filter.

If you try adding those filters in the `draw()` loop, each layer that you add below an image visually stacks on top of the other in your sketch. This means that the first image would have all of the subsequent filters applied to it. That would be quite a mess! Fortunately, if you do want all images to have some filter in common, even after

each image has its own filter, you can still apply a full filter within your `draw()` loop as well.

Filters and the `tint()` function are great ways to add interest and creativity to your images and your sketch as a whole. A lot of things that are normally accomplished with high-level, expensive editing software can be accomplished in Processing, and in much more creative and interactive ways.

TAKING IT FURTHER

Now that you've played around with changing filters and changing image parameters with variables, you can do some really cool work with images and Processing. Try experimenting with not only photographs but also hand-drawn characters. Just scan them into your computer and add them to your sketch! Processing is a great way to create basic animations and even presentations.

To get more practice with tints and filters, try creating an image of yourself or someone else in the spirit of Andy Warhol. Just make a 3×3 grid of the same image, and apply different filters and tints to each image to create variations on the original. The cool thing is that you only need to include a single image file in your sketch; you just

use the image function nine times over with different filters. The end product will be more interesting than the sum of its parts. For a final inspiration, Figure 6-13 shows a quick example I created.

FIGURE 6-13:

My Warhol-inspired portrait of Brian

FIGURE 6-13:

My Warhol-inspired portrait of Brian

And here is some code to get you started:

```
PImage brian;

void setup()
{
  brian = loadImage("brian.jpg");
  brian.filter(THRESHOLD,.88);
  size(900,900);
}

void draw()
{
  tint(255,0,0);
  image(brian,0,0,300,300);
```

```
  tint(0,0,255);
  image(brian,300,0,300,300);
  tint(0,255,0);
  image(brian,600,0,300,300);
}
```

I applied the THRESHOLD filter to the image in the setup() and
then tinted each image individually. This code is only for the first row,
so you'll have to finish the other rows yourself. Choose an image of
your own, and use this method to create a Warhol-inspired painting!

PLAYING WITH TEXT

WHEN YOU WANT TO DISPLAY TEXT IN PROCESSING, IT'S IMPORTANT TO UNDERSTAND THE BASICS OF WORKING WITH STRINGS, AND THAT'S WHERE THIS PROJECT STARTS. ONCE YOU HAVE THE FUNDAMENTALS DOWN, I'LL SHOW YOU HOW TO CREATE A FONT, MAKE A ROUGH TYPING PROGRAM, AND EVEN CREATE YOUR OWN DATA DASHBOARD IN PROCESSING.

Just like numbers, text and letters have data types associated with them. Individual letters fall under the char, or *character*, data type. Characters are normally written inside a pair of single quotes—for example, 'a'. A grouping of characters is called a *string* and is normally written in double quotes—for example, "Cool!".

THE STRING DATA TYPE

The String data type holds—you guessed it—strings. Just as with any other data type, when you create a string, you need to give it a variable name and initialize the variable to some value. Here I initialize the string as empty, as you can see in the following example:

```
String myString = "";
String myOtherString = "Something cool";
```

For this example, I started with the creative name of myString, and I initialized it to "", which is an empty string. Even when you're not ready to initialize a new string to any particular value, always at least set it equal to the empty string, or your code won't compile. If you wanted to start with a string, you could make it equal to "Something cool" instead.

A great thing you can do with strings is add, or *concatenate*, them. That means you can take two strings and mash them together to make one longer string. For example, let's combine our example string, "Something cool", with a new string.

```
String myOtherString = "Something cool";
String aString = "is going to happen, I promise!";
String myString = "";

void setup()
{
❶  myString = myOtherString + " " + aString;
   print(myString);
}
```

This piece of code shows the power of concatenation by adding aString to myOtherString ❶. You can even throw single characters into the mix, as I did by adding a space (" ") between the two strings. In this case, I'm just printing the string to the console, as shown in Figure 7-1, but you can perform a whole slew of actions with strings.

FIGURE 7-1:

The Processing IDE prints
`myString` to the console.

You can split strings, read individual characters, use an `if()`
statement to test them, and more. For now, you'll deal with strings
strictly on an output and display basis.

BASIC TEXT FUNCTIONS

Displaying information in the console is handy, but displaying informa-
tion within your sketch itself is even more useful. This is where the
`text()` function comes in: it takes a string or piece of data and draws
it within your sketch. Let's print `myString` from the previous example
within a sketch using the `text()` function.

```
String myOtherString = "Something cool";
String aString = "is going to happen, I promise!";
String myString = "";

void setup()
{
  size(250,250);
  myString = myOtherString + " " + aString;
  print(myString);
}

void draw()
{
❶   text(myString,125,125);
}
```

The `text()` function needs at least three parameters ❶. The first
parameter is the data you want to display, which is either a string or
variable data. Your variable data can be of any data type, as long as
you have created the variable and it has a value assigned to it. The
next two parameters are the x- and y-coordinates of your string. The
origin of the text is the upper-left corner of the string you're printing,
just like in the `rect()` function. Your example text should appear with
the origin at the center of your sketch, as in Figure 7-2.

FIGURE 7-2:

Imaginary rectangle
around a text field
displaying myString
with a position of x,y.
The last four words
weren't drawn because
the sketch window was
too small for the string.

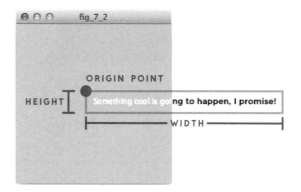

Okay, that wasn't too impressive; in fact, the sketch window was so small that half of the string was cut off! But it's a start, and you can take your text to the next level with modifiers.

TEXT MODIFIERS

The text() function has a number of modifier functions that make displaying and reading text much easier. The first, and probably the most useful, is the textSize() function, which you'd pass a single parameter to set the height you want in pixels. Text modifiers work just like the other modifiers we've worked with: you place them before the text you want to modify in your sketch.

If you want to change where the origin of the text field is located, you can use the textAlign() function with the same parameters you saw in Project 6: CORNER, CORNERS, or CENTER. Most of the time, I'll use the CENTER or CORNER modes because they're easier to envision in my head.

Text boxes are particularly useful when you're designing specific areas for information within a sketch, and you can envision the text() function like a text box you would use in any other presentation or document software. Passing the text() function width and height values will cause the text to wrap automatically when your string data gets too long. You can even use fill() to change the text color! Just add another fill() function above the text and give it an RGB value.

```
void setup()
{
  size(250,250);
  background(150);
  smooth();
}

void draw()
{
  background(150);
  String myString = "I love strings, even when they are in ↵
knots.";
  textAlign(CENTER);
  textSize(20);
  fill(0,0,0);
❶  text(myString,10,height/4,180,200);
}
```

Here, I've also specified where the string should start and the
dimensions it should be contained in ❶ so that it doesn't run off the
sketch like the example in "Basic Text Functions" on page 121. This
code should result in the sketch shown in Figure 7-3.

FIGURE 7-3:

myString printed as text
within a sketch

Notice that this time, the string doesn't look so pixelated. That's
because there's now a background() call in the draw() loop. The text is
still a little lacking, however. Let's make it prettier, and try a different font.

FONTS

You can improve the look and feel of your text through fonts, and fonts have their own data type called PFont. The process for adding a font is similar to the process for adding an image, though it's not exactly the same.

Creating a Font

To add a font to your sketch, first place that font file in your *data* folder. Click **Tools ▸ Create Font** to bring up a dialog like the one in Figure 7-4.

FIGURE 7-4:

The Create Font dialog

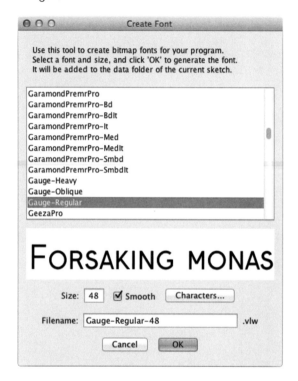

The Create Font tool is pretty self-explanatory; just select the font you want from the list at the top of the dialog. If you've ever picked a font in a word processing application, you'll feel right at home.

This list of fonts is generated from the fonts installed on the computer you're using. If you have any custom fonts installed on your computer, they should show up here so you can use them in your Processing sketch. And if you want some great fonts for free, check out Dafont (*http://www.dafont.com/*). Almost all of the fonts I've added to my computer came from that site, and checking out new fonts is one of the most entertaining ways to waste time.

After you select your font, select a size. Font size is an important choice: even though you can change the size of the text in your sketch, you still want a readable font size to start with. Fonts, just like images, get pixelated or grainy if you start out small and blow them up. But if you start out larger than you need, shrinking your font usually doesn't have the same impact as making it bigger.

Finally, give your new font a name. Just as with images, I tend to give font files simple but descriptive names. If I'm using only one font in my sketch, my personal convention is to name it "font." (I know, what an exciting life I live.)

Once you've named your font file, click **OK**. The window will close, and if you check your sketch's *data* folder (**Sketch ▸ View Sketch Folder ▸ Data**), you should see a *.vlw* file with your font name (in my case, *font.vlw*). If you have a *.vlw* file, give yourself a pat on the back: you've officially created a font!

Loading a Font

Now that the shiny new font you've created resides in your *data* folder, bring it into your sketch. First, create a variable to hold your font file. Again, use something simple and descriptive, but don't use the same name as your font filename, because that could get confusing.

```
PFont myFont; //create a PFont variable

void setup()
{
  myFont = loadFont("font.vlw"); //load your font to
                                 //the variable
}
```

I created a font variable called myFont with the data type of
PFont, and then in the setup() code, I assigned the *font.vlw* file
to myFont using loadFont(). The loadFont() function takes the
filename as a string, but be careful when assigning files this way.
Processing is really finicky when it comes to spelling errors, incor-
rect capitalization, and so on. I recommend copying and pasting the
filename directly into the function to avoid any errors.

Once you call loadFont(), that's it! You've loaded your font into
your sketch; now, it's project time.

A SIMPLIFIED TYPEWRITER

Most projects, especially data dashboards, rely on text to communi-
cate specific information. In this section, you'll create a really simple
(if a bit janky) typewriter application. I wouldn't write a book using it,
but it's a fun little project nonetheless. The ultimate goal of the final
sketch is to read the keyboard keys being pressed, add each charac-
ter to a string, and draw that string onto the sketch.

First, open the Create Font tool, create your font (I selected a
14-point Arial font), and load it to your sketch.

```
   PFont myFont;
❶ String myString = "";

   void setup()
   {
❷   size(800,1100);
     background(255);
     myFont = loadFont("font.vlw");
   }

   void draw()
   {
❸   textFont(myFont);
   }
```

To ensure your page begins blank, start with an empty string ❶. To make your sketch window feel like a piece of paper, set window size to 800×1100 pixels ❷, which is roughly the same aspect ratio as a sheet of US Letter paper. Your string should stay visible the entire time, so place the background() function in the setup() code as well. I chose a white background, but pick whatever color you like.

After you're all set up, applying the loaded font to text is just like using any other modifier: you need to place it before the text() function that you want to modify. To change the font, call textFont() and pass it the variable name ❸.

Fetching Letter Keys

Next, tackle the rest of the draw() loop. The keyPressed and key system variables will help you read keypresses within your sketch, and you can check those using an if() statement.

```
void draw()
{
  background(255);
  textFont(myFont);
❶  if(keyPressed)
  {
❷    myString = myString + key;
  }
❸  fill(0);
❹  text(myString,10,10,width,height);
}
```

When a key is pressed ❶, concatenate new letters to your string by adding the key variable ❷, which returns the character of the key that was pressed. Then set a fill() color for your text ❸; I'm using black. Finally, display your string using the text() function in the text box mode ❹, which will allow for text wrapping. Click **Run** and try it out! Some of the text I typed in my final application is shown in Figure 7-5, though I've included only part of the sketch window here.

My font size grew because of the size I set in the Create Font tool, but you could also use the textSize() function to bump the size up or shrink it down. If the font seems fuzzy or horribly grainy, I'd recommend re-creating the font at a larger size and replacing the file that you currently have for best results.

FIGURE 7-5:

Processing replaces the
default font with yours,
and now you can type
away!

this is my text in a
processing sketch

When you're done marveling at your text, notice that the type-writer actually gets ahead of itself, repeating the same letter multiple times for one keystroke. The characters get added to myString really fast, making it impossible to type anything legibly. Let's slow the computer down a bit, because it's reading faster than you can push a key and then pick your finger up.

Useful Delays

The advent of Processing 2.0 brought the incredibly handy delay() function. If you're familiar with Arduino, you probably know this function and its power all too well, so do a happy dance; I'll wait.

If you're completely new to this function, delay() is essentially a stoplight for your computer—a way for you to tell it to wait for a given amount of time before moving on. Just pass it the amount of milli-seconds you want it to wait, keeping in mind that 1,000 milliseconds equals 1 second. Try it out!

```
void draw()
{
  background(255);
  textFont(myFont);
  if(keyPressed)
  {
    myString = myString + key;
    delay(100);
  }
  fill(0);
  text(myString,10,10,width,height);
}
```

❶

Add the delay right after concatenating the latest keypress ❶ to give a time buffer before Processing grabs the next one. And with that, your typewriter application is finished!

Of course, there are plenty of tools that would work a whole lot better for writing a research paper than this one. But Processing is really useful for communicating information, such as statistical data, in text form. I'll show you how to do that next.

A DATA DASHBOARD

You can build live text readouts of information using the `text()` function and raw variable data, and you can have text change when a value changes, too. You can do this with a simple group of `if()` statements and reassigning of a string.

The readout (or dashboard) that I'll teach you to make in this section is meant for you to hack and change, and it gives you a good structure to use for the rest of this book. Text, strings, and dashboards will show up more as you progress, so come back to this project whenever you need a refresher. But first, spend some time playing with this simple sketch to get familiar with the order you should place functions in and how they impact what you see.

Fetching Statistics and Setting Up

This clear, concise data dashboard displays three statistics: the time, your mouse coordinates, and which quadrant of the sketch your cursor is in. The code for the dashboard starts with four global variables:

```
PFont font;
String myString = "";
String location = "";
String dispTime = "";
```

These global variables include three strings for storing text information and the `font` variable for the font we want to use. I've also named each variable so it's clear what information each string will hold.

Next, look at this project's `setup()` function.

```
void setup()
{
  size(800,800);
  font = loadFont("ADAM-48.vlw");
}
```

This code sets the size of the sketch window and loads the font object with a font called Adam-48, which is one of SparkFun's standard fonts. You should replace `ADAM-48.vlw` in your code with a *.vlw* filename for a font of your choice.

The `draw()` loop is pretty lengthy, so I'll explain it in a few subsections.

Indicating Mouse Quadrant

The `draw()` loop opens with a chain of `if()` statements that displays text indicating which quadrant of the sketch window the cursor is in.

```
void draw()
{
  background(150,150,0);

  if(mouseX <= width/2 && mouseY <= height/2)
  {
    myString = "UPPER LEFT";
    fill(255);
  }
  if(mouseX >= width/2 && mouseY <= height/2)
  {
    myString = "UPPER RIGHT";
    fill(0,0,255);
  }
  if(mouseX <= width/2 && mouseY >= height/2)
  {
    myString = "LOWER LEFT";
    fill(0,255,0);
  }
  if(mouseX >= width/2 && mouseY >= height/2)
  {
    myString = "LOWER RIGHT";
    fill(255,0,0);
  }
}
```

Each `if()` statement compares the `mouseX` and `mouseY` variables to half the sketch width and height, respectively. These comparisons determine which of the four quadrants the mouse cursor lies in. Depending on the cursor position, `myString` is assigned to one of four quadrant location labels we specify (`"UPPER LEFT"`, `"UPPER RIGHT"`, `"LOWER LEFT"`, or `"LOWER RIGHT"`). We also define a different fill color depending on quadrant, which will be applied to an ellipse that follows the mouse around.

Next, draw that ellipse immediately after the last if() statement, but before the ending curly brace.

```
noStroke();
ellipse(mouseX,mouseY,200,200);
```

Remove the outline of the ellipse with the noStroke() function and pass mouseX and mouseY to the ellipse() function so the shape follows your cursor.

After writing the ellipse code, add modifiers inside the draw() loop to display the text stored in myString on the ellipse.

```
❶   fill(0);
❷   textFont(font);
    textAlign(CENTER);
    textSize(25);
    text(myString,mouseX,mouseY);
```

First, set your fill ❶ and font ❷. Then, to center the text on the cursor, pass CENTER to the textAlign() function. If you don't like the current text size (48 point for this font, which I didn't want to use), just call the textSize() function to resize it. Finally, display myString with the text() function; pass mouseX and mouseY as the x- and y-coordinates so the text follows your mouse along with the ellipse. Run your code to see the dashboard so far; it should look similar to the sketch window in Figure 7-6.

FIGURE 7-6:
The labeled ellipse should follow your cursor and tell you the current quadrant.

You should see a simple but cool sketch that displays text and changes color.

Showing Time and Mouse Coordinates

The last code in this project creates two strings and displays the exact location of your cursor, along with the time. Add this inside your `draw()` loop:

❶
❷
```
String location = "Cursor Location: " + mouseX + "," + mouseY;
text(location,width/2,height/2);

String dispTime = "Time-> " + hour() + ":" + minute() + ":" ↵
+ second();
text(dispTime,width/2,(height/2) + 45);
```

To concatenate a string to variable data, all you have to do is add them together ❶. For example, the location string adds `"Cursor Location"`, `mouseX`, `","`, and `mouseY` to form an ordered pair. This allows you to build complicated strings of text and data but keep the `text()` function clean and simple.

Once you create your data string, just print it out ❷! Follow a similar process to concatenate and display the `dispTime` string, and then add the final curly brace to end your `draw()` loop. The final product should look something like Figure 7-7.

FIGURE 7-7:

Final dashboard sketch

TAKING IT FURTHER

How would you improve either the typewriter or the dashboard to make it more useful? I suggest coding a way to clear the sketch window in your typewriter (hint: clear it with a mouse click) and adding more information to the dashboard, such as the current date.

As you progress through this book and build your knowledge, I really urge you to tinker with previous projects and incorporate new functions and concepts. For example, to practice using text, you could label the photos in your collage from Project 6 or add a greeting like "Happy Holidays!" to your holiday image from Project 2. Processing is just like any spoken language: the more you use it, the more fluent you'll be.

TWO DRAWING PROGRAMS

IN PROJECT 5, YOU STAMPED SHAPES BASED ON YOUR MOUSE'S POSITION, AND IN PROJECT 7, YOU CREATED A SIMPLE PROGRAM TO DISPLAY TYPED TEXT. BOTH PROJECTS RELIED ON USER INPUT, AND FOR THE NEXT FEW CHAPTERS, WE'LL EXPLORE MORE INPUT OPTIONS, ORGANIZED BY THE TYPES OF PERIPHERALS YOU CAN USE WITH YOUR COMPUTER AND THEIR LEVEL OF DIFFICULTY.

In this project, I'll introduce you to two more mouse input variables, after which we'll cover event functions. Event functions will launch you to the next level in Processing, as they allow you to create much more robust functionality while reducing the amount of code you have to write. Finally, you'll learn to harness mouse clicks to create two simple drawing programs that work a lot more efficiently than what you've created in previous chapters.

MORE MOUSE VARIABLES

You've already used a few of Processing's built-in system variables, but there are others that can make your sketches respond to physical inputs, including `mousePressed` and `mouseButton`.

The `mousePressed` variable is similar to the `keyPressed` variable from Project 7: it returns `True` if either mouse button was pressed and `False` if neither button was pressed. The `mouseButton` variable tells you which button (`LEFT` or `RIGHT`) was pressed.

These variables are handy when you only need to detect button presses, but as you're about to learn, event functions offer even more input-based functionality.

EVENT FUNCTIONS

An *event function* executes only when a certain event happens. You implement your event function outside the basic `draw()` loop in your sketch, and when it is triggered by the event (i.e., the user input), it will run in parallel with the `draw()` loop until the event is no longer active. Then the sketch should return to solely running the `draw()` loop. Figure 8-1 illustrates this process.

Event functions allow your sketch to listen for user input while executing a `draw()` loop. They reduce the number of `if()` statements you need, and they're much more responsive because they're always listening for an input. By contrast, `if()` statements are run only once per `draw()` loop, and they must wait for the `draw()` loop to repeat to check again for the input.

Your mouse has several event functions associated with it, including the following:

`mouseClicked()` The event triggers when the mouse button is clicked.
`mouseDragged()` The event triggers when the mouse moves while a button is held down.

PROCESSING SKETCH

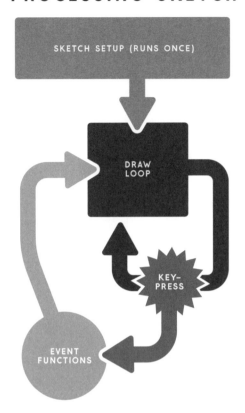

FIGURE 8-1:

Flow of an event function

mouseMoved() The event triggers when the mouse moves.

mousePressed() The event triggers when the mouse button is pressed.

mouseReleased() The event triggers when the mouse button is released.

When you want to use an event function, just create another function of the void type underneath your draw() function. A complete Processing program with an event function would follow this structure:

```
void setup()
{
  //your usual setup code goes here
}
```

```
void draw()
{
  background(255);   //the background is white
}

void mouseClicked()
{
  background(0);     //the background turns black!
}
```

NOTE

*If you place an event func-
tion within the draw() loop,
you'll just get an error.*

In this example, I used only the mouseClicked() function, but you can add multiple event functions, as I'll show next.

RAINBOW DOODLES

In this section, we'll explore the mouseDragged() and mousePressed() event functions to write a program that lets you create rainbow-colored drawings.

Implementing mouseDragged()

First, add the usual setup() and draw() sections, and then implement the mouseDragged() event function outside of your draw() loop as follows:

```
void setup()
{
  size(850,1100);
  background(255);
}

void draw()
{
  //no code needed here!
}

void mouseDragged()
{
  strokeWeight(50);
  stroke(random(255),random(255),random(255));
  line(pmouseX,pmouseY,mouseX,mouseY);
}
```

Inside mouseDragged(), set a stroke weight, apply a random() stroke color, and call the line() function to draw your line. Pass line() the previous and current mouse coordinates— (pmouseX,pmouseY) and (mouseX,mouseY), respectively—as its start

and end points. You should have no code inside of your `draw()` loop, because your line should be drawn only when you click and drag your mouse.

You might be wondering, if there's no code in the `draw()` loop, then why include the loop at all? The reason is that if you have no `draw()` loop, your sketch will just run your `setup()` function and then stop. Your sketch needs to be actively running for event functions to work. An empty `draw()` loop lets your sketch actively wait for something to happen.

Click the **Run** button to run your code. You should be able to click and drag when you want to draw, and release the mouse button to pick up your pen. Now, move the mouse to a different spot, press the button to put your pen down, and draw again. For my first drawing, I made a horrible version of the SparkFun flame logo (Figure 8-2).

NOTE

Some programmers like to leave a single semicolon in an empty draw() loop to show that the loop is meant to be blank.

FIGURE 8-2:
A rainbow-colored drawing in Processing

The only problem is that you have to start your sketch over to erase anything. Let's add another event function to fix that!

Implementing mousePressed()

We'll use the mousePressed() event function, paired with your right mouse button, to redraw the background and clear your drawing. Add the new function after mouseDragged().

```
void mouseDragged()
{
  if(mouseButton == LEFT)
  {
    strokeWeight(50);
    stroke(random(255),random(255),random(255));
    line(pmouseX,pmouseY,mouseX,mouseY);
  }
}

void mousePressed()
{
  if(mouseButton == RIGHT)
  {
    background(255);
  }
}
```

The mousePressed() event function has an if() statement that checks which mouse button you're pressing, left or right. It redraws the background only when the right mouse button is pressed. Run your code again, and any time you want to start over, just click the right mouse button!

Save your project now, because you'll enhance it in the next section.

A SIMPLE PAINTING PROGRAM

Now that we've explored mouse event functions, let's make our drawing application a little more useful and creative. We'll tweak the draw() loop to let you change the color of your pen on the fly from the keyboard.

To add this functionality, start with the code you had at the end of "Rainbow Doodles" on page 138. First, add three integer variables as global variables, named r, g, and b, at the top of your sketch:

```
int r = 10;
int g = 10;
int b = 10;
```

Each new integer represents one piece of an RGB color: r is red, g is green, and b is blue. I gave them all an arbitrary starting value of 10.

After creating these new variables, we'll modify the draw() loop to create a feedback box that shows our current pen color and its RGB value.

Creating a Color-Changing Feedback Box

Inside the draw() loop, create a small feedback box that displays the current pen color and its RGB setting as follows:

```
void draw()
{
  fill(r,g,b);
  noStroke();
❶ rect(0,0,100,12);
  fill(255);
❷ text((r + "," + g + "," + b),10,10);
}
```

Set a fill color using the variables r, g, and b, and draw a rectangle ❶ in the upper-left corner of the sketch. This rectangle's color will change when you press the R, G, and B keys. To display the current RGB setting, pick another fill color and call the text() function ❷; this prints the RGB values as a concatenated string inside the new rectangle. You can see the finished product of this nifty feedback tool in Figure 8-3.

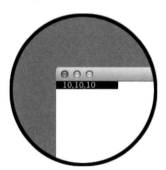

FIGURE 8-3:

The RGB color setting for your pen. Use the R, G, and B keys to change the color.

The rectangle and text will display the hardcoded color values, but how do you change the color on the fly? We'll put if() statements to good use to increment the color variables r, g, and b. Add the following code to your draw() loop:

```
if(key == 'r')
{
  r++;
```

```
key = ' ';
if(r > 255)
{
   r = 0;
}
}

else if(key == 'g')
{
   g++;
   key = ' ';
   if(g > 255)
   {
     g = 0;
   }
}

else if(key == 'b')
{
   b++;
   key = ' ';
   if(b > 255)
   {
      b = 0;
   }
}
```

These if() and else if() statements check which key is being pressed. If it's one of the color keys (R, G, or B), then we increment the corresponding color variable. If any of the values becomes greater than 255, then it is reset to 0, because Processing has no RGB values greater than 255.

Notice, too, that once you increment r, g, or b, key is set to ' ' (the space character). This funky assignment is a quick hack, and without it in the if() statement, the color variable you just changed would continue to increment until you pressed another key. By setting key to ' ' (or really, anything but 'r', 'g', or 'b'), you stop the incrementing process and gain more control over the color.

Run your sketch to make sure that you can change the color of the rectangle. You may notice that your pen color doesn't change yet; we'll add that functionality next.

Changing the Pen Color

To change the color of your pen, find the `stroke()` function in the `mouseDragged()` event function and modify it to use your new color variables:

```
void mouseDragged()
{
  if(mouseButton == LEFT)
  {
    strokeWeight(50);
    stroke(r,g,b);
    line(pmouseX,pmouseY,mouseX,mouseY);
  }
}
```

❶

Set a stroke weight you like, and replace the three `random()` arguments to `stroke()` with r, g, and b ❶. Since these three variables are global, you can use them in any function, anywhere in your sketch.

Now when you run your sketch, you should be able to change the color of your pen using the R, G, and B keys, and make the most beautiful drawing ever. Figure 8-4 is a drawing of my friend Brian.

FIGURE 8-4:

A lovely picture of Brian, created with the paint tool from this project by our senior designer Pete Holm

TAKING IT FURTHER

Think about other drawing programs you've used, and reproduce some of their tools in your sketch. For example, you could use event functions to change the background color, add an eraser to one of your drawing programs, or even change the stroke weight.

To get you started, I've provided some skeleton code to add a way to change the pen size in your project. Processing actually has another mouse event function, called mouseWheel(). I left it out of the discussion in "Event Functions" on page 136 because not every mouse has a scroll wheel, but if your mouse does, you could use mouseWheel() to change your pen size.

First, create a global variable called penSize at the top of the sketch you finished in "A Simple Painting Program" on page 140 and initialize penSize to 2, a good standard line thickness. Next, below your existing event functions, create the mouseWheel() event function:

```
void mouseWheel(MouseEvent event)
{
  penSize = penSize + event.getCount();
  println(penSize);
}
```

This code simultaneously creates and passes the mouseWheel() function a MouseEvent object called event. You can then set your penSize to event.getCount(), which returns the number of mouse wheel clicks. Scrolling away from yourself increases the value, and scrolling toward yourself decreases the value.

Even once you add this new variable and event function to the drawing program, it won't quite work. How will you make penSize become the stroke weight of your pen? Watch penSize change in the console; how can you limit penSize to only positive numbers to prevent your sketch from crashing?

I leave both of these questions as exercises for you to answer. Have fun, and please share your beautiful drawings with SparkFun at processing.book@sparkfun.com!

A MAZE GAME

IN PROJECT 5, YOU STAMPED SHAPES BASED ON YOUR MOUSE'S POSITION, AND IN PROJECT 7, YOU CREATED A SIMPLE SKETCH TO DISPLAY TYPED TEXT. BOTH PROJECTS RELIED ON USER INPUT, AND FOR THE NEXT FEW CHAPTERS, WE'LL EXPLORE MORE INPUT OPTIONS, ORGANIZED BY THE TYPES OF PERIPHERALS YOU CAN USE WITH YOUR COMPUTER AND THEIR LEVEL OF DIFFICULTY.

You met event functions in Project 8, but so far, you've used only the mouse. In this chapter, you'll tackle the keyboard! First, I'll introduce you to a new keyboard variable as well as some keyboard event functions. Once we've covered the basics, you'll write a maze game that players can navigate with the arrow keys. You'll use your knowledge of if() statements, image processing, and incrementing and decrementing variables to create this game.

After you write the sketch, I'll also show you how to add an external controller made with the MaKey MaKey, a little circuit board that can turn just about anything (including Play-Doh or a banana!) into a key on your keyboard.

GATHER YOUR MATERIALS

The MaKey MaKey controller is optional, but if you want to add one, you'll need the following supplies:

- One MaKey MaKey
- Four alligator clip wires (included with MaKey MaKey kit)
- Four assorted fruits or vegetables
- One mini USB cable (included with MaKey MaKey kit)

If you buy the MaKey MaKey kit, shown in Figure 9-1, from SparkFun (product WIG-11511), you should have everything you need, except the fruits and veggies. For those, just pick your favorites!

Before we put these materials to use, though, let's review the basics of event functions, system variables, and keyboard input.

FIGURE 9-1:

The MaKey MaKey kit

MORE WAYS TO READ INPUT

You used key and keyPressed in Project 7, but there's one more system variable you'll find invaluable: keyCode, which returns the value for any key you press, including the up arrow, ENTER, and so on. When you pair these variables with keyboard event functions, you can take input from your keyboard with a lot less code.

Keyboard event functions work just like mouse event functions. They allow you to interrupt the top-to-bottom flow of code execution and trigger an event "out of order." In this project, you'll encounter three keyboard event functions:

keyPressed() Triggers an event when a key on the keyboard is pressed

keyReleased() Triggers an event when a key on the keyboard is released

keyTyped() Triggers an event when a key is pressed and then released

But to implement game controls, you need to be able to do more than detect keypresses; you also need to be able to find out which key was pressed. Fortunately, Processing can help you with that, too.

Working with ASCII and keyCode

The *American Standard Code for Information Interchange (ASCII)* is the standard for encoding the letters and numbers on your keyboard so that your computer will know which key you're pressing. ASCII uses the numbers 0–127 to represent 128 different characters: the numbers 0–9, the letters of the English alphabet in both upper- and lowercase, and a few punctuation symbols, including the space character. Each character has an ASCII code associated with it, and when your computer receives that code, it recognizes the number as that specific character. For example, the character *A* has an ASCII value of 65.

You can search online for "ASCII table" to see a complete list of ASCII codes, but you can also whip together a little Processing sketch to check the ASCII value of a given key. Write the following sketch in a new code window:

```
void setup()
{
  size(200,200);
}
```

NOTE

*The event **keyPressed()** is different from the **keyPressed** system variable that returns a Boolean (true or false). You can tell them apart because the **keyPressed** system variable is not followed by parentheses.*

```
void draw()
{
  background(150);
  textSize(50);
  fill(355,0,0);

  if(❶key == CODED)
  {
    text(keyCode,50,100);
  }

  else
  {
    text(❷int(key),50,100);
    text(key,150,100);
  }
}
```

The first three lines of the draw() loop paint the background, set a text size, and pick a fill color for your text. The if()/else() statement displays one of two things, depending on which kind of key you've pressed. First, it checks to see if key is equal to CODED ❶, a constant that indicates special keys (like the arrow keys) in Processing. If Processing sees a special key, we print the keyCode to the sketch window, because that key has no ASCII value to print. Otherwise, the last key pressed must have been a key with an ASCII value, so we print that value by converting key into an integer ❷; then, we print the actual character pressed. As you press different keys on your keyboard, you should see those values change. For example, after you press the D key, your sketch window should look like Figure 9-2.

FIGURE 9-2:

Displaying the ASCII
code and character for
the D key

One great way to use these variables is by creating a shape you can move with the arrow keys, a skill you'll later apply to the maze game too. Processing assigns the arrow key codes to the global variables UP, DOWN, LEFT, and RIGHT. This makes checking for the arrow keys much easier than checking for some random ASCII value that would be impossible to remember.

Driving Shapes

Making something move on the screen in response to the keyboard or mouse is a basic building block of video game development. Let's start simple and use the arrow keys to send an ellipse zooming around the sketch window.

Since you want to move the ellipse, you need to be able to change its x- and y-coordinates. First, in the code window, create global variables for those values:

```
int x = 300;
int y = 300;
```

Start your ellipse in the middle of the sketch window. In my example, the center is (300,300). Yours may be different, if you change the size of your sketch window.

Now write the setup() and draw() calls:

```
void setup()
{
  size(600,600);
}

void draw()
{
  background(150);
  fill(255,0,0);
  noStroke();
  ellipse(x,y,50,50);
}
```

In the setup() function, I set my sketch window size to 600×600 pixels. The draw() loop sets the background color and draws the ellipse using the x and y variables as the x- and y-coordinates of my ellipse. Click **Run**, and you should see your ellipse, as in Figure 9-3.

FIGURE 9-3:

An ellipse waits
patiently in the middle
of the sketch.

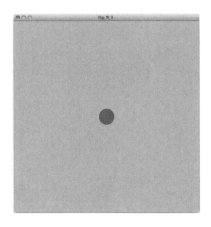

Once you've drawn your ellipse, add a keyboard event function
to implement movement. Outside of your draw() code, create the
keyPressed() event function as shown in Listing 9-1.

LISTING 9-1:

Using keyPressed() to
make an ellipse respond
to keypresses

```
void keyPressed()
{
  if(❶(key == CODED) && ❷(keyCode == UP))
  {
    y--;
  }

  if((key == CODED) && (keyCode == DOWN))
  {
    y++;
  }

  if((key == CODED) && (keyCode == RIGHT))
  {
    x++;
  }

  if((key == CODED) && (keyCode == LEFT))
  {
    x--;
  }
}
```

Any code inside the keyPressed() event function will be run
only when someone presses a key on the keyboard, and there are
two movement requirements. First, we want the ellipse to move only
in response to the arrow keys; and second, we want it to move in
certain directions depending on which arrow is pressed.

The trusty `if()` statement, compound logic, and a few handy built-in constants make up this event function. You might envision a mess of `if()` statements, but using the `keyPressed()` event function lets you get away with only a few. Each `if()` statement checks whether a coded key was pressed, using the `key == CODED` ❶ condition. We then check whether the `keyCode` was `UP`, `DOWN`, `LEFT`, or `RIGHT` ❷ (as mentioned earlier, these constants represent the arrow keys). If both conditions are true, `keyPressed()` increments or decrements the x and y variables accordingly.

Run the code, and when you press the arrow keys, your ellipse should move in the direction of the arrow you press. Try moving it to the positions shown in Figure 9-4!

FIGURE 9-4:
Pressing the up arrow should move your ellipse up.

Hold the arrow keys down, and the ellipse should glide smoothly where you direct it. If you want your ellipse to move faster, increment and decrement your x- and y-coordinates by larger values. For example, swap each `++` and `--` with `+= 5` and `-= 5`, respectively. This will increment and decrement the ellipse's coordinates by 5 rather than 1. If that's still not enough for the speed demon in you, make the numbers even bigger!

When you're done playing with the ellipse, put your newfound superpower to good use by making a game!

BUILDING THE MAZE GAME

You implemented the basic mechanics for a maze game when you created your `keyPressed()` event function. In this section, I'll show you how to create a maze, add it to your ellipse code, and make a simple game.

Generating a Maze

First of all, we need a maze! Go to *http://www.nostarch.com/sparkfunprocessing/*, download the resources for this book, and open the *Project 9* folder. The file *maze.png* is the maze used in this project. You can follow along with that file, or go to Maze Generator (*http://www.mazegenerator.net/*) to generate your own. I'll walk you through that now.

Maze Generator's interface (shown in Figure 9-5) lets you set the dimensions, shape, and difficulty of your maze.

FIGURE 9-5:

Maze Generator settings and the maze they generated

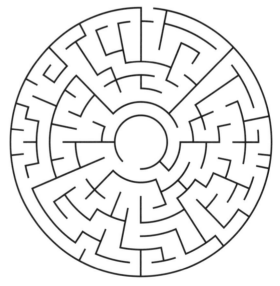

For this project, leave all settings at their defaults except for three: change Style to **Theta (Circular)**, which creates a more challenging circular maze; select **Always use PNG** so that Maze Generator produces an image you can use in Processing; and set Starts At to **Bottom or center** so that you can easily specify the starting point for the maze as width/2 and height/2 in code.

Click **Generate**, right-click the maze that appears, and save the image as a PNG file called *maze*. Once you save your maze image, add it to your sketch by clicking **Sketch ▸ Add File. . .** and selecting *maze.png*. Now you can bring your maze into Processing!

Writing the Sketch

Once you have a maze, it's time to write your game in Processing. The sketch window will display both the maze and an ellipse that players will move around, so first you'll create variables for both.

```
PImage maze;

int x = 162;
int y = 162;
```

Your maze is just an image, so you'll need a PImage variable to load it; I called mine maze. You'll also need variables for the ellipse's x- and y-coordinates; set x and y to your maze's start position, in pixels. I used 162 pixels for both because my maze starts in the middle, and the default size of a maze from Maze Generator is 324 pixels square.

Next, write your setup() and draw() loops.

```
❶ void setup()
  {
    maze = loadImage("maze.png");
    size(324,324);
  }

❷ void draw()
  {
    background(150);
    image(maze,0,0);
    fill(255,0,0);
    noStroke();
    ellipse(x,y,10,10);
  }
```

In the setup() loop ❶, load *maze.png* into maze and set your sketch size to the size of your maze. Here, the maze's dimensions

are 324 pixels square. In your `draw()` loop ❷, use `image()` to draw the maze on the sketch window, and then draw your ellipse.

Outside your `draw()` loop, add the same `keyPressed()` function you created in Listing 9-1:

```
void keyPressed()
{
  if((key == CODED) && (keyCode == UP))
  {
    y--;
  }
  if((key == CODED) && (keyCode == DOWN))
  {
    y++;
  }
  if((key == CODED) && (keyCode == RIGHT))
  {
    x++;
  }
  if((key == CODED) && (keyCode == LEFT))
  {
    x--;
  }
}
```

After adding the event function, run your code. If your ellipse isn't at the start of your maze, adjust your x and y variables to be the starting point of the maze. You may also want to change the diameter of your ellipse, if your maze's walls are too close together.

You should be able to press the arrow keys and move the ellipse around the maze too. There's just one problem: you can just pass through the walls to get to the finish! You need a way to figure out whether the ellipse is touching a wall.

Detecting Wall Touches with get()

Your maze's walls are black, so if the ellipse hits one it will be touching the color black. Let's use that information to stop the ellipse from passing through walls! Fortunately, Processing's `get()` function makes it easy to determine what color the ellipse is touching.

The `get()` function retrieves the color of a pixel at a given position. Then, you can extract the pixel's red, green, or blue value from that color by passing it to the `red()`, `green()`, or `blue()` functions, respectively. Try it by adding this line to your existing `draw()` code:

```
println(red(get(mouseX,mouseY)));
```

This code prints the red value of the pixel at (mouseX, mouseY). If you move your mouse around, the value printed should be 255 while you mouse over white, for which all color values are 255. When you move your mouse to a line of the maze, the value should be 0. Now change mouseX and mouseY to your x and y variables and move that println() function one line above the ellipse() function. Move your ellipse around; do you see a difference?

You can use the value from get() to detect a touch! Modify your draw() loop like this:

```
void draw()
{
  background(150);
  image(maze,0,0);
  fill(255,0,0);
  noStroke();
❶  float touch = red(get(x,y));
  ellipse(x,y,10,10);

❷  if(touch < 255)
  {
    x = 162;
    y = 162;
  }
}
```

Create a new variable called touch of type float ❶ and set it to the value you printed earlier, red(get(x,y)). Using an if() statement ❷, test whether touch goes below 255. If so, the ellipse touched a wall! In that case, assign x and y their original values to return the ellipse to the start of the maze.

Now players can't get through the walls, but what happens when they actually finish the maze correctly?

Adding the Victory Condition

You can see the end of the maze in your image, but you also need to create a finish line in your code. You can use a compound if() statement to check if the ellipse is within an invisible bounding box, and if so, end the game.

First, you need to define the finishing box. To determine where the maze ends, print mouseX and mouseY to the console window. Add this line to your draw() loop:

```
println(mouseX + "," + mouseY);
```

Restart your sketch, and as you move the mouse, you should see its x- and y-coordinates in the console window. Hover your mouse over the area where your maze's finishing box should be, and note the coordinates. In this book's maze, the box is roughly centered at (170,8). Create your bounding box with a compound `if()` statement in the draw() loop.

```
void draw()
{
  image(maze,0,0);

  if(❶(x > 165) && ❷(x < 180) && ❸(y < 10))
  {
❹    textSize(48);
    textAlign(CENTER);
    fill(255,0,0);
    text("YOU WIN!",width/2,height/2);
  }

  fill(255,0,0);
  noStroke();
  float touch = red(get(x,y));
  ellipse(x,y,10,10);

  if(touch <= 200)
  {
    x = 162;
    y = 162;
  }
  println(mouseX + "," + mouseY);
}
```

First, create the box's left and right boundaries. For this maze, I tested whether x is greater than 165 ❶ and less than 180 ❷. Then, add one more condition for the y boundary. My `if()` statement looks for anything less than 10 ❸. If all three conditions are true, it displays a victory message ❹. This code draws text in the middle of the screen that says, "YOU WIN!"

The placement of this `if()` statement is important because Processing layers materials based on their position in the code. Make sure the `if()` statement comes after the `image()` call so the text appears on top of the maze image.

Run the completed code to see if you can reach the victory message shown in Figure 9-6. When you're confident the game works, I'll show you how to leave the keyboard behind and add a controller.

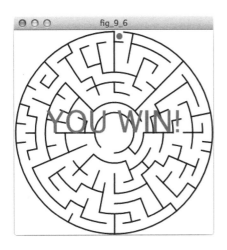

FIGURE 9-6:

Yay! You win!

ADDING A MAKEY MAKEY CONTROLLER

In this section, I'll teach you to take your maze game to the next level with a custom controller. Make sure you have the materials listed in "Gather Your Materials" on page 148, and let's use a MaKey MaKey to replace your arrow keys with fruit!

Meeting the MaKey MaKey

The MaKey MaKey (Figure 9-7) is an invention kit that tricks your computer into thinking that almost anything is a keyboard. For example, you could play *Super Mario* with a Play-Doh keyboard, or play a digital piano with keys made of fruit!

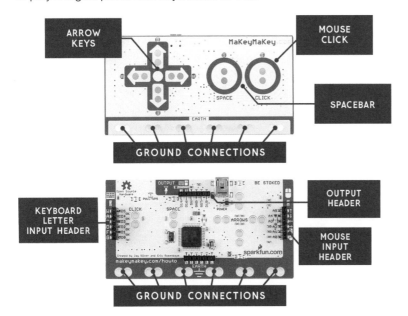

FIGURE 9-7:

The MaKey MaKey. Most connections are pairs of metal-rimmed holes, where you'll clamp alligator clips. You can also plug stiff jumper wires into the mouse input, keyboard input, and output headers on the back of the board.

You can connect the MaKey MaKey to objects with alligator clip wires, and it detects when you've touched those objects even if they're materials that don't conduct electricity very well, like leaves, pasta, or people. The MaKey MaKey's brain is an on-board ATMega32U4 microcontroller that communicates with your computer using the *Human Interface Device (HID)* protocol, which means you can use the MaKey MaKey as a keyboard or mouse without having to install any drivers or other software.

Each pair of metal circles on the MaKey MaKey in Figure 9-7 (six at the bottom, one in each arrow, and one in each circle) is an input you can attach to with alligator clips, solder, and other connectors. It has another 12 inputs on the back: 6 for keyboard keys, and 6 for mouse motion.

Now that you're acquainted with the MaKey MaKey, I'll show you how to turn it into a controller for your maze.

Building a Controller

The wonder of the MaKey MaKey is that you can turn almost anything into a game controller, a keyboard, or a mouse. The key is closing the circuit between the input and the ground connections at the bottom of the board.

For my controller buttons, I used fruit from my refrigerator. (Don't tell my wife!) The maze game requires only the arrow keys, so I chose four different fruits: a banana, an orange, and two apples. To attach the fruits to the contact points, connect one end of an alligator clip wire to the MaKey MaKey button point, as shown in Figure 9-8, and connect the other end to the fruit in any way you can.

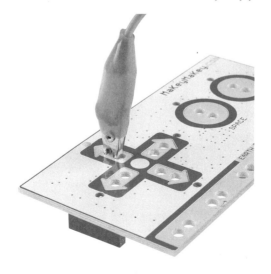

Sometimes it's a little tough to connect a fruit to the alligator clip, so I suggest sticking a screw or nail into the fruit and attaching the alligator clip to that, as shown in Figure 9-9.

FIGURE 9-9:
This orange has a screw in it to make the connection easier.

The MaKey MaKey should look something like Figure 9-10 when you have all of your fruit attached.

FIGURE 9-10:
It's a fruit controller!

NOTE

For a great demonstration of ways to hook up a MaKey MaKey, check out our guide at https://learn .sparkfun.com/tutorials/ makey-makey-quickstart- guide. *It leads you through the basics and includes the original video that creator Joy Labs used to launch MaKey MaKey on Kickstarter.*

Now, just attach yourself to a ground connection on the MaKey MaKey! You could just connect an alligator clip to ground and hold the other end in your hand, but you'll need both hands to work the controller. Instead, we'll build a bracelet out of aluminum foil and masking tape, and attach the alligator clip to that.

Tear off a length of tape that is roughly the circumference of your wrist. Starting at one end, add aluminum foil to the strip of tape, leaving about an inch of the sticky side open at one end. Then wrap the bracelet around your wrist with the foil touching your skin, and fasten your bracelet. Finally, attach the alligator clip to the bracelet, making sure it contacts the foil and that the foil contacts your skin, as in Figure 9-11.

FIGURE 9-11:

Connection made to my tape bracelet

Congratulations, you've taken your first step on the road to cyborgdom! In the next section, we'll introduce your new controller to Processing.

Connecting the MaKey MaKey to Your Computer

Now that you've built your controller, let's hook it up to your computer. Grab the USB cable, plug the mini USB end into the port at the top of the MaKey MaKey board, and plug the rectangular end into a USB port on your computer, as shown in Figures 9-12 and 9-13.

Once you plug in the MaKey MaKey, you should see the board flashing—that's good! Wait a bit, and your computer should tell you that it sees a new piece of hardware.

FIGURE 9-12:
Connecting the MaKey
MaKey to the USB cable

FIGURE 9-13:
Connecting the USB cable
to a laptop

At this point, the MaKey MaKey should be ready to use. Run your maze game sketch, and with your bracelet attached to ground on the MaKey MaKey, touch one of the four pieces of fruit. The ellipse in your maze should move in the direction of the key to which that piece of fruit is connected. Pretty cool! Now, see if you can beat your maze using your fruit controller.

NOTE

Be gentle with your new controller! If you get too excited and press the fruit buttons hard, you may turn it into a fruit-salad controller.

TAKING IT FURTHER

You can take this project further in both the hardware and software directions. In terms of hardware, try creating a more elaborate MaKey MaKey controller. Make your sketch into a party game by replacing your fruit with friends: just give each person a bracelet like yours (I don't think they would enjoy getting stuck with a nail). Try playing with other conductive materials such as copper tape, aluminum foil . . . and even pizza!

You could also improve the maze program itself. You know how to add images, so try replacing the ellipse with a character of your own design. Then, create places that teleport your character to another spot in the maze. (Use code similar to the code you added in "Detecting Wall Touches with get()" on page 156, but change the location from your maze's start to some other location.) And dare I suggest drawing your own maze and importing it as a scanned picture? The possibilities are limitless!

10

MANIPULATING MOVIES AND CAPTURING VIDEO

IN PREVIOUS CHAPTERS, YOU TACKLED INPUT FROM THE MOUSE, KEYBOARD, AND MAKEY MAKEY, BUT THOSE INPUTS WERE ALL BUTTON PRESSES. WHAT ABOUT OTHER INPUTS, LIKE VIDEO FROM YOUR WEBCAM? FORTUNATELY, PROCESSING HAS CODE LIBRARIES THAT CAN HELP YOU ADD VIDEO AND MORE TO YOUR PROJECTS.

This project introduces you to libraries in Processing and shows you how to incorporate video and movies into a sketch. You'll perform some simple movie modifications, capture live video from a webcam, and create a photo booth program in Processing.

The world of video manipulation is ahead, so buckle up. Our first stop is the library!

WHAT IS A LIBRARY?

A *library* is a collection of prewritten code. One function in a library might be hundreds of lines long, but since someone already wrote it, all you have to do is call it. Anyone can write a library for any programming language, and you'll find many Processing libraries on the Web. For your introduction to libraries, I'll show you Processing's Video library.

Adding Libraries to Processing

Depending on your version of Processing, you may need to install the Video library. Click **Sketch ▸ Import Library. . . ▸ Add Library. . .** to open the Library Manager, which lists several libraries you can add to Processing. Scroll down until you see the Video library. If it has a button labeled Remove, you're in good shape. Otherwise, select the Video library, and click the **Install** button that appears.

Using Libraries in Your Sketch

You can learn how to use a library by exploring an example program from Processing. Go to *http://www.nostarch.com/sparkfunprocessing/*, download the resource files for this book, and open the *Loop.pde* file in the *Project 10* folder.

With the Loop sketch open, click **Run** to make sure it works with your current computer settings and your version of Processing. You should see a planet traverse the sun over and over, until you close the window or stop the sketch. The video should look like Figure 10-1.

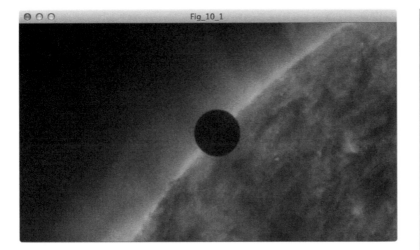

Fig_10_1

FIGURE 10-1:

A screenshot from the
Loop video

The Loop sketch in your code window should look like this:

```
❶ import processing.video.*;

❷ Movie movie;

  void setup()
  {
    size(640,360);
    background(0);
    //load and play the video in a loop
❸   movie = new Movie(this,"transit.mov");
❹   movie.loop();
  }

❺ void movieEvent(Movie m)
  {
    m.read();
  }

  void draw()
  {
    //if (movie.available() == true)
    //{
    //  movie.read();
    //}
❻   image(movie,0,0,width,height);
  }
```

When you want to use a library, you must first add it to your sketch. At ❶, the `import` keyword tells Processing to include the specified library in your project so you can use its functions and variables. The asterisk just tells Processing to load all classes that are associated with that library—in this case, the `Movie` class and the `Capture` class. The next part of the sketch creates a `Movie` object named `movie` ❷, which looks similar to how you created `PImage` objects in Project 6. In the `setup()` code, you'll find the usual `size()` and `background()` functions as well.

After the sketch window is defined, we instantiate the `movie` object ❸. Instances of the Video library's `Movie` class have two parameters: the sketch you're working with (given by the `this` keyword) and the name of the movie file you want to play (entered as a string). In sentence form, this statement could read, "Add a new movie to this program, and place the *transit.mov* file in it." The keyword `this` always refers to the sketch that you are working with currently.

Calling Library Functions

As an instance of the `Movie` class, the `movie` object has functions from that class that you can use. When calling functions that belong to an object, we have to tell Processing which function we want to run, and which object should run it.

As you saw in "Processing Objects" on page 111, class functions are available to all objects of that class. The function `loop()` at ❹ is part of the `Movie` class, which means that we can call it on the `movie` object.

Many libraries also have event functions. For example, the Loop sketch calls a `movieEvent()` function ❺, which reads the next frame once it becomes available and then displays it every time the `image()` function ❻ draws a new frame to the sketch window. To keep your sketch tidy, it's typically a good practice to use event functions.

If your sketch uses only a single video, however, you may want to just run a video in your `draw()` loop, as in Listing 10-1:

LISTING 10-1:

Running a video in
the `draw()` loop

```
import processing.video.*;

Movie movie;

void setup()
{
  size(640,360);
  background(0);
  //load and play the video in a loop
```

```
  movie = new Movie(this,"transit.mov");
  movie.loop();
}

void draw()
{
❶  if (movie.available() == true)
  {
    movie.read();
  }
  image(movie,0,0,width,height);
}
```

Here, I've uncommented the if() statement ❶ inside the draw()
loop and deleted the movieEvent() function.

This code should function identically to the version with the event
function in place. If your future projects have multiple videos, use an
event function to help Processing run your sketch efficiently, but for
now, let's focus on using the if() statement.

Modify your Loop sketch to use the if() statement, keep it open
in Processing, and save it as a new project to avoid losing your work. In
the next section, I'll teach you to add your own video. Let's get hacking!

ADDING YOUR OWN VIDEOS TO A SKETCH

To add a video to a Processing sketch, the file must be in a common
video format like *.mov*, *.mp4*, or *.avi*. For this example, I'll use a video
about launching high-altitude balloons by one of SparkFun's friends,
Dave Stillman. Figure 10-2 shows a frame of the balloon inflating.

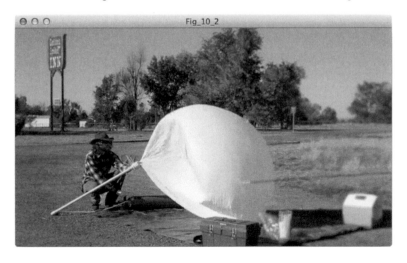

FIGURE 10-2:

Let's process this video of
inflating a weather balloon!

To use the same video, go to *http://www.nostarch.com/ sparkfunprocessing/* and download the source files for this book; you should find *dave.mp4* in the *Project 10* folder. You could also follow along with a video file from your computer. If you do use your own video, name the file something simple and descriptive.

Note the resolution of your video to help you decide the size of your sketch. (The video *dave.mp4* is in standard definition at a resolution of 640×360 pixels.) Then, add your video to your sketch folder as you would an image: click **Sketch ▸ Add File. . .** and select your video file.

In your modified Loop sketch from Listing 10-1, change the filename when you instantiate the `movie` object to match the video you'll use. For example, I changed that line to read:

```
movie = new Movie(this,"dave.mp4");
```

Click the **Run** button. Your video should load at the same size as the planet video. Pretty cool, huh? Now let's explore what we can do with this video!

APPLYING TINTS AND FILTERS

Once your video and library are in place, you can think of the video as an image and modify it as such. In Project 6, we explored image processing and focused on modifying images with the `tint()` and `filter()` functions. Since you'll display videos with the `image()` function, you can use the same functions to add effects to your videos, too.

In your modified Loop sketch from Listing 10-1, create a second `image()` call that displays the `movie` object, and add `tint()` functions as follows:

```
void draw()
{
  if(movie.available() == true)
  {
    movie.read();
  }
❶ noTint();
  image(movie,0,0,width/2,height/2);

❷ tint(255,0,0);
  image(movie,width/2,0,width/2,height/2);
}
```

There will be two videos: one in the top-left quadrant and another in the top-right quadrant of the sketch window, as shown by the coordinates of these image() calls. To keep one copy of the video as is, call noTint() ❶ before its image() function. Otherwise, place your tint() function ❷ above the image() functions you want to color. Click **Run**, and both copies of the video should play simultaneously, as shown in Figure 10-3.

FIGURE 10-3:
Tinting a video

Having multiple videos open in Processing is a great way to play with and compare different tints, but you can also apply filters to your videos. Change your draw() loop to display one copy of your video, remove the tint() functions, and add some filters, like so:

```
void draw()
{
  if(movie.available() == true)
  {
    movie.read();
  }
  image(movie,0,0,width,height);
  filter(GRAY);
  filter(BLUR,2);
}
```
❶ `filter(GRAY);`
❷ `filter(BLUR,2);`

Use any filters you like; I've used GRAY ❶ and BLUR ❷ to add some old-timey character to the balloon launch video, as shown in Figure 10-4.

FIGURE 10-4:

Dave's balloon video,
with GRAY and BLUR
filters applied

INTRODUCING FOR() LOOPS AND ARRAYS

Now let's briefly explore two new programming elements that will help you capture video and create this project's photo booth program.

When you want to run the same code over and over, use a for() loop. Here is the basic structure:

```
for(int ❶x = 0; ❷x < 100; ❸x += 10)
{
    point(x,10);
}
```

A for() loop has its own set of curly brackets, and you place the code you want to iterate inside them. Inside the parentheses, you tell the for() loop how many times to run. First, create a local count variable (in this case, x) and initialize it with a starting value ❶. Then, set a boundary ❷. This example tells the loop to run as long as x is less than 100. Finally, give the loop a value to increment the count variable by ❸; here, we increment x by 10.

This for() loop plots a series of points, and at each one, x increments by a value of 10. I elaborated on that concept in this simple sketch:

```
void setup()
{
    size(250,250);
}
```

```
void draw()
{
  strokeWeight(10);
  for(int x = 0; x < 255; x += 10 )
  {
    stroke(random(255),random(255),random(255));
    point(x,height/2);
  }
}
```

This sketch draws a point every 10 pixels and gives each point a random fill color. Start a blank sketch, add this program to it, and click **Run** to see the result plotted in Figure 10-5.

FIGURE 10-5:
Circles drawn with a for() loop and random color

The for() loop is useful for simplifying and condensing code, and it's particularly handy for populating arrays. An *array* is nothing more than a list of elements that your program can reference, add to, or remove from. Here's a simple array:

```
int[] ages = {30,30,5,2};
```

To create an array, first specify what kind of data will be in it; this array contains elements of type int. Then, place a set of square brackets, [], after the data type to tell Processing you're making an array. The brackets are followed by the name of the array; this array is called ages, and it contains the ages of my family members, in years. My wife and I are both 30, and my sons are 5 and 2. The values stored in an array must be bound by curly brackets.

To use a value from an array, call the array name and place the *index* (position in the array) of the value you want inside a set of square brackets:

```
int derekAge = ages[0];
```

This example fetches the first element from the age array (at index 0), which is my age, and stores it in the variable derekAge. This is great if your array already contains values, but what if you want to store values instead? Just reverse the order:

```
int derekAge = 30;
ages[0] = derekAge;
```

This will add the value of derekAge (30) to the ages array at index 0.

Arrays can help you store data in order, and they can store anything from integers (as shown here) to strings or floats. In the photo booth project, you'll actually use a for() loop to populate a string array with different camera settings available to your computer. You'll then reference what camera setting you want by its index.

Here's a simple sketch that counts up to 100 using a for() loop and populates an array with all of the count values:

```
❶ int[] numberLine;

void setup()
{
❷   numberLine = new int[100];

❸   for(int i = 0; i < 100; i++)
    {
      numberLine[i] = i;
      println(numberLine);
    }
}

void draw()
{
  ;
}
```

This sketch creates an uninitialized integer array called numberLine ❶. The setup() function instantiates the numberLine array like an object by defining it as a new integer array of size 100 ❷. Notice that numberLine is created differently from the ages array; numberLine starts out empty, which is why we have to specify a size. Next, we use a for() loop to increment the integer i 100 times. On each iteration, the loop adds the value of i to the numberLine array and prints the current list of values to the console ❸.

In the next section, we'll use both arrays and `for()` loops to help set up your webcam in Processing.

CAPTURING VIDEO

We'll explore other ways to customize movies in "Taking It Further" on page 182, but you don't have to limit yourself to existing movies. With a little prep work, Processing can capture live video!

First, make sure your webcam works. Open your favorite video recording software now and check whether you can actually record with the camera you intend to use with Processing. When you know the webcam can capture video, you can move on to the sketch.

Modifying the setup() Function

Instead of opening a new example sketch, we'll continue modifying the Loop sketch from Listing 10-1. Before the `setup()` function, we'll add a `Capture` object to the existing sketch, and inside, we'll replace one of the `Movie` objects in the side-by-side comparison shown back in Figure 10-3 with that `Capture` object:

```
   Movie movie;
❶  Capture cam;

   void setup()
   {
❷     String[] cameras = Capture.list();
       println("Available cameras:");

❸     for(int i = 0; i < cameras.length; i++)
       {
         println(cameras[i]);
       }

       size(640,360);
       background(0);

       //load and play the video in a loop
       movie = new Movie(this,"dave.mp4");
❹     cam = new Capture(this,cameras[0]);
       movie.loop();
❺     cam.start();
       frameRate(120);
   }
```

First, create an object of the `Capture` data type ❶ for your webcam video. You can name this anything except the name of a video object you've already loaded; I named it `cam`. Once your `Capture` object is named, let's add code to your `setup()` function to let Processing access your webcam.

Capturing your webcam feed does make instantiating the `cam` object a little tricky. The webcam may have multiple settings or may be hooked up to a specific port that we need to find. For example, my webcam has a number of frame rates and resolution settings that I can choose from as individual "cameras" in Processing.

You can create a list of these settings with some code in your `setup()` function. First, save a list of the available cameras as a string array called `cameras` ❷. Once we have our camera list, we can print it out to the console line by line ❸. We run the loop once for each entry in the `cameras` array by starting a count value `i` at 0 and incrementing it (`i++`) until we reach the end of the list.

Even though you don't have the camera list yet, instantiate your `Capture` object ❹ to `cameras[0]` next. I always select `cameras[0]` to start with because it's the first element in your array of cameras, and that should be your camera's standard setting.

Finally, call the `cam.start()` function ❺ to start capturing video from the camera. I bumped up my `frameRate()` to 120 frames per second as well, but that's optional.

Click the **Run** button, and you should see your list of camera settings in the console window, though your live video will not show up yet because we haven't added the `cam` data to the `draw()` loop. If you want to change to a different setting, you can do so by changing `cameras[0]` to the number of the entry you want in the list, counting from 0. Once you can see your list in the console, you can select which settings you want and, if you are using multiple cameras, which camera.

For example, here are a few of the camera options that print out in my Processing console:

```
❶ name=WebCam SC-13HDL11624N,size=640x480,fps=5
  name=WebCam SC-13HDL11624N,size=640x480,fps=30
  name=WebCam SC-13HDL11624N,size=160x120,fps=5
❷ name=WebCam SC-13HDL11624N,size=160x120,fps=30
```

If you want to change your settings, you can select a different camera by counting up from 0 as you move through the list. In my

case `cameras[0]` is at ❶. If I wanted to change to a smaller frame size and more frames per second, I could use `cameras[3]`, which is at ❷.

Displaying Live Capture

Now that your setup code is ready, let's display the live video in your sketch. Change your `draw()` loop as follows to show both a movie and a live feed:

```
void draw()
{
❶  if((movie.available() == true) && (cam.available() == true))
    {
      movie.read();
      cam.read();
    }

❷  image(cam,width/2,height/4,width/2,height/2);

    image(movie,0,height/4,width/2,height/2);
}
```

First, change your original `if()` statement into a compound `if()` statement ❶. This version checks that both your movie and camera are available, and assuming they are, it reads the frame from both of them. Next, change one of the `image()` functions to use the `cam` data ❷ instead of both having the `movie` data.

Click **Run**, and your webcam should play your movie and display live video, as in Figure 10-6.

FIGURE 10-6:
This sketch window shows the balloon launch movie on the left and a camera capture of me on a Saturday morning on the right.

NOTE

Video in any format is tough for Processing to work with, and it may take extra time to load and display, so be patient.

Since you are using the image() function to display the frames of your live video, you can again treat it like an image and apply filters and tints to it. Play around until you feel comfortable with applying these effects to live video; they will help you add some pizzazz to your photo booth in the next project!

CREATING A PHOTO BOOTH

Now that we've explored Movie and Capture objects in Processing, let's combine the two and create a photo booth! Open a new sketch to start this project from scratch, and save it as *myPhotoBooth.pde*. Then, click **Sketch ▸ Import Library. . . ▸ Video** to add the Video library to your project. This should automatically populate the top of your sketch with an import line:

```
import processing.video.*;
```

After importing the library, you can create library objects. You just need a Capture object:

```
Capture cam;
```

I called my Capture object cam.

Adding the setup() Function

Next, add the following setup() function to your sketch:

```
void setup()
{
❶   String[] cameras = Capture.list();
❷   println("Available cameras:");

❸   for(int i = 0; i < cameras.length; i++)
    {
      println(cameras[i]);
    }

❹   size(1280,1024);
❺   cam = new Capture(this,cameras[30]);

❻   cam.start();
}
```

First, create the list of available camera options. Create a string array called cameras ❶ and fill it with the output of Capture.list() ❷.

Use `Capture` rather than `cam` because you have not instantiated your `cam` object yet. Then, use a `for()` loop ❸ to print out each camera in the list.

Next, set the sketch size to your webcam's resolution ❹; for example, my webcam has a resolution of 1280×1024 pixels. Then instantiate `cam` ❺ as a `Capture` object.

When you instantiate the `cam` object, select a camera setting from the list you printed. I chose option 30, but you may have more or fewer options, so check your camera list in the console before you choose. A safe bet is to always start with option 0 and then play around with different settings once everything works.

Finally, start your movie and your capture feed ❻.

Creating the draw() Loop

Now let's create the `draw()` loop and display some video!

```
void draw()
{
❶  if(cam.available() == true)
    {
      cam.read();
    }

    image(cam,0,0,width,height);
❷  if(second()%10 == 0)
    {
❸    cam.stop();
❹    saveFrame();
❺    delay(1000);
      cam.start();
    }
}
```

Start by checking if the `cam` capture is available ❶. When the condition inside the `if()` statement returns `true`, Processing reads a frame from each object, then displays the `cam` frame as an image.

Photo booths snap pictures at timed intervals, so let's have Processing take a photo every 10 seconds. Our `if()` statement ❷ checks whether the output of the `second()` function is divisible by 10 with the *modulo* function. Written as a percent sign (%), the modulo function returns the remainder of a division; for example, 100%10 = 0, and 5%2 = 1. So the condition `second()%10 == 0` checks whether the number of seconds passed is divisible by 10.

If you find a camera setting that you really like, you can skip this step and just hardcode your camera selection when you initiate your **Capture** *object.*

When the condition is `true`, call the `pause()` function from the `Capture` class on `cam` to pause the video ❸. You can use `pause()` to freeze the live webcam feed.

Once you pause the capture, call a function called `saveFrame()` ❹. This function saves the frame currently displayed in your sketch as an image in your sketch folder, and labels each image by frame number. Finally, delay ❺ for 1 second (1,000 milliseconds) to let the photo booth participants view their photo, and then restart the capture feed. Figure 10-7 is a series of photos taken using this project!

FIGURE 10-7:

A series of photo booth images. This is the last time I leave my laptop alone at the office.

TAKING IT FURTHER

We've only scratched the surface of Processing's Video library, and there are a bunch of other functions (not to mention other libraries!) that you can put to good use in your sketches. Visit the Processing website (*https://processing.org/reference/libraries/*) to learn more.

One way to take this project further is to turn your photo booth into a time-lapse program. You could make the photo booth take a photo every hour, and track the weather over the course of the day or even take time-lapse footage of your kitchen to see how often your refrigerator is opened.

For an extended use of the Video library, try creating a multi-media presentation. If you want to give a movie a certain aesthetic, you can record your own file and then use Processing to add filters and tints to your video as you did in this project. You could also create a video collage with different videos playing all at the same

time. Try to re-create the video grid from the *Brady Bunch* opening credits! (Check out this YouTube clip if you're not familiar with the *Brady Bunch*: *https://www.youtube.com/watch?v=K5StTXQofqs/*.) You can use the code for my Warhol-inspired image from Project 6 (see page 116), and add the Video library to it.

If you're feeling very confident in your programming skills, take a look at OpenCV for Processing, a library with a focus on computer vision. *Computer vision (CV)* essentially adds eyes to your computer to track objects or faces, or even determine what something is by its shape.

In the next project, you'll explore how to use data from the world around you with Arduino and the serial communication library!

AUDIO PROCESSING WITH MINIM

YOU MET YOUR FIRST PROCESSING LIBRARY IN PROJECT 10, AND NOW YOU'LL TACKLE MINIM, AN AUDIO PROCESSING LIBRARY. YOU CAN USE MINIM TO MAKE SKETCHES THAT PLAY SONGS OR REACT TO INPUT WITH SOUND EFFECTS, AND IN THIS PROJECT, YOU'LL MAKE A SIMPLE AUDIO PLAYER AND AN INTERACTIVE SOUNDBOARD THAT REACTS TO KEYPRESSES.

When you're done with the sketch, I'll challenge you to take it further with some hardware, too! Are you ready to rock?

Note that Processing 3 has its own audio library; you can read about it at *https://processing.org/reference/libraries/sound/index .html*. You should still be able to use Minim with Processing 3, however. This book covers Minim instead of the default library so that readers using Processing 2 can do the projects, and because Minim gives you a different degree of control over your audio content.

GATHER YOUR MATERIALS

You can just use your keyboard for all of the inputs in this project, but if you want to create a MaKey MaKey controller for the challenge I set out in "Taking It Further" on page 206, you'll need the following parts, which are both included in the SparkFun MaKey MaKey kit (product WIG-11511):

- One MaKey MaKey
- One mini USB cable

You may also want to have some copper tape and a small cardboard box handy for that challenge; the copper tape also comes with the SparkFun MaKey MaKey kit, and any old box will do.

INTRODUCING THE MINIM LIBRARY

From audio recording and playback to audio synthesis and processing, you can do just about anything with sound using Minim, a wonderful audio processing library created by Damien Di Fede. Depending on what you want to accomplish, Minim probably has the perfect class for your sketch:

`AudioInput` Receives mono or stereo input

`AudioMetaData` Stores meta and ID information about your track

`AudioOutput` Synthesizes mono or stereo input

`AudioPlayer` Plays mono and stereo sound in many popular formats

`AudioRecorder` Records mono or stereo audio to a buffer or file

`AudioSample` Similar to `AudioPlayer`, allows for buffered playback

`BeatDetect` Lets you detect beats in audio files

`FFT` Enables frequency and spectrum analysis

You can read about Minim in more detail at *http://code .compartmental.net/minim/*, where Damien has documented the library so well that pretty much anyone can pick it up and play with sound. For this book, I'll focus on the basics of accessing a sound

file and triggering it for the project, but I'll also discuss a few other classes and how you can apply them in Processing.

To get a feel for using Minim, you will create a basic audio player application that plays a song when you run your sketch. First, click **Sketch ▸ Import Library ▸ Add Library. . .** to launch the Library Manager. Look for the Minim library, and click **Install** to add it to Processing.

Then, open a new Processing sketch and add the following to the top:

```
import ddf.minim.*;   //import library
Minim minim;          //minim library class object called minim
AudioPlayer song;     //AudioPlayer object called song
```

Your import line for the Minim library is pretty much the same as the ones you used for the Video library; it just replaces processing with ddf. After the import line, create a Minim object and an AudioPlayer object; I named mine minim and song, respectively.

Once you've created the two library objects, instantiate them in a new setup() loop as follows:

```
void setup()
{
  //instantiate the minim library class
❶ minim = new Minim(this);

  //load the mp3 file to the song object
❷ song = minim.loadFile("song.mp3");
}
```

First, instantiate the minim object ❶, which allows the library to access the *data* folder and any other content within your sketch. Notice that to instantiate song, you call loadFile() on minim ❷, rather than creating a new AudioPlayer, which would more closely mirror what you did to instantiate Video library objects.

Unlike the Video library, which has classes that do not depend on one another, the Minim library has an *overarching class*. The overarching class is named Minim, and it contains the functions you need to use the other classes, including the loadFile() function. That's why you instantiate the minim object first; otherwise, you won't be able to load other objects to play songs! In general, larger libraries tend to have classes like minim that act as utility classes or help you to use other classes.

NOTE

Many of the example sketches that I show in this chapter are based on the examples that come with the Minim library. You can find more information about Minim and its other classes and more example code at http:// code.compartmental.net/ minim/.

NOTE

If you import the Minim library through the menu (Sketch ▸ Import Library) instead of adding the line manually, Processing will automatically import a number of other library utilities. You can leave them in, and they shouldn't affect your sketch.

Now that you have some code in place, save your sketch and add an MP3 file called *song.mp3* to your sketch's *data* folder. You can either download the file with the rest of this book's resources at *http://www.nostarch.com/sparkfunprocessing/*, or rename any MP3 file you like to *song.mp3*. When you've picked a file, click **Sketch ▸ Add File** and select it.

Once you've loaded your song, you can play it by adding a call to the AudioPlayer class's play() function. Update your setup() function, as shown in Listing 11-1.

LISTING 11-1:

A basic sketch to play your song

```
import ddf.minim.*; //import library

Minim minim;          //Minim library class object called minim
AudioPlayer song;     //AudioPlayer object called song

void setup()
{
  //instantiate the minim library class object
  minim = new Minim(this);    //initialize minim as a
                              //new Minim object
  song = loadFile("song.mp3"); //load mp3 to song object

❶ song.play();                 //play song
}

void draw()
{
  ;                           //nothing in draw loop
}
```

Here you call play() on song ❶, and add an empty draw() loop. I placed this call in the setup code, so the song will play only once, at the beginning of the sketch. If you want it to repeat, place it in your draw() loop. Run this sketch now, and your song should play!

Now that you've seen how to get the AudioPlayer class up and running, here are a few more class methods that will be useful for you in your endeavors as an audiovisual artist:

cue() Set where in the file to start playback

length() Fetch the length of the audio file

pause() Pause the audio file

mute() Mute the audio

position() Fetch the current position in the audio file

rewind() Rewind the audio file back to the beginning

skip() Skip a certain amount of the song

unMute() Unmute the audio

You'd call these functions on an `AudioPlayer` object, so in the sketch you just made, you'd call them on `song`, like this:

```
song.rewind();
```

The Minim library is designed with a wide spectrum of audio use in mind, so try these out on all kinds of sound files, and check the Minim website to find more functions and classes to try. I'm no expert in audio synthesizing or processing and haven't fully explored Minim, so I'm still finding really cool things to do with it every time I use it. In fact, this chapter took the longest to write because I couldn't decide on a project to share with you!

CREATING A SINGLE-SONG AUDIO PLAYER

With Minim, you can do more than just start an MP3 file. In this part of the project, you'll create playback controls. Add some of your favorite songs, sound effects, podcasts, or other files to your sketch folder (just make sure they're WAV, AIFF, AU, SND, or MP3 files), and I'll show you how to make a single-song audio player.

To start, let's get one audio file playing. Create a new sketch, add some audio files to its *data* folder, and add the following to the code window; if you're adding your own song, replace `01 Radioactive.mp3` with your own filename.

NOTE
If you don't want to use a song of your own, visit http://www.nostarch .com/sparkfunprocessing/, *download the examples for this book, and use the* MP3 *files in the* Project 11 *folder.*

```
import ddf.minim.*;
Minim minim;
AudioPlayer song;

void setup()
{
  size(500,500);
  minim = new Minim(this);

  song = minim.loadFile("01 Radioactive.mp3");

  song.play();
}
```

This sketch is nearly the same as Listing 11-1. After importing the library and creating your objects, you start the song in the `setup()` function again to make the song play right away when someone starts the sketch.

LEARNING A NEW LIBRARY

There are a lot of libraries out there that make Processing more powerful, and like Processing itself, these libraries are open source. They're written by people just like you, who were looking for functionality in Processing that wasn't there initially, so they created it for themselves!

Each library is a little different in its functionality, documentation, and ease of use. Here are a few tips to figure out if a library is right for you:

Documentation Check out the library's web page or GitHub page, and if you can't envision how to use it in a "Hello World" sketch from the documentation provided, then you may want to try another library. Many libraries have what are called *javaDocs*; you'll find Minim's javaDocs at *http://code.compartmental.net/ minim/javadoc/*. These describe details of the library (for example, the classes and functions it contains), much like the Reference page of the Processing website.

Example sketches The library should come with a good set of example sketches that demonstrate its breadth and the functionality of each class and its functions. If there is a small number of examples, don't fret: it may just be a small library. Always open the examples and play with them before diving in to writing your own sketch.

Check the Library Manager Processing's Library Manager (under Sketch ▸ Import library ▸ Add a Library. . .) houses an ongoing list of libraries that have been vetted by Processing.org and approved in terms of functionality, documentation, and example sketches. The Library Manager is probably the safest place to find and install new libraries, so check it out!

Now you'll add some playback controls to this example with a keyboard event function. At the end of your current sketch, add an empty draw() function followed by a keyPressed() event function that uses a couple of keys and an if() statement to pause and play the song, as shown in Listing 11-2:

LISTING 11-2:

Adding a keyPressed() event function to pause and play the song

```
void draw()
{
    ;     //nothing in draw()
}

void keyPressed()
{
    if(key == 's')
    {
❶       song.pause();   //if S key is pressed, stop the song
    }

    if(key == 'p')
    {
❷       song.play();    //if P key is pressed, play the song
    }
}
```

Once you add this event function to your sketch, run it. Let it play for a bit, and then press the S key. The song should stop, thanks to the pause() function ❶. To play the song again, press the P key, which should call the play() function ❷.

Now you'll show information about the song in your sketch window. Enter this code in the draw() loop between your setup() function and the keyPressed() function:

```
void draw()
{
    background(150);
    fill(0);
    text(❶song.position() + " out of " + ❷song.length(), ↵
width/2,height/2);
}
```

First, set a fill color of 0 to make black text. Then, use the text() function to print the position of the song. I concatenated some string labels with both the current position ❶ and the total length ❷, at a position of width/2 and height/2. This begins the text in the center of the sketch window, as you can see in Figure 11-1.

FIGURE 11-1:

Displaying a song's
current position in
playback

14373 out of 227213

Run your sketch to confirm you can fetch information about your song. Then, show that data graphically using a horizontal bar display. Update your draw() loop as follows:

```
void draw()
{
  background(61,147,76);
❶  noStroke();
❷  float pos = map(song.position(),0,song.length(),0,300);

❸  textAlign(CENTER);
  fill(0);
  text(song.position()/1000 + " out of " + ↵
song.length()/1000,width/2,height/2);

❹  fill(255);
  rect(100,110,300,50);
  fill(255,0,0);
  rect(100,110,pos,50);
}
```

First, you set the background color and turn off stroke outlines for both rectangles ❶. Next, you create a local float variable called pos and set the value of pos to the mapped value of song.position() ❷, which ranges from 0 to 300.

The `map()` function scales a value x from `xMin` and `xMax` to `zMin` and `zMax`:

```
map(x,xMin,xMax,zMin,zMax);
```

This function will save you a lot of time and effort when you need to scale and divide more complicated numbers, such as song lengths.

Now to display the text values: this part works the same way it did in earlier projects. At ❸, you align your text, set the color, and then display it. Finally, you draw two rectangles ❹. The first shows the maximum value of the song length, and the second is the gauge rectangle that will grow based on the mapped `val` of the song length. When the song ends, the second rectangle should completely cover the first rectangle.

Run your sketch. As the song plays, a red rectangle should grow in width, and the text readout should increment, as shown in Figure 11-2.

FIGURE 11-2:

Adding the time bar with the song length in text

As you've seen, `AudioPlayer` has some useful and creative applications. It isn't the only fun class in the Minim library, though—in the next section, I'll introduce you to `AudioSample` and show you how to use it.

INTRODUCING MINIM'S AUDIOSAMPLE CLASS

NOTE

The one negative side of the AudioSample class is the large amount of buffer or memory space it takes up when you have multiple samples ready to be played.

For the rest of this project, you'll also use the AudioSample class, which is very similar to the AudioPlayer class you just practiced with. An AudioSample object keeps a sound file in an internal buffer so that it can be triggered quickly. While AudioPlayer is used to play whole songs or longer tracks, AudioSample is often used as a mixing tool. Each instrument might be a sample, and you can play several instruments over one another quickly, enriching the audio in your sketch. You can have up to 20 separate audio samples in your sketch at once.

Let's compare some setup and playback code for an AudioPlayer object and an AudioSample object. To refresh your memory, here's a working AudioPlayer sketch:

```
import ddf.minim.*;

❶ Minim minim;
  AudioPlayer song;

  void setup()
  {
    minim = new Minim(this);
❷   song = minim.loadFile("song.mp3");
  }

  void draw()
  {
❸   song.play();
  }
```

Now, here's a working AudioSample sketch:

```
import ddf.minim.*;

❹ Minim minim;
  AudioSample sample;

  void setup()
  {
    minim = new Minim(this);
❺   sample = minim.loadSample("sample.mp3",512);
  }
```

```
void draw()
{
❻   sample.trigger();
}
```

You need to create a `Minim` object (❶ and ❹) and a class object to use both `AudioPlayer` and `AudioSample`. Then, for an `AudioPlayer` file, you instantiate your class object with a call to `loadFile()` ❷, which takes the file and loads it for use. With `AudioSample`, you use the `loadSample()` function ❺ instead, which requires you to also pass a buffer size. I used `512` as my buffer size, but you may need to make this number larger depending on your system. The buffer size determines how responsive the sound will be: the larger the buffer, the more responsive the trigger. Finally, to actually play a song, you use `play()` function ❸ in the `AudioPlayer` class, as opposed to the `AudioSample` class's `trigger()` function ❻, which triggers a sample.

As you can see, you follow roughly the same formula to use both classes; their functions just work a little differently. I'll opt for the `AudioSample` class from here on because I'm looking for sounds that have quicker response and loading times.

IMPROVING YOUR AUDIO PLAYER WITH METADATA

In this section, we'll explore the `AudioMetaData` class included in Minim. Your audio player now has a nifty little progress bar. But who is singing? What is the name of the song? What album is it from? Most media players display this information, called *metadata*. Metadata is all of the background and contextual data that goes along with a song or album, including the song titles, album title, and artist. Many songs even include copyright information, publication dates, and the record company in the metadata.

To access metadata in a Processing sketch, you use the `AudioMetaData` class of the Minim library. Remember that to add a class object, you have to create the object at the top of your sketch. For simplicity, I'll start a new sketch now, though enough code is the same here that you could work from your single-song audio player and just add the new parts.

NOTE

Always look at the length of your audio file before deciding what Minim class to use. If your file is longer than 15 seconds or so, use AudioPlayer; if it's shorter, use AudioSample. Also keep in mind how you want to use the file in terms of agility and audio layering.

NOTE

Metadata can differ from song to song, based on whether you ripped the song from a CD and filled in the data by hand or bought the song through a service like iTunes, which usually includes all the metadata. For this project, I assume that you're using a song that has all of its metadata.

Here's what the beginning of your sketch should look like:

```
import ddf.minim.*;

Minim minim;
AudioPlayer song;
❶ AudioMetaData data;
```

I placed my `AudioMetaData` object ❶ underneath my `AudioPlayer` object and called it `data`. Once you have created the object, instantiate it in the `setup()` function, along with the `minim` and `song` objects:

```
void setup()
{
  size(500,200);

  minim = new Minim(this);   //create minim object
  song = minim.loadFile("01 Radioactive.mp3");   //load song
❶ data = song.getMetaData(); //get metadata from song object
  song.play();                                //play song
}
```

Instantiate the `AudioMetaData` object ❶ after instantiating your `AudioPlayer` object, because the `AudioMetaData` class needs to know which song is being used by the `AudioPlayer` object in order to access the information from the correct file. For the song file, you can either load the MP3 file you used in the previous example code into your new sketch folder or use a new one. I recommend using a professionally produced song, downloaded from a service or ripped from an album, so that it will have sufficient metadata available for you to use.

Now you'll display some basic information about your song in the `draw()` loop and use the `keypressed()` event function from Listing 11-2 to add playback controls. Fortunately, Minim returns all of the metadata in a string format, which is nice because you can just display it with the `text()` function, as follows:

```
void draw()
{
  background(150);
  noStroke();

  //map position to 0-300
  float pos = map(song.position(),0,song.length(),0,300);
```

```
   textAlign(CENTER);              //align text to center
   fill(0);
❶ text(data.title(),width/2,55);   //song title
❷ text(data.author(),width/2,70);  //artist
❸ text(data.album(),width/2,85);   //album title

   //position
   text(song.position()/1000 + " out of " + ↵
song.length()/1000,width/2,100);

   fill(255);
   rect(100,110,300,50);    //base rectangle
   fill(255,0,0);
   rect(100,110,pos,50);    //song position rectangle
}

void keyPressed()
{
   if(key == 's')
   {
     song.pause();    //if S key is pressed, pause the song
   }
   if(key == 'p')
   {
     song.play();    //if P key is pressed, play the song
   }
}
```

Add the song title ❶, author ❷, and album name ❸ to the sketch with the text() function, placing each 15 pixels lower than the previous one. Run your sketch with the new code, and you should see something like Figure 11-3.

FIGURE 11-3:

The simple single-song player with metadata added

Congratulations! You just made an audio player that displays the metadata associated with the file you play.

You can also use your microphone as an input device in Processing, and in the next section, we'll do that with the Minim

library. If you're on a laptop with a built-in microphone, you should be just fine, but if you are working on a desktop computer, plug in an external microphone before you begin.

VISUALIZING SOUND

Using the microphone on your computer is a great way to bring real-world interactivity to your Processing sketches, and it is also relatively painless. The first step to using sound as an input is to check your chosen sound's *amplitude*, or how loud it is.

Setting Up Audio Input

Now you'll bring audio input into a Processing sketch. Begin a fresh sketch, and as always, start by creating class objects and global variables:

```
import ddf.minim.*;

Minim minim;
AudioInput mic;

int x = 1;
```

To use a microphone, you need to create an `AudioInput` class object as well as a `Minim` object, so import the Minim library and add both class objects. My `Minim` object is called `minim` and my `AudioInput` object is called `mic` to keep everything straightforward. Then, create a variable called x and initialize it as 1. You'll use this variable later to create a graph visual, but since it needs to be global, it belongs at the top of your sketch.

Next, add your `setup()` function, as shown in Listing 11-3.

```
void setup()
{
  size(500,200);

  minim = new Minim(this);
❶ mic = minim.getLineIn();

❷ frameRate(120);
  background(150);
}
```

LISTING 11-3:
Instantiating an audio input using an external line in

Create a sketch window first. For this application, I recommend a window that's wider than it is tall. Next, instantiate the `Minim` library object and the `AudioInput` object ❶. If no other devices are plugged in to your computer, the result of `minim.getLineIn()` should be your microphone, so leave everything else unplugged when you first run this sketch.

To increase your sample rate to make your visualization a lot closer to real time, bump up the frame rate of the sketch ❷. Last, set the background in the setup, because the graph you'll draw depends on the stamp effect of not redrawing the background with every frame.

Drawing Sound

Now, on to the fun part: visualizing sound! You'll create a scrolling bar graph that will show the real-time loudness (amplitude) of sound around you. This graph is not to scale in terms of decibels; you'll just see change and reaction.

Most of the magic happens in the `line()` function itself. In Project 3, you made an ellipse bounce back and forth when its x-position went beyond the width of the window. You'll revisit that concept here to make a simple area graph made up of a series of adjacent vertical lines.

NOTE
Amplitude is the measured and literal loudness of a sound, whereas volume is the perceived loudness. You can have two frequencies that have the same amplitude but different volumes; one sounds louder even though they have the same amplitude.

Add the following `draw()` loop after your `setup()` function now:

```
void draw()
{
  stroke(0,0,255);
  line(x,❶(height - 20), x, ↵
❷((height - 20) - abs(mic.left.get(0) * 200)));
  x = x + 1;

❸ if (x >= width)
  {
    background(150);
    x = 0;
  }
}
```

Draw a line where both x-coordinates are the same value, in this case the x variable. The y-values of the line make the graph move up and down, and they're tied to your audio input. Y1 is the baseline of the graph and is equal to `height - 20` ❶. In other words, it's 20 pixels up from the bottom of the window. You can tweak the 20 to move the entire graph up or down.

The Y2 value is (`height - 20) - abs(mic.left.get(0) * 200`) at ❷. Y2 is the point that will move up as the sound gets louder. To get the sound amplitude, you use the `mic.left.get()` function. This checks the audio sample from the buffer storage and returns a number between –1 and 1, as shown in Figure 11-4, which is the amplitude of the sound wave. But that number isn't very big, so loudness changes would be really hard to visualize as is. To scale that value up, multiply it by 200 for a range of –200 to 200.

FIGURE 11-4:

An audio sine wave that ranges from –1 to 1

Since you are looking for a loudness level, not a mathematical amplitude, you also need to take the absolute value of the range given. (Taking the absolute value of a negative number removes the negative sign, making it positive.) To get the absolute value, pass the whole function of mic.left.get(0)*200 to the abs() function.

To calculate a line height, take your baseline value (height - 20) and subtract the absolute value function. This should produce a graph that spikes the louder the sound gets. The last bit of the draw() loop increments the x variables and checks for the graph's width by using an if() statement to compare x to width. If x is equal to or greater than the width of the sketch window, the background is redrawn and the line moves back to 0 ❸. Run the sketch and make some noise (for example, sing and stomp your feet), and you should see an active graph similar to Figure 11-5.

Before moving on, try using the audio input to also change the color of the graph. You can just copy the absolute value of the scaled input and paste it as any R, G, or B value of your stroke color for the line in your draw() loop. For example, tweak your stroke() function as follows:

```
stroke(abs(mic.left.get(0) * 1000),0,255);
```

FIGURE 11-5:

A simple graph of an
audio input from my
laptop microphone

Here, you keep 255 as your blue value, but now the red value
changes with the loudness level. So instead of staying blue, as your
sound gets louder the graph should turn purple! Check it out in
Figure 11-6.

FIGURE 11-6:

Now the stroke
value changes with
the amplitude in the
sound graph

RECORDING AUDIO TO CREATE A SOUNDBOARD

The final class you'll explore within the Minim library is `AudioRecorder`. I am not going to lie: I love this class and have put it to some interesting uses, such as recording a song, doing some sneaky sleuthing, and making a fun soundboard. `AudioRecorder` allows you to capture audio input and save it as a WAV file. This is a huge win in my opinion, because it allows for some really interesting sketches that can record audio to use later or with a different interaction.

You can create a simple soundboard with the `AudioRecorder` class. For now, you'll just use the arrow keys to get all of the software working, but later you can add a MaKey MaKey and some fun craft materials.

Creating the Class Objects

Start a new sketch, import the Minim library, and create your class objects:

```
import ddf.minim.*;

❶ Minim minim;

❷ AudioInput mic;        //for microphone input
❸ AudioRecorder left;    //left record
  AudioRecorder right;   //right record
  AudioSample Pright;    //right playback
  AudioSample Pleft;     //left playback
```

Just as before, start a new sketch to work with recordings. Import the Minim library and create all of your class objects. Remember that to use the microphone you need to create a `Minim` object called `minim` to start with ❶, followed by an `AudioInput` object ❷ and then two `AudioRecorder` objects and two `AudioSample` objects ❸.

Writing the setup() and draw() Functions

Once everything is created and named, dive in to the `setup()` for this sketch. Here, you'll set the window size and instantiate your class objects:

```
void setup()
{
  size(800,900);

❶  minim = new Minim(this);
```

```
❷   mic = minim.getLineIn();

❸   right = minim.createRecorder(mic,"data/right.wav");
    left = minim.createRecorder(mic,"data/left.wav");
}
```

The first object is `minim` ❶, which is pretty self-explanatory; it's been used in all of the example code in this chapter. The `mic` object ❷ is instantiated the same way as in Listing 11-3. Finally, you have two separate `createRecorder()` functions ❸, which each take a directory path and filename. This lets you record two separate audio tracks, one for each arrow key. For every audio file you want to record, you need to have a separate `AudioRecorder` object. Since this sketch needs to access the file you record, structure the directory path as */data/filename.wav*. This will put the recorded audio file in your *data* folder with a specific name and location, versus just floating in your sketch folder.

Now, add an empty `draw()` loop after your `setup()` function:

```
void draw()
{
    ; //nothing here!
}
```

My `draw()` loop is empty because the real magic happens in an event function, which I'll show you next.

Recording and Playing Samples in an Event Function

What about instantiating the `AudioSample` objects? They'll be instantiated within a `keyPressed()` event function. When your sketch starts, there's no audio file to load to either object, so you have to wait until something is recorded first, and then you can instantiate the object and trigger it. Create the following event function now:

```
void keyPressed()
{
    //record and stop/save controls for the left sample
    if(keyCode == LEFT)
    {
❶       if(left.isRecording())
        {
            left.endRecord();
            left.save();
        }
```

```
    else
    {
      left.beginRecord();
    }
  }

  //record and stop/save controls for the right sample
  if(keyCode == RIGHT)
  {
❷    if(right.isRecording())
    {
      right.endRecord();
      right.save();
    }
    else
    {
      right.beginRecord();
    }
  }

  //play the right sample
❸  if(keyCode == UP)
  {
    Pright = minim.loadSample("right.wav");
    Pright.trigger();
  }

  //play the left sample
❹  if(keyCode == DOWN)
  {
    Pleft = minim.loadSample("left.wav");
    Pleft.trigger();
  }
}
```

--

This might look like a mess of if() statements, but it's not that different from the keyboard event functions you used in your MaKey MaKey controller in Project 9. There are just a few new functions, but don't worry: you can tackle it.

First, create if() statements that check keyCode for the four arrow keys (UP, DOWN, LEFT, and RIGHT). Then, add functionality to each statement. I set it up so the RIGHT and LEFT keys start and stop the recording process for my two audio samples, while UP and DOWN trigger the freshly recorded audio samples.

To create the Record and Stop/Save controls, you'll use a new concept called *latching*, which refers to something that's turned on when triggered and stays on until triggered again, at which point it

turns off. We'll use the `isRecording()` function to check whether an `AudioRecorder` object is recording or not and then switch to the opposite state, as in the left and right `if()`/`else()` statement pairs at ❶ and ❷. In English, the right statement might read, "If `right` is recording, then end the recording and save it; else, start recording."

Finally, instantiate the two `AudioSample` objects. In the UP and DOWN key `if()` statements, instantiate the given sample, and directly afterward, trigger that sound, like I've done at ❸ and ❹. Notice that the audio filenames are exactly the same as the files created by the recorders. This code will not work if the filenames are not identical.

Once you get your `keyPressed()` event function programmed, run your soundboard sketch. You shouldn't see anything but a small sketch window. Press the left arrow key, and then make a funny noise into the microphone. Once you are done, press the left arrow key again. Do the same for the right arrow. Now, press your up and down arrows. You should hear the noises you just recorded!

Remember that my `draw()` loop is pretty simple; there's nothing in it. I suggest you add an image and some text instructions for anyone using your simple soundboard app. If you are looking for a real challenge, think about how you could animate or change your image when each `keyPressed()` event is triggered.

TAKING IT FURTHER

This has been a huge chapter, and the content is really dense, yet you've only scratched the surface of the Minim audio library. I highly recommend exploring other possibilities that the library offers, too. Try adding a theme song to your maze game from Project 9, or record a greeting for your holiday card from Project 2. I'm sure you could find a fun way to add audio to any project in this book! To see the example code for the theme song I added to my maze game, go to *https://nostarch.com/sparkfunprocessing/*.

With what you have learned and built so far in this book, you also have the skills and knowledge to take on a small project on your own. My challenge to you is to build a musical synthesizer using the Minim library and your MaKey MaKey.

There are a couple of ways to tackle this project. You could use the `AudioPlayer` class to play a song of your choice, and then have prerecorded sounds you can trigger using `keyPressed()` event functions and the `AudioSample` class you used in "Recording and Playing Samples in an Event Function" on page 204.

An extension of this idea would be to add a recording option and build an audio looping system, where you can record sounds and then play them later as audio samples during your song. Really explore the MaKey MaKey this time—look at the back of the board for inputs beyond the basic arrow keys and mouse clicks on the front. In a way, your mission is to combine concepts from each piece of example code in this chapter to build a project that puts your MaKey MaKey to use again. If you need inspiration, check out what Komag did with a MaKey MaKey (*https://www.youtube.com/watch?v=Aq-xBatZx7Q*), or if you are looking for a simpler and well-documented project, check out our sound page tutorial (*https://learn.sparkfun.com/ tutorials/sound-page-guide/*); you can see the result from the latter in Figure 11-7. Both examples are similar to this challenge and give you different options in terms of scale.

FIGURE 11-7:

A wall-sized soundboard at SparkFun headquarters

If you need a piece of code for this project to get you started, take a look at this book's resource files at *http://www.nostarch.com/ sparkfunprocessing/*. Head to the *Project 11* folder and open *ExampleSoundBoard.pde* to see one solution.

At this point, you can say you're a veteran at using sound in Processing and controlling it through your keyboard. Besides the synthesizer challenge, try creating more visuals that respond to songs or sound samples. You could show album art, or even a slideshow of concert photos you took from the mosh pit. Enjoy being the hit of the party, and go make some beautiful music! When you're done, share it with us at *processing.book@sparkfun.com*.

12

BUILDING A WEATHER DASHBOARD WITH JSON DATA

YOU'VE CREATED PROCESSING SKETCHES THAT CHANGE BASED ON USER INPUT, BUT YOU CAN ALSO MAKE ART PIECES THAT RESPOND TO DATA. THE INTERNET PLACES A VAST AMOUNT OF VARIED INFORMATION RIGHT AT YOUR FINGERTIPS, SO NATURALLY THERE ARE A NUMBER OF WAYS TO COLLECT THAT DATA.

In this project, I'll teach you how to harness online data to create a simple weather dashboard that you can customize on your own. The key to this project is finding a way to get all that weather information into a Processing sketch, and that's where *JavaScript Object Notation (JSON)* comes in. JSON is a standard for communicating data across different tools and languages, and it's a popular way of formatting information on the Web (since all browsers run JavaScript). In practical terms, JSON allows you to transfer data across the Web in a way that's language-agnostic and easy to work with.

This project will focus on how JSON data is structured, where to get it, how to get it, and finally, how to use it in Processing. The weather dashboard you'll build is just a starting point; I want you to focus on learning how to capture JSON data, parse it, and display it in Processing. Once you've created the basic weather dashboard, I encourage you to apply the skills you've learned in previous projects to make it more visually pleasing.

WHAT DOES JSON DATA LOOK LIKE?

JSON data often comes in the form of a *JSON object*, a collection of data that assigns *keys* to various *values* in the form of *pairs*. These key-value pairs are separated by commas and placed inside a set of braces to form the JSON object. Here's a simplified example of a JSON object:

```
{
❶"First Name": ❷"Derek" ,
   "Last Name": "Runberg",
   "Height": 6,
   "Eye": "Brown",
❸  "Age": 30,
   "Author": true,
❹  "Job":
   {
      "Company": "SparkFun",
      "Position": "Regional Education Developer",
      "Years": 2
   }
}
```

Between the two bounding braces, this object has five data pairs (also called *properties*). Each piece of data is labeled with a string (the key) ❶ and has a value assigned to it ❷. The key is separated

from its associated value by a colon. If you want to find a specific value in an object, all you have to know is the key that the value is assigned to. If you're looking for a person's age in a JSON object like this one, for example, just ask your JSON parsing tool to look up the Age key ❸, and it will return the value associated with Age. In this example, it would return 30.

One cool aspect of JSON data is that a property's assigned value could be an entire JSON object, in which case the value is known as a *nested* object. In this example, the data about my job with SparkFun ❹ is an object nested within the object describing me. Nesting becomes really useful when a single value isn't convenient for describing all aspects of a key. Just imagine the string value for "Job" without nesting!

But most JSON data doesn't start out as neat as the object I just showed. For example, at SparkFun, we share data in JSON format on all the products we carry. Open a browser window and go to *https://www.sparkfun.com/SIK/*. This will bring up the page for our SparkFun Inventor's Kit, as seen in Figure 12-1.

To view the product information in JSON format, click the two braces in the upper-right corner. The output may look scary at first, as you can see in Figure 12-2.

FIGURE 12-2:

The mess of unformatted JSON data

I've shown only part of the JSON output, but if you read the text carefully, you'll see that despite the clutter, the data still follows the same syntax as on page 210, complete with bounding braces, comma-separated pairs, and so on. This is the way your computer reads JSON data, because unlike us, computers don't need information to be neatly organized visually in order to understand it.

Fortunately, you can reformat this data for human consumption with a free tool called JSONLint. Just copy the URL for the JSON data you want to format, go to *http://jsonlint.com/*, paste the copied URL into the JSONLint text box, and click **Validate**. JSONLint will reformat the output as seen in Figure 12-3. Pretty cool!

FIGURE 12-3:
JSON data formatted
by JSONLint for human
consumption

Spend some time exploring the formatted JSON data from the Inventor's Kit page, and you'll notice that at SparkFun, we keep a lot of data on each product, from its product number (SKU) to its weight, price, and whether it's open source. As people purchase items or we restock, our backend computer system for *http://www.sparkfun.com/* updates this JSON file.

Scroll toward the bottom of the JSON file you just formatted and look for a subtle difference in some of the data, specifically in the `"images"` property. This and some other properties in the Inventor Kit's JSON data don't use braces; instead, they use square brackets, []. This structure is a JSON array, which you'll explore now.

ARRAYS OF JSON OBJECTS

A *JSON array* is like any other array in that it's an ordered grouping of data. For instance, if I were to extend my first example to include

data for multiple people, I'd put them in a JSON array that would look something like this:

```
[
  "me":
  {
    "First Name": "Derek",
    "Last Name": "Runberg",
    "Height": 6,
    "Eye": "Brown",
    "Age": 30
  },
  "wife":
  {
    "First Name": "Zondra",
    "Last Name": "Runberg",
    "Height": 5,
    "Eye": "Blue",
    "Age": 30
  },
  "son1":
  {
    "First Name": "Bear",
    "Last Name": "Runberg",
    "Height": 3.5,
    "Eye": "Brown",
    "Age": 5
  },
  "son2":
  {
    "First Name": "Bridge",
    "Last Name": "Runberg",
    "Height": 3,
    "Eye": "Blue",
    "Age": 2
  }
  "pet": false,
  "cars": 2
]
```

Essentially, an array is a group of comma-separated objects inside a set of square brackets. In this case, the array is my family, and each object in the array is a member of my family. The array is not named because it is the top level of organization, so it should inherit the name of the JSON file as a whole. If an array or object is named, you can assume that it is part of a larger data set, like the arrays you saw in Figure 12-3.

All JSON arrays follow this basic structure:

```
[
  "Object1":
  {
    "Object1 name": "Object value",
    "Object1 name": "Object value"
  },
  "Object2":
  {
    "Object2 name": "Object value",
    "Object2 name": "Object value"
  },
  "Object3": value
]
```

The same rule about nesting holds true for arrays as it does objects: you can nest arrays within other arrays or within objects. You can also have individual ordered pairs within an array.

Now that you've seen how JSON looks and how the data is structured, your next project is where the rubber meets the road: you are going to use JSON to build a local weather dashboard in Processing. Are you ready to get some data?

GETTING WEATHER DATA IN JSON

Using JSON data in Processing is actually pretty simple, and you've already used most of the concepts necessary to work with it by now. The hard part is knowing what data you're looking for, where to get it, and how to parse it appropriately. JSON may be a standard for conveying data, but there's no standard for labeling or arranging that data in the JSON itself.

In your weather application, you will collect JSON data from a database called *openweathermap.org*. OpenWeatherMap has a great API and structures its JSON data consistently, which is a plus for you. That means that if you finish this project and want to change the city that you fetch OpenWeatherMap JSON data for, the data should just change in Processing, without breaking your code. Take a look at the JSON data provided by OpenWeatherMap now.

Go to *http://www.openweathermap.org/*, click the **API** menu option, and select the Current Weather Data page. This page has a number of different options for retrieving weather data. You want to get

NOTE

JSON doesn't have any hard-and-fast rules for what is right and wrong in terms of hierarchy or order. But remember, JSON should simplify data for machines and humans alike. If your JSON object doesn't do that, then you may need to restructure it.

JSON weather data for your town, so find the "By City Name" section and copy the JSON hyperlink; it should look something like this:

http://api.openweathermap.org/data/2.5/weather?q=London,uk

To view the JSON weather data for your city, simply paste this text into your URL bar and change the query portion of the URL (the part after the *?q=*) from *London,uk* to your own city and state. For example, the URL for my home in Niwot, Colorado, would be:

http://api.openweathermap.org/data/2.5/weather?q=Niwot,CO

This URL returns a bunch of JSON data in the same hard-to-read format you saw on the Inventor's Kit web page in Figure 12-2, but you can run it through a tool like JSONLint to make the output a little nicer. Here's an example of neatly formatted weather data for Niwot, Colorado:

```
    {
❶    "coord":
    {
      "lon": -105.17,
      "lat": 40.1
    },
❷    "sys":
    {
      "message": 0.1849,
      "country": "United States of America",
      "sunrise": 1419862942,
      "sunset": 1419896626
    },
❸    "weather":
    [
      {
        "id": 803,
        "main": "Clouds",
        "description": "broken clouds",
        "icon": "04d"
      }
    ],
    "base": "cmc stations",
❹    "main":
    {
      "temp": 259.619,
      "temp_min": 259.619,
      "temp_max": 259.619,
      "pressure": 742.33,
      "sea_level": 1042.44,
```

```
      "grnd_level": 742.33,
      humidity": 66
    },
❺    "wind":
    {
      "speed": 1.41,
      "deg": 95.0029
    },
❻    "clouds":
    {
      "all": 64
    },
    "dt": 1419882623,
    "id": 5580305,
    "name": "Niwot",
    "cod": 200
}
```

Wow, that's a lot of data! But you can break it down a bit and focus just on the parts you really need. Luckily, the data is already grouped into a number of smaller JSON objects, so you can use those to navigate through the information and see if it contains what you're looking for.

The first JSON object is assigned to the `"coord"` label ❶ and contains the GPS coordinates (longitude and latitude) of the city you queried for. This data is really useful if you are looking to integrate it into a map or compare it with another location.

The second JSON object is under the `"sys"` property (short for *system*) ❷. It contains a system message (which you won't use; it's meant as feedback for other tools), the location's country code, and the sunrise and sunset times in Unix UTC (Coordinated Universal Time) format.

Next is a JSON array with a single weather condition object, `"weather"` ❸. The first item in the object is the weather condition's ID number, which you can look up in the table found at *http://openweathermap.org/weather-conditions/*. But the values you'll be using are in the `"main"`, `"description"`, and `"icon"` properties. You'll use `"main"` and `"description"` to display the weather conditions in text format. The `"main"` property is a general condition like `"Clouds"`, while `"description"` includes more detailed information about, say, how cloudy it is (in this example, `"broken clouds"`). You'll use the reference code in `"icon"` to display the appropriate icon for the current weather condition in your application later.

NOTE

You will display the GPS coordinates in your dashboard application, but I highly recommend the Unfolding *library for Processing if you ever plan on working with maps, as it provides a quick and easy way to integrate maps and geolocation into your sketches.*

Finally, the last three objects contain detailed weather measurements that will make up the bulk of the data you'll use for your app. The "main" JSON object ❹ houses the temperature, humidity, and pressure values from the weather station. It also includes pressure readings at sea level and at the station's elevation (or "grnd_level") for comparison purposes.

The temperature measurements are in Kelvin by default, but you can convert them to Fahrenheit by appending *&units=imperial* to your JSON URL, like so:

http://api.openweathermap.org/data/2.5/weather?q=Niwot,CO&units=imperial

Alternatively, you can append *&units=metric* to get the temperature in Celsius instead.

The next two JSON objects are smaller, and contain data for cloud coverage and precipitation. The "wind" object ❺ gives the direction (in degrees) and speed (in meters per second) of the wind, while "clouds" ❻ reflects the cloud coverage percentage.

As you can see, once you learn how to read it, JSON is a really clean and simple way to arrange data for others to use, especially if you're not sure how they're going to use it. Now you can pull all that data into Processing!

USING JSON DATA IN PROCESSING

If you haven't done so already, open a new Processing IDE window. You are going to start by parsing the JSON data to get the weather station's GPS coordinates. Luckily, Processing has its own JSONObject class to make working with JSON data easy. Here's how you can use it:

```
JSONObject json;

void setup()
{
❶  json = loadJSONObject("http://api.openweathermap.org/data/ ↵
    2.5/weather?q=Niwot,CO");

❷  JSONObject coord = json.getJSONObject("coord");
❸  float lon = coord.getFloat("lon");
    float lat = coord.getFloat("lat");

❹  println(lon + "," + lat);
}
```

First, define a variable called `json` to store the `JSONObject` in, and use a setup with simple test code to ensure you're accessing the JSON data correctly. In the `setup()` function, use the `loadJSONObject()` function ❶ to fetch the raw JSON weather data from the OpenWeatherMap URL (making sure to pass the URL as a string in double quotes), and then save it to the `json` variable as a `JSONObject`.

Remember that the weather data comes as several smaller JSON objects wrapped inside a larger one. That outer object is what I saved in the `json` variable, but you still need to reach those smaller inner objects to get the data you want. In this case, you're looking for the weather station's GPS coordinates, which you know are stored inside a smaller object under the `"coord"` key.

Since the value of `"coord"` is a JSON object, use another `JSONObject` variable (named `coord`) to store it ❷. Then extract the object by calling `json.getJSONObject()` with the name of the item you're looking for (`"coord"`); this tells the `json` object that you want it to retrieve the value for that key, and return it to you as a `JSONObject`.

Using the `JSONObject` class is helpful, because you can take advantage of its various *getter* functions to fetch the values you need in their respective data types. In this case, GPS coordinates have decimal points, so parse them as floats using `coord.getFloat()` ❸ and store the results in `lon` and `lat`.

Finally, print out the two coordinate variables to check the data ❹. There is no `draw()` loop, because you only want to print these values once as a diagnostic. When you click Run, Processing should print the GPS coordinates of the weather station in the console. It may take a few seconds for Processing to access the URL and parse the JSON data, but eventually you should see the longitude and latitude of your weather data printed out in the console, as shown in Figure 12-4.

Success! You just used data from the Web in Processing. Your output may vary depending on the location you use, but you can always double-check your output against the raw JSON data. Just visit your location's OpenWeatherMap URL as described in "Getting Weather Data in JSON" on page 215, and look at the `"lon"` and `"lat"` values inside `"coord"`.

FIGURE 12-4:

The output of your

JSON object in the

console

```
JSONObject json;

void setup()
{
  json = loadJSONObject("http://api.openweathermap.org/data/2.5/weath

  JSONObject coord = json.getJSONObject("coord");
  float lon = coord.getFloat("lon");
  float lat = coord.getFloat("lat");

  println(lon + "," + lat);
}
```

Done Saving.

-105.33,40.07

13

WRITING A CUSTOM DATA PARSING FUNCTION

Your weather dashboard will keep track of a number of objects, and your initial reaction may be to instantiate all your objects in the setup() function. The problem with creating objects there is that setup() runs only once, so while you'd create all your objects successfully, they would never get updated with newer weather data. In other words, the JSON from the URL would be loaded only once, and updates require revisiting the URL for new data constantly.

You could load the JSON data in your draw() loop, but then you'd be cluttering it with several lines of nondrawing code. What you need is a custom function!

Starting a New Function Tab

You can put all your JSON code in a custom function, and separate it into its own tab in your Processing editor. This simplifies your update code down to a single function that you'll only need to call once from your draw() loop.

To create a new tab, click the small circle with a down arrow next to your current sketch tab's name. From the drop-down menu that opens, select **New Tab**. You will be prompted to name the tab in the alert bar at the bottom, as in Figure 12-5 (top). Name it *update_data*.

(You cannot have spaces in Processing sketch names, so the under-score is a placeholder.)

FIGURE 12-5:

Creating a second tab called *update_data*. The Name text box should appear above your console.

Once you accept the name, you should have a second tab at the top of your IDE window called *update_data*, like the one in Figure 12-5 (bottom).

Tabs help you organize functions and keep your code neat, and you can treat them like separate pages of your sketch. They're still part of your sketch, though, so they shouldn't have setup() functions or draw() loops. For example, as your sketch gets longer, you may place your setup() function on one tab, your draw() loop on another, and a number of custom functions on yet more tabs. It's up to you.

I suggest keeping setup() and draw() on the main tab and sep-arating custom functions into their own tabs with any global variables they need. Keeping the global variables in the tab of the function that needs them will make your code easier to use in other projects.

Save the sketch with your main tab and update_data tab now, and open your sketch folder. There should actually be two differ-ent *.pde* files because Processing creates a new sketch file for each tab. This makes your Processing code modular: just copy the *update_data.pde* file and paste it into another sketch folder to reuse it!

In the update_data tab, you'll write a custom function that updates the JSON data for the sketch. Essentially all of your JSON programming will go in this tab.

Listing Data Variables

Now that you have a new function tab, create a list of variables to store your JSON data in once you've parsed it. This list helps you do two important things: it makes those variables global so that all functions can access them, and it ensures that you have the correct data type for the data you are parsing. Listing the variables you need is always a good idea when importing data from anywhere outside of Processing.

Create a list of weather variables at the top of your update_data tab, as shown in Listing 12-1. This way, they'll be global so that your main tab can access them, but they'll be transported with your function if you use it somewhere else.

LISTING 12-1:

Global weather variables in the update_data tab

```
//coord variables
float lon;
float lat;

//system variables
int sunR;
int sunS;

//main weather variables
float temp;
float pressure;
int humidity;

//wind variables
float windS;
float windD;

//cloud variable
int cloud;

//weather variables
int ID;
String condition;
String description;
String icon;
PImage weatherIcon;
```

NOTE

It's good practice to create your own variable list and decipher the JSON data you want to use before you start parsing that data. I gave you the list of variables this time, but when you use JSON on your own, always start with the variable list!

Compare this variable list to the JSON data on page 216, and you'll see that I tried to label my variables as close to the names of the JSON data pairs as possible.

Writing a Basic Custom Function in update_data

Now in the update_data tab, start writing your function, using the following syntax:

```
void update_data()
{
  println("Function works!");
}
```

First, specify the data type you want the function to return (in this case void, because you don't need to return anything after performing a JSON update). Then, type the function name (update_data), followed by parentheses and a set of braces to put your code in. To keep your code modular, it's good practice to name the custom function after your tab, if it is the only function within that tab.

For now, inside the braces, write a simple println() statement so you can test the function in the main tab. Go back to your main tab, and create a setup() function. Inside setup(), call your custom function:

```
void setup()
{
  update_data();
}
```

Run your sketch. If everything is correct, you should see the "Function works!" message in your console once.

Calling your update_data() function is the same as running the code inside it. This may not seem like a big deal now, but you'll make it more useful. Back in your update_data tab, create a JSONObject named json at the very top of the page:

```
JSONObject json;
```

Instantiate json inside the update_data() function so it re-instantiates with updated data every time you call the function.

```
void update_data()
{
  json = loadJSONObject("http://api.openweathermap.org/ ↵
data/2.5/weather?q=Boulder,CO&units=imperial");
  print(json);
}
```

Pass the loadJSONObject() object your location's weather data URL, and set json to that result. To double-check that Processing is getting the JSON data smoothly, change the println() statement in update_data() to print(json). Run your sketch, and if everything goes as planned, the entire JSON stream should print in your console window, as shown in Figure 12-6.

FIGURE 12-6:

JSON data printed in
the console

```
{
  "id": 5574999,
  "dt": 1433433321,
  "clouds": {"all": 0},
  "coord": {
    "lon": -105.33,
    "lat": 40.07
  },
  "wind": {
    "speed": 1.21,
    "deg": 149.502
  },
  "cod": 200,
  "sys": {
    "message": 0.68,
    "sunset": 1433471190,
    "sunrise": 1433417578,
    "country": "United States of America"
  },
  "name": "",
  "base": "stations",
  "weather": [{
    "id": 800,
    "icon": "01d",
    "description": "Sky is Clear",
    "main": "Clear"
  }],
  "main": {
    "humidity": 54,
    "pressure": 749.67,
    "temp_max": 288.754,
    "sea_level": 1023.18,
    "temp_min": 288.754,
    "temp": 288.754,
    "grnd_level": 749.67
  }
}
```

Parsing Your Weather Data in a Custom Function

Now you'll parse that data so you can actually use it! Recall from
the GPS coordinate example that Processing has a convenient
JSONObject class that allows you to break down and access any
part of a JSON object and parse its data into your variables. The
example JSON is formatted as a list of JSON objects and a JSON
array, so change your update_data() function as follows to parse it:

```
JSONObject json;

void update_data()
{
  json = loadJSONObject("http://api.openweathermap.org/ ↵
data/2.5/weather?q=Niwot,CO&units=imperial");
  print(json);

❶ JSONObject coord = json.getJSONObject("coord");
  lon = coord.getFloat("lon");
  lat = coord.getFloat("lat");
```

```
JSONObject sys = json.getJSONObject("sys");
sunR = sys.getInt("sunrise");
sunS = sys.getInt("sunset");

JSONObject main = json.getJSONObject("main");
temp = main.getFloat("temp");
pressure = main.getFloat("pressure");
humidity = main.getInt("humidity");

JSONObject wind = json.getJSONObject("wind");
windS = wind.getFloat("speed");
windD = wind.getFloat("deg");

JSONObject clouds = json.getJSONObject("clouds");
cloud = clouds.getInt("all");

❷  JSONArray weather = json.getJSONArray("weather");
JSONObject mainCond = weather.getJSONObject(0);
ID = mainCond.getInt("id");
condition = mainCond.getString("main");
description = mainCond.getString("description");
icon = mainCond.getString("icon");

weatherIcon = loadImage("http://openweathermap.org/img/w/" ↵
+ icon + ".png");
}
```

To capture data from JSON, you need to create a `JSONObject` class object for each JSON object in the JSON file. Working your way down the file, the first object you reach is the `"coord"` object that holds the GPS coordinates of the weather station. To access the `"coord"` JSON object, you have to create another class object for coord and instantiate it as `json.getJSONObject("coord")`. From there you can initialize your lon and lat variables using the `getFloat()` function within the class object of coord as shown at ❶.

To capture the paired data, you pass the `getFloat()` function the name of the pair as a string. So `coord.getFloat("lon")` returns the longitude value that you'll use to set the lon variable in your Processing sketch. The process is similar for all of the other JSON objects in the file, and the getter function changes according to the data type. Continue in the same manner for the next four JSON objects, and parse only the data that you need.

The last piece to the JSON puzzle is the JSON array in the file. Parsing the array follows roughly the same pattern as parsing an object, but with an extra step. Recall that any array is an ordered list

numbered from 0; that is, the first item in the array is element 0, the second item is 1, and so on. A JSON array is no different.

First create an array object called `weather`, and instantiate it with `json.getJSONArray("weather")` ❷, which looks up the value of `"weather"` in the raw JSON object, and returns a `JSONArray` object you can use. From there, you can parse the objects in the array. There is only one object in this array, so you'd work only with element 0. You create a `JSONObject` class object called `mainCond` and instantiate it as `weather.getJSONObject(0)`. You pass 0 instead of a string because you are parsing the object's position in the array, not the object itself. From there, parse the four variables you are looking for. Notice that the last three variables are strings and are required to use the `getString()` functions.

If you read through each section of this code, you can see that it follows the same pattern as the GPS coordinate example in "Using JSON Data in Processing" on page 218. You create a `JSONObject` variable, initialize it with the JSON object you are going to parse, and then parse it for the values you want below that. During this process, I suggest having the JSON file open (as in Figure 12-7) so you can reference names of objects and data types without having to play a guessing game. This step is case sensitive, so check your spelling!

FIGURE 12-7:

Refer to the JSON file you're working with when trying to parse it.

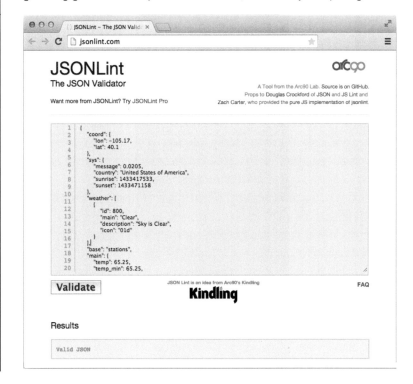

To test your new code, go back to your main tab and `println()` any of the variables you have parsed data to. A value matching the JSON data should appear in the console.

DRAWING THE WEATHER DASHBOARD IN THE MAIN TAB

Now that you have your data, you can build your weather dashboard. Go back to your main tab and update your current code as follows:

```
void setup()
{
  size(400,500);
  update_data();
}
```

First, flesh out the setup code and set the dashboard window to a reasonable size of 400×500. Then, call your `update_data()` function to make sure your sketch can access the JSON file on the Web. You will move it to your `draw()` loop later, but calling it once in `setup()` now lets you test your code and see any data errors only once.

Now it's time to show the dashboard in the `draw()` loop!

```
void draw()
{
  background(150);
  textSize(20);
  fill(0);
  text("GPS Location: " + lat + " , " + lon,50,100);
  text("Sunrise: " + sunR,50,125);
  text("Sunset: " + sunS,50,150);
  text("Temperature: " + temp,50,175);
  text("Atmospheric Pressure: " + pressure,50,200);
  text("Humidity: " + humidity + "%",50,225);
  text("Wind Speed: " + windS + "mps",50,250);
  text("Wind Direction: " + windD,50,275);
  text("Cloud Coverage: " + cloud + "%",50,300);
  text("Conditions: " + condition + " , " + description,50,325);
}
```

Set the background color of the sketch, and then use the `text()` function to display all the weather stats you want, starting with the GPS location and moving down the variable list. Here, I concatenated labels and units of measurement wherever they made sense for the values, but you can make your text say anything you like.

Once you get this code into your `draw()` loop, run your sketch. You should get something that looks similar to Figure 12-8, but with different data (assuming you didn't use Niwot, Colorado, as your location).

Awesome! You took JSON data from the Web and translated it into something useful and human-friendly. If you leave this running for a while, you'll notice that it doesn't update at all. That is because your `update_data()` function call is still in `setup()`, which collects the JSON file only once at the beginning of your sketch. But you can't just drop it into your `draw()` loop yet; right now, you'd call the JSON URL 60 times a second! This would cause OpenWeatherMap to block your Processing sketch from accessing its JSON data after about 15 seconds or so, because it would think you were spamming the site.

To solve this problem, create an `if()` statement that runs the `update_data()` function every 15 minutes and place it at the end of the `draw()` loop:

```
if((minute()%15 == 0) && (second() == 1))
{
  update_data();
}
```

This should keep the sketch from bombarding OpenWeatherMap with JSON requests. I also suggest adding the `frameRate()` function to the `setup()` and passing it 1 so that it runs the `draw()` loop only

once per second to reduce the number of calls even further during that second when the if() statement is true.

PULLING A WEATHER ICON FROM THE WEB

Now for the icing on the cake for this project: a little weather icon! Every weather application has one, so why not yours?

If you scroll up through your global variables, you will notice that you capture a string called "icon". That string is the icon code for the current weather at your location. You can access this icon from OpenWeatherMap using a URL call specific to that icon. Figure 12-9 shows an example icon.

FIGURE 12-9:

A sample weather icon

Ask Processing to load an image file from a URL, and save it to a variable so you can use it in your sketch as you did with the JSON data. Just like including any other image file in Processing, the first step is to create a PImage variable to use it with. Fortunately, you've done that already if you created the global variables in "Listing Data Variables" on page 221; there should be a weatherIcon object at the end of your list in the update_data tab. You should also have already instantiated the weatherIcon object, in Listing 12-1. Make sure your update_data() function contains the following line:

```
PImage weatherIcon = loadImage("http://openweathermap.org/ ↵
img/w/" + icon + ".png");
```

Then, head back to your main tab and add a simple call to image() near the end of the draw() loop with your shiny new weather icon. Here are my final setup() and draw() loops for the dashboard:

```
void setup()
{
  size(400,500);
  update_data();

  frameRate(1);
}
```

```
void draw()
{
  background(150);
  textSize(20);
  fill(0);
  text("GPS Location: " + lat + " , " + lon,100,100);
  text("Sunrise: " + sunR,100,125);
  text("Sunset: " + sunS,100,150);
  text("Temperature: " + temp,100,175);
  text("Atmospheric Pressure: " + pressure,100,200);
  text("Humidity: " + humidity + "%",100,225);
  text("Wind Speed: " + windS+ "mps",100,250);
  text("Wind Direction: " + windD,100,275);
  text("Cloud Coverage: " + cloud + "%",100,300);
  text("Conditions: " + condition + " , " + ↵
description,100,325);
  image(weatherIcon,50,350);

  if((minute()%15 == 0) && (second() == 1))
  {
    update_data();
  }
}
```

Run your sketch with these changes, and now you should see a weather icon at the bottom of your sketch, as in Figure 12-10.

TAKING IT FURTHER

For a cherry on top, make your dashboard a little more visually appealing by adding a photo of the location of the weather conditions. In my case, that's SparkFun headquarters. Luckily, there's no shortage of photos of this building!

In my main tab, I added an image to my project and loaded it into the sketch, just like you did in Chapter 6. I created an image object using the `PImage` data type, used `loadImage()` in the `setup()` function to load the image to the object, and then used the `image()` function to display it in my `draw()` loop. I don't show the code for this mod because I want you to try it on your own, but you can see my final dashboard in Figure 12-11.

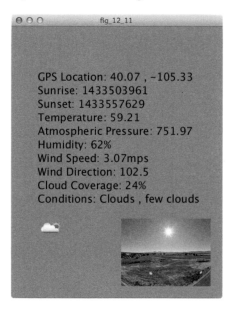

FIGURE 12-11:

Final weather dashboard, including an image of my location

My dashboard may seem a little stark and gray, but that bright, sunny picture certainly communicates the weather outside!

Even without this final touch, you've taken data from the Web and built something amazing. Try extending the project by adding visual readouts in bar graph form. You could even draw a little thermometer that changes with the data updates.

When you're done exploring this weather data, look for other data in JSON format and create more Processing sketches to visualize it. A great place to start is *http://www.data.gov/*, which is a repository for open government data that anyone can use. There are a number of different data formats there, but JSON is pretty popular. Now, go forth and do something big with big data!

13

USING SENSORS WITH PROCESSING AND ARDUINO

YOU'VE EXPLORED KEYBOARD, MOUSE, AND WEBCAM INPUTS IN PROCESSING, AND BUILT A CUSTOM GAME CONTROLLER WITH A MAKEY MAKEY. BUT WHAT IF YOU WANT TO CREATE SOMETHING THAT RESPONDS TO LESS-CONVENTIONAL INPUTS? WITH A LITTLE HELP FROM AN ARDUINO, YOU CAN MONITOR TEMPERATURE, AMBIENT LIGHT, AND MORE WITH PROCESSING.

This chapter focuses on using Processing's Serial communication library to bring data from the world around you into your sketches. The Serial protocol sends data 1 bit at a time, allowing devices to communicate simply and efficiently.

In this chapter, you'll read sensor values for temperature, sound, and light with an Arduino and visualize those values in Processing. In "Taking It Further" on page 261, I'll also walk you through sending data to the microcontroller from Processing to control the color of a red/green/blue (RGB) LED.

GATHER YOUR MATERIALS

In this project, you'll need the following materials:

- One mini USB cable (CAB-11301)
- One SparkFun Digital Sandbox (DEV-12651)

WHAT IS A MICROCONTROLLER?

A *microcontroller* (like the one in Figure 13-1) is similar to the central processing unit (CPU) on your computer, but it operates much slower and can do only one process at a time. A microcontroller can run code, but unlike your multitasking CPU, it just runs a single program over and over until you reprogram it.

Microcontrollers control many of the electronics in your car, your kitchen, and even your alarm clock. You can program these chips to read temperatures, turn motors and lights on and off, and even communicate with other devices! These controllers are in a number of maker projects, from automated lawnmowers and DIY drones to cube satellites and interactive art installations.

FIGURE 13-1:

An ATMEGA328 microcontroller

Microcontrollers have *pins* (tiny metal legs) that you can use to read data from sensors and transmit data to control hardware. But without a circuit, a microcontroller is just a bit of plastic and metal. To have Processing communicate with a microcontroller, we'll use a development platform called Arduino.

WHAT IS ARDUINO?

Arduino is an electronics platform that uses Atmel microcontrollers to make hardware and software easy to use together. Arduino, like Processing, is open source, so there have been a number of copies, mashups, and other boards based on the platform. For example, the RedBoard in Figure 13-2 is SparkFun's major Arduino-compatible board.

FIGURE 13-2:
The SparkFun RedBoard (left) and an Arduino Uno (right)

This chapter will scratch the surface of Arduino and show you how to use it with Processing. My goal is to give you just enough knowledge to make you dangerous. That means there will be some hand waving. If you want more detailed tutorials, I recommend SparkFun's Digital Sandbox tutorial (*https://learn.sparkfun.com/tutorials/digital-sandbox-arduino-companion/*) and the SparkFun Inventor's Kit experiment guide (*https://learn.sparkfun.com/tutorials/sik-experiment-guide-for-arduino---v32*).

THE SPARKFUN DIGITAL SANDBOX

In addition to the RedBoard, SparkFun also develops other boards that you can program with Arduino software, like the Digital Sandbox in Figure 13-3.

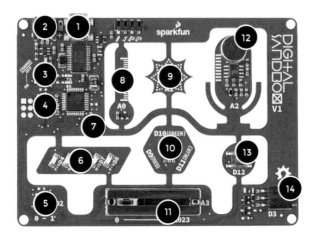

1. **USB Mini-B Connector:** Used to connect to a computer.

2. **JST Right-Angle Connector:** Used to supply power to the board.

3. **Slide Switch for Charging:** Used to charge a lithium polymer battery that is plugged in to the two-pin JST connector, while the Digital Sandbox is connected to a computer and the slide switch is in the "on" position.

4. **Reset Button:** This is a way to manually reset your Digital Sandbox, which will restart your code from the beginning.

5. **Slide Switch (Pin 2):** "On" or "off" slide switch.

6. **LEDs (Pins 4-8):** Use one or all of the LEDs (light-emitting diodes) to light up your project!

7. **LED (Pin 13):** Incorporate this into your sketch to show whether your program is running properly.

8. **Temperature Sensor (Pin A0):** Measures ambient temperature.

9. **Light Sensor (Pin A1):** Measures the amount of light hitting the sensor.

10. **RGB LED (Pins 9-11):** RGB (red/green/blue) LEDs have three different color-emitting diodes that can be combined to create many colors.

11. **Slide Potentiometer (Pin A3):** Change the values by sliding it back and forth.

12. **Microphone (Pin A2):** Measures how loud something is.

13. **Push Button (Pin 12):** A button is a digital input. It can be either "on" or "off."

14. **Add-on Header (Pin 3):** Three-pin header for add-ons. Example add-ons are servos, motors, and buzzers.

The Digital Sandbox is an Arduino with a bunch of inputs and outputs built into the board, so you can focus on programming over building circuits. In essence, the Digital Sandbox is designed to be a training board for Arduino, so the labels A0 through A3 and D2

through D13 on the Digital Sandbox correspond to pin names you'd see on a standard Arduino. These labels also correspond to the pin names in the Arduino programming language.

For simplicity, and to keep you focused on Processing, we'll use the Digital Sandbox to build this chapter's project. I recommend using the Digital Sandbox in future Processing-to-Arduino explorations, too, as it allows you to get up and going quickly without spending a lot of time wiring.

NOTE

If you own an Arduino and the parts to build the circuits for this chapter, you could use those instead of buying a Digital Sandbox. You'll find a wiring diagram for a standard Arduino and breadboard in the DigitalSandbox_on_bb.jpg file of the online resources at https://nostarch.com/sparkfunprocessing/*. The programming is all the same as what I describe in this project.*

INSTALLING THE ARDUINO SOFTWARE

Like Processing, Arduino's *integrated development environment (IDE)* is free to download. You'll use that software to program the hardware. Go to *https://arduino.cc/download/* and download the latest stable version of the Arduino IDE for your operating system. If you get stuck at any point, check out the "Installation Resources" on page 240 and read the official Arduino installation guide for your system for more detailed instructions.

Installing Arduino and Drivers on Windows

If you're running Windows, download the Windows installer package, which should include the required drivers for Arduino and prompt you to install them.

Once it's downloaded, open the installer executable. You will be greeted with a pretty standard license agreement. Select **Agree** (assuming you do), and a dialog will appear with installation options, as shown in Figure 13-4.

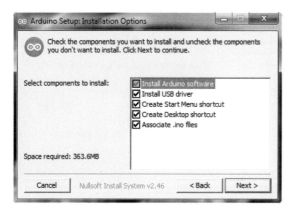

FIGURE 13-4:

Arduino installation options

Select the options **Install Arduino software** and **Install USB driver**. The others are up to you, though I do suggest selecting the Associate *.ino* files box for ease of opening files later.

Once you make your selections, click **Next**. The installer will ask where you'd like to install it; you can leave this at its default. Click **Next** to begin the install process.

Once the install finishes, click **Complete**. Select that Arduino is trusted, and install the drivers. With that, your Windows machine should be ready to go with Arduino and the drivers installed.

Installing Arduino and FTDI Drivers on OS X

If you're an Apple user, download the OS X installer package from the Arduino website. When you open the downloaded folder, the Arduino app should be the only file it contains. Drag the app to your *Applications* folder to install Arduino. After that, there's just one more step: downloading *Future Technology Devices International (FTDI)* drivers for the Digital Sandbox and any other Arduino that uses FTDI.

NOTE

FTDI chips translate the USB communication protocol to serial, and vice versa.

Go to FTDI's drivers page at *http://www.ftdichip.com/Drivers/ VCP.htm* (make sure you include the "chip" portion of the URL or you'll end up buying flowers!) and find the correct download for your OS X system. Depending on your system, click the OS X link for 32-bit, 64-bit, or PPC (Power PC) to download the *.dmg* file.

Double-click the *.dmg* file, and you'll see a single install package called *FTDIUSBSerial.pkg*. The directory will look like Figure 13-5. Double-click that option to start the driver installation process. Accept the license agreement and click **Continue** to finish.

FIGURE 13-5:

FTDI installation on Mac OS X

Installing Arduino on Ubuntu Linux

There are too many Linux distributions to cover all of them here, but I'll walk you through the basic install on Ubuntu 14.04. To install Arduino, navigate to the download page of the *http://www.arduino.cc/* site and download the appropriate version; for most modern Ubuntu systems, you'll probably want the Linux 64-bit version. Then, navigate to your *downloads* directory (or wherever you might have saved the file), right-click the compressed package shown in Figure 13-6, and select **Extract Here**.

FIGURE 13-6:
Arduino IDE download package

Once you've extracted the package, double-click the Arduino icon to run it. Alternatively, you can download a stable version of Arduino through your package manager interface or through the command line. If you are new to Linux, I highly recommend using the package manager and installing Arduino through the GUI.

You'll also have to install Java and a few other dependencies for Arduino to work properly on Linux. From a command line, enter the following command to install Java and avr-gcc, which is the compiler used for Linux.

```
$ sudo apt-get install openjdk-6-jre avr-libc gcc-avr
```

NOTE

You may also need to add your user to the dialout group before you can actually upload code to the Arduino via USB. If this is the case, you should see a message to that effect when you run the IDE for the first time.

After everything downloads, you'll be asked for permission to install it all. Press Y to agree to the installation. Once Arduino is installed, you can run it from the command line by navigating to its directory and running the Arduino script as follows:

```
$ cd ~/Downloads/arduino-1.6.0/
$ ./Arduino
```

Or to enable a double-click option so you can to run Arduino from the desktop GUI, double-click on the file from your GUI file manager, and select **Edit ▸ Preference** from the drop-down menu. In the dialog that appears, select **Double Click to Open** and **Ask Each Time** from the options. Now, double-click the script file and select **Run** from the pop-up window. The Arduino IDE should launch. If it doesn't, or you're not running Ubuntu, try visiting the Linux link in the "Installation Resources" box for more detailed instructions from the Arduino website.

INTRODUCING THE ARDUINO IDE

Plug your Digital Sandbox into your computer. If you see a notification that your device is being installed, don't fret: your computer is just making sure the correct drivers are installed.

Two LEDs (light emitting diodes) on the Digital Sandbox should be turned on. The power LED should always be on if the board is powered, so it should glow steadily. The LED labeled D13 should be blinking because SparkFun preprogrammed the microcontroller with a simple Arduino program (also called a *sketch*) to test the board. So that blinking LED means you are good to go so far!

Open the Arduino software, and after a splash screen, you will see the IDE in Figure 13-7.

FIGURE 13-7:

The Arduino IDE

The Arduino IDE should look familiar because it's based on Processing, but there are a few differences. The code window and console function similarly to their Processing counterparts. If your sketch has errors, they will pop up in the alert bar ❶ and console ❷. At the top are the Verify ❸ and Upload ❹ buttons (the check mark and right arrow, respectively).

Since Arduino code runs on the Arduino board, you have to upload it to the Sandbox for it to run, so the IDE doesn't offer the same immediate feedback as Processing's Run button. You can, however, *verify* your sketch, which checks to make sure there are no errors in your code without uploading it to the board.

Continuing right from the Verify and Upload buttons, you should also see the New ❺ button for opening a new sketch, Open ❻ for opening an existing sketch, and Save ❼ for saving your current work.

SELECTING YOUR BOARD AND CHOOSING A PORT

NOTE

To figure out if your board is on a particular serial port, unplug it and refresh your list of ports. If the updated list has one unselectable option or a port has disappeared, that is the port for your board.

Since there are so many different Arduino boards, you need to tell the Arduino IDE which one is plugged into your computer. First, click **Tools ▸ Board** to view a list of board types. The Digital Sandbox works like an Arduino Fio board, so select **Fio** from the list.

Next, select **Tools ▸ Port . . .** to specify which communication port the board is on. In Windows, you should see a COM*X* option, where *X* is a port number. If you have multiple COM port options, the Sandbox COM port is usually the highest number in the list. Regardless of your operating system, select your port by clicking on it; when properly selected, the port will have a checkmark or dot next to it in the list, as shown in Figure 13-8.

FIGURE 13-8:

Mac serial port selection

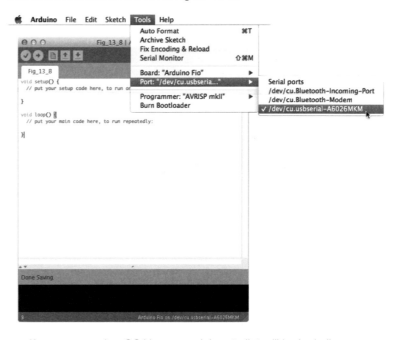

If you are running OS X, your serial ports list will look similar to Figure 13-8, instead of listing COM ports. If the FTDI drivers were installed correctly, you will have an option that reads */dev/tty .usbserial-<XXXXX>*. You can ignore the others in the list; they're your computer's Bluetooth connection and other ports. Linux users will see a similar naming convention for the serial ports on their machines (for example, */dev/ttyUSB0*), since Mac and Linux are both based on Unix and have similar directory structures for things like their serial ports.

With your board and serial port selected, you're ready to code!

AN ARDUINO HELLO WORLD

In this section, you'll program the Digital Sandbox with an Arduino sketch to make sure everything works correctly. Blinking an LED is the hardware version of Hello World, so we'll start there.

Exploring an Arduino Sketch

First, let's explore the basic structure of an Arduino sketch in Listing 13-1.

```
void setup()
{
  // put your setup code here, to run once:
}

void loop()
{
  // put your main code here, to run repeatedly:
}
```

LISTING 13-1:

The bare-bones Arduino sketch

This is the skeleton sketch you see when you open the Arduino IDE. It looks just like a basic Processing sketch, except that instead of `draw()`, there's a `loop()` function that works exactly like `draw()`. You will also notice that in Arduino sketches, the keyword coloring is a little different from Processing, with most key words being a red-orange color—but no need to worry about that too much.

Writing the setup() Function

The `setup()` code for blinking an LED is pretty simple. Open a new Arduino code window now and fill in the `setup()` function as follows:

```
void setup()
{
❶  pinMode(4,OUTPUT);
}
```

First, specify which pin you want to control on the microcontroller and how you are going to use it with the `pinMode()` function ❶. This function takes two parameters as arguments: a pin number, which can range from 0 to 13, and a constant, which should be `INPUT` or `OUTPUT`. Passing `INPUT` tells the Arduino to set up a pin to receive data, and passing `OUTPUT` tells the Arduino that the pin will send data. Here, you tell the Arduino to set pin 4 as an output, because that pin is connected to the LED you want to blink on the Sandbox (in this

case, D4). Any time you want to use a pin, you need to have a pinMode() function for it.

That's all for the setup!

Writing the loop() Function

Now, you'll tackle the loop() function, which is where you'll actually blink your LED. As the second comment in Listing 13-1 states, the Arduino runs this code over and over again, at a speed of millions of lines of code per second. Conceptually, the loop() function for blinking an LED would work something like Figure 13-9.

FIGURE 13-9:

How blinking works behind the scenes

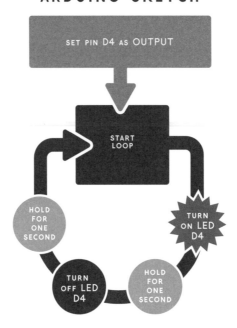

ARDUINO SKETCH

SET PIN D4 AS OUTPUT

START LOOP

TURN ON LED D4

HOLD FOR ONE SECOND

HOLD FOR ONE SECOND

TURN OFF LED D4

You only have to tell the Arduino to blink once inside the loop() function because when it reaches the end, the loop starts over again. Because the loop runs so fast, you also need to tell the microcontroller to wait or delay for a given amount of time, so you can actually see the LED blink.

In the same Arduino code window where you added the setup() function, write the loop() code shown in Listing 13-2 to translate the flow chart into the Arduino language.

LISTING 13-2:

The loop() code for your blinking Arduino sketch

❶

```
void loop()
{
  digitalWrite(4,HIGH); //turn pin 4 on
```

```
❷  delay(1000);          //wait 1,000 milliseconds (1 second)
❸  digitalWrite(4,LOW);   //turn pin 4 off
❹  delay(1000);          //wait 1 second
}
```

The digitalWrite() function ❶ is like a code light switch; it allows you to turn pins on and off. You pass it two parameters: the pin number (0–13, corresponding to D0–D13 on the Arduino) and either HIGH (on) or LOW (off). Here, you turn pin 4 on.

Next, you wait for 1 second using the delay() function ❷, turn pin 4 off ❸, and wait for 1 second again ❹. From there, the sketch loops back up to the top.

Make sure your Digital Sandbox is plugged in to the computer, and click the **Upload** button. The two LEDs labeled TX and RX should blink really fast.

After TX and RX stop blinking, D4 should blink once per second, as shown in Figure 13-10.

NOTE

TX *is short for* transmit, *and* RX *is short for* receive, *and these LEDs light up any time data is passed between the board and the computer. Here, the sketch you just uploaded went from the computer to the Digital Sandbox.*

FIGURE 13-10:
Our best print rendition of D4 blinking

Congratulations on your first Arduino sketch! Before you move on, play around with this sketch a bit. Try replacing pin 4 with other output pin numbers, according to the labels in Figure 13-3 (you'll need to change them in the pinMode() and digitalWrite() functions), and tweak the delay time for faster or slower blinks.

ANALOG VERSUS DIGITAL

Now that you know how to program an Arduino, let's explore the two types of data you can use with the platform. *Digital* data has only two possible values: on and off, which correspond to 0 and 1 or HIGH and LOW, respectively, in a sketch. The power button on pretty much any electronic device is a digital input, and when you turned on LED D4, you sent a digital output from the Arduino.

Analog data, on the other hand, has infinitely many possible values, including on, off, and everything in between. Analog is more like a dimmer switch. See Figure 13-11 for a visualization of the difference between digital and analog data.

FIGURE 13-11:

Comparing digital and analog signals

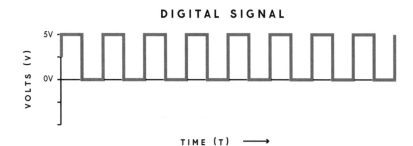

DIGITAL SIGNAL

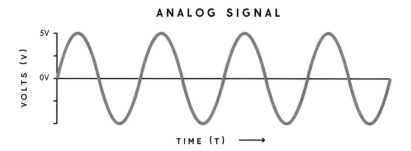

ANALOG SIGNAL

The digital signal is the *square wave*, which has only two possible values; on corresponds to 5V, and off corresponds to 0V. The analog signal is the *sine wave*, which transitions smoothly between all the way on and all the way off.

READING VERSUS WRITING DATA

When you fetch data from a sensor or any other Arduino input, you are *reading* that information. When you send information to a pin, you're *writing* to that pin.

There are four Arduino functions that let you read and write analog and digital data:

analogRead() Reads an analog value of a pin
analogWrite() Writes an analog value to a pin
digitalRead() Reads if a pin is on or off
digitalWrite() Turns a pin on or off

You've seen `digitalWrite()` already: you used it to write HIGH and LOW to pin 4 in Listing 13-2, in order to blink LED D4 on the Digital Sandbox.

In this project, you'll use the `analogRead()` function to read a sensor value and print that value out over the serial port. The first step is making the data available to your computer.

READING DATA FROM SENSORS

Sensors, like the light sensor and microphone on the Digital Sandbox, output analog data, which you can read with the Arduino. But computers can operate only on digital data! Fortunately, you can write Arduino sketches that send analog data values to your computer as digital data, using serial communication.

Try sending some data from the light sensor on the Digital Sandbox. Start a new Arduino sketch, write the following program, and upload it to the Digital Sandbox:

```
void setup()
{
❶  Serial.begin(9600); //start serial communication at 9600 bps
}

void loop()
{
❷  int val = analogRead(A1);   //read the light sensor
❸  Serial.println(val);        //print val over serial
❹  delay(100);                 //wait 100 milliseconds
}
```

This little sketch does a lot of cool magic, so let's unpack it a bit. In the `setup()` function, you start serial communication with `Serial.begin()` ❶. You pass `begin()` the *baud rate*, which is the speed at which the Sandbox will talk to your computer.

In the `loop()` function, you create a local variable called `val` and set it to whatever is read over analog input pin A1 ❷. You then print

val over the serial port using the `Serial.println()` function ❸. Just like in Processing, Arduino's `println()` means that there is a carriage return after Arduino prints the value you pass it. Finally, you use the `delay()` function ❹ to slow the Digital Sandbox down so you can actually read the values when you open the serial port.

Upload this sketch to your Arduino if you haven't done so already; the TX LED should blink really fast to tell you the board is sending data to your laptop. Next, click the magnifying glass icon in the upper-right corner of the Arduino IDE. The window that opens is called the *Serial Monitor*, and it allows you to view data being sent over the serial port from the Digital Sandbox. You will see a stream of numbers flying by, as in Figure 13-12. These values are being read from the light sensor labeled A1 on the Digital Sandbox.

FIGURE 13-12:

The Arduino Serial
Monitor with a single
sensor output

Put your hand over the sensor, and the numbers in the Serial Monitor should decrease. The lowest value you will read is 0 (completely dark) and the highest is 1023 (really bright). As you move your hand away from the sensor, the values should grow again. Pretty cool, huh?

These numbers are being transmitted from the Digital Sandbox to your computer over your USB cable. Now you've successfully transferred information from one small computer (the Digital Sandbox) to a larger computer, but wait: it gets better.

You can send more than one sensor value to your computer at a time because the Arduino can also send a string of *comma-separated values (CSV)* over the serial port. That's important because the more information you can pass to and from Processing, the more control and freedom you have within a project. This capability also allows you to use fewer resources on your computer. Sending one string is much more efficient than sending three separate values, and Processing can easily work with the single string, as you've seen in previous projects.

To send multiple values, just change your existing loop as follows:

```
void loop()
{
  int light = analogRead(A1);    //light sensor
  int sound = analogRead(A2);    //microphone
  int temp = analogRead(A0);     //temp sensor
  Serial.print(light);           //print light over serial
  Serial.print(",");             //add comma
  Serial.print(sound);           //add sound
  Serial.print(",");             //add comma
  Serial.println(temp);          //add temp with carriage return
  delay(100);                    //wait 100 milliseconds
}
```

This version of the loop creates three different variables: `light`, `sound`, and `temp`. These correspond to the three analog sensors you are reading, which are labeled A1, A2, and A0, respectively, on the Digital Sandbox. Next, you print the sensor values over the Serial Monitor with a comma between each pair of values. The final value, `temp`, is printed with `println()` so that each set of data appears on a single line, followed by a carriage return. That way, your trios of sensor data won't run together.

Upload this sketch to your Digital Sandbox and open your Serial Monitor. You should see output similar to Figure 13-13, with sets of three comma-separated values scrolling by.

To change `temp` (the last value in every trio), place your finger on the temperature sensor. Yell, sing, or just make some noise near the microphone to watch the `sound` variable (the second value) change. And of course, if you place your hand over the light sensor, the `light` variable should still change. Save your Arduino sketch now so you don't lose your work, and then head over to Processing.

FIGURE 13-13:

Serial Monitor with
sets of three comma-
separated values

CREATING THE SENSOR DATA DASHBOARD IN PROCESSING

Your sensor dashboard is half complete: you have three sensor values coming from your Digital Sandbox, and you can see them as a long list of numbers flying by. But those numbers probably don't tell you much; you can see changes, but it's hard to picture what they mean.

In this project, you'll build a dashboard to translate the data coming into your computer through serial communication into helpful visualizations, and then you'll log that data into a text file for future analysis in a graphing program such as Microsoft Excel or Google Sheets. The Processing sketch you'll write is a great base for any project that uses serial communication.

Importing Libraries and Creating Variables

First, open a fresh Processing sketch and import the Serial library. This library is native to Processing, so simply click **Sketch ▸ Import Library . . . ▸ Serial**. When you see the `import` line at the top of your sketch, create a class object so you can use functions from the Serial library:

```
import processing.serial.*;

Serial myPort;
```

When you used the Video library, you created a `Movie` object; with the Serial library, you create a `Serial` object. You'll use only a single port for this project, so you can just call it `myPort`.

You'll also need to create three global variables to receive data from the serial port:

```
float temp = 0;
float light = 0;
float sound = 0;
```

Add three variables with the same names and data types as the sensor variables you created in your Arduino sketch. (Using the same names will help you remember which values in Processing match the values from the Arduino.) These need to be global variables so you can use them in both your `draw()` loop and in an event function to collect the serial data.

Initialize each variable to 0. This keeps Processing from generating an error the first time it runs through the sketch, since it won't have a value from the serial port right away.

Preparing Processing for Serial Communication

Next, tackle the `setup()` function of the sketch, starting with picking a sketch window size. To identify the serial port your Digital Sandbox is on, you can list all possible serial ports on your computer, just like you did for your webcam in Project 10. Add the `setup()` function in the following listing to your Processing sketch now:

```
void setup()
{
  size(700,400);

❶  println(Serial.list());
❷  myPort = new Serial(this,Serial.list()[0],9600);

  //generate a new serial event at new line
❸  myPort.bufferUntil('\n');
}
```

To view the serial ports, pass `Serial.list()` to the `println()` function ❶. Next, instantiate your `Serial` object, `myPort` ❷. This creates a new `Serial` object for the port defined by `Serial.list()[n]` (where *n* is the index of the port you want to use) at a baud rate of 9600 bits per second (bps).

Finally, at ❸, specify the *buffer*, which is where Processing stores incoming data from the serial port until you use it. The Serial library's `bufferUntil()` function allows you to set a character that Processing uses as a flag or alert. Processing holds (or "buffers")

data until it receives that character, and on receipt, it triggers a call
to an event function.

Fetching Your Serial Data

Normally, you'd write the draw() loop now, but you should make sure
you can run and receive data from your serial port first. Otherwise,
you'll have no data to create visualizations for! You will insert the
draw() loop between the setup and event functions once you know
you are receiving data.

Create a serialEvent() function and pass it the Serial object
myPort, so the function knows which port to listen on.

```
void serialEvent(Serial myPort)
{

}
```

Like other event functions, serialEvent() just waits patiently
until it's triggered. When it sees data come in over myPort, it starts
capturing the values. Add the following to your event function:

```
void serialEvent(Serial myPort)
{
❶    String inString = myPort.readStringUntil('\n');

❷    if(inString != null)
     {
❸      inString = trim(inString);
❹      float[] vals = float(split(inString,","));

❺      if(vals.length >= 3)
       {
❻        light = map(vals[0],0,1023,0,200);
         sound = map(vals[1],0,1023,0,200);
         temp = map(vals[2],0,1023,0,200);
       }
     }
}
```

Use the readStringUntil() function ❶ to create a string and
store data from the serial port until a newline character ('\n') comes
through. Once Processing stores the data as inString, you can har-
vest the usable data. At ❷, an if() statement checks whether your
sketch received data by comparing inString to null (or nothing).
If inString equals null, then it has no characters. But if there are

characters in `inString`, you tell Processing to `trim()` any whitespace in the data ❸. (Whitespace refers to blank spaces at the beginning and end of a string.)

Now you need to break up `inString` into three pieces of usable data. "Usable" is key: right now, `inString` contains the temperature, light, and sound data you need, but as a bunch of characters, not numbers!

To fix this, first create a float array called `vals` ❹. To get the data from `inString` to `vals`, you have to do a little inception: putting functions inside functions. When Processing sees nested functions like `split()` inside of `float()`, it executes them according to the same order of operations you hated in middle school. The innermost function is performed first, and Processing moves out from there. First, `inString` is split into pieces of data at every comma in the string. Then, those pieces of data are turned into floats and placed in the `vals` array. Figure 13-14 shows the conversion process with an example piece of data.

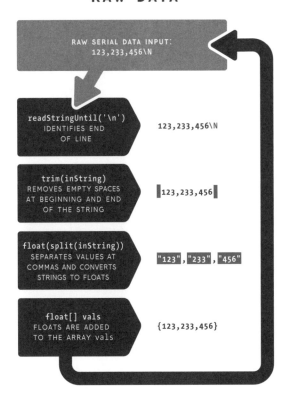

PROCESSING RAW DATA

FIGURE 13-14:

Progression of preparing and parsing a comma-separated string

The last if() statement ❺ in the event function checks to make sure you have the correct number of values from the serial port. If the vals array has a length of at least 3, map the first three values to numbers that you want to use, and assign the mapped values to temp, light, and sound.

For this sketch, you'll get a value from 0 to 1023 from the Digital Sandbox, but your sketch window is set to 700 pixels wide by 400 pixels high. To display the sensor values within that area, you need to scale them down. The map() function allows you to take a variable with an expected minimum and maximum and map its values to a different minimum and maximum. You will be creating a bar graph with a maximum height of 200, hence the scale from 0 to 200 ❻.

Here is the syntax for the map() function:

```
map(x,Fmin,Fmax,Tmin,Tmax);
```

The x argument is the value you need to map, Fmin and Fmax are the original range of values, and Tmin and Tmax are the range you want to map to.

Save your Processing sketch now. That may have looked like a lot of fancy coding, but it's worth it! Just look at what you've done so far. You programmed two different computers—the Digital Sandbox and your computer—to talk to each other. That's pretty cool!

Testing the Serial Connection

You'll perform one final check before taking off to draw your dashboard: is your sensor data actually being received correctly in Processing? To find out, call the println() function in a simple draw() loop. Add the following after your existing setup() function, and before the serialEvent() function:

```
void draw()
{
  println(light + "," + sound + "," + temp);
}
```

Make sure your Digital Sandbox is plugged in to your computer and the TX LED is blinking. Then, click the **Run** button in Processing. Depending on your serial port settings, your sketch may just run, or you may get an error that prevents it from doing so, as shown in Figure 13-15.

FIGURE 13-15:
Processing shows an error if you get the wrong serial port

Whether you get an error or not, in your Processing console there should be a list of all available serial ports. If your sketch runs but your console fills with `0.0,0.0,0.0`, then you've selected a working serial port on your computer, but it may not be connected to the Digital Sandbox. Stop your sketch, click **Run**, wait 1 second, and quickly stop the sketch again. Scroll to the top of your console, and you should see your list of ports.

You need to select the port that matches the one you used to program your Digital Sandbox. The list is an array, so the first port is 0 and the rest count up from there. Change the 0 in your `myPort` object to reflect the correct serial port.

```
//change the 0 to your port in the list
myPort = new Serial(this,Serial.list()[0],9600);
```

Once you change the port number, click the **Run** button in Processing. A blank sketch window appears, and the console prints strings of three numbers (each ranging from 0 to 200) separated by commas. Those number strings are the scaled values after Processing has mapped the raw values coming over your serial monitor in Arduino. Success!

Play with the sensors, and the values the console window should change as shown in Figure 13-16.

FIGURE 13-16:

Sensor values
coming from the
Digital Sandbox

```
import processing.serial.*;

Serial myPort;

float temp = 0;
float light = 0;
float sound = 0;

void setup()
{
  size(700, 400);

  println(Serial.list());
  myPort = new Serial(this, Serial.list()[2], 9600);
```

```
13.294233,0.58651024,35.97263
13.294233,0.58651024,35.97263
13.294233,0.58651024,35.97263
13.294233,0.58651024,35.97263
13.294233,0.58651024,35.97263
13.294233,0.58651024,35.97263
```

The values are your light, sound, and temperature sensor values. Remember that you mapped these values to 0–200, so some may be lower than the raw 0–1,023 values you are really getting from the Digital Sandbox.

When you know everything works, save your sketch so you don't lose it, and flesh out your draw() loop.

Visualizing Your Sensor Data

Now that you're sending sensor data to light, sound, and temp, you can use them just like any other variables in Processing. To demonstrate, let's make a bar graph to visualize these values.

In the same sketch, draw a few different-colored rectangles, using the three sensor variables to set the height of each:

```
void draw()
{
  println(light + "," + sound + "," + temp); //print serial
                                             //data to console
  background(150);  //standard gray background
```

```
      stroke(0);                  //base-level line color
❶     line(0,300,width,300);  //base-level line

      noStroke();      //remove outline
      fill(0,255,0);   //light rectangle
      rect(300,300,100,❷-light);

      fill(0,0,255);   //sound rectangle
      rect(500,300,100,-sound);

      fill(255,0,0);   //temp rectangle
      rect(100,300,100,-temp);

}
```

At ❶, I drew a single line across the entire sketch. This line is your base or zero line for the bar graphs. Then, I called noStroke() to avoid drawing an outline around the graph bars. Following that, I drew three rectangles. Notice that I set the sensor variables to negative ❷ to calculate the height parameter in the up or down direction for each rectangle. This step inverts the rectangle height, since the y-value increases in the downward direction.

Drawing the bars of the bar graphs also reveals why you mapped the values to the range of 0 to 200. If you left the raw values at 0–1,023, your rectangles would extend beyond your sketch and you'd probably rarely see any change. Since you mapped the values to 0–200, the highest bars should be 300 – 200 = 100 pixels from the top of your sketch.

Click **Run** in Processing, and as the variables change (that is, when you make noise, put your hand over the Digital Sandbox, and so on) you should see the rectangles move up and down. Yay—you can now visualize the change in your variables! See Figure 13-17 for an example.

To fully take advantage of the bar graph, label each bar and display the actual number you are graphing. Add the following to your draw() loop now, after the last call to rect() but before the final curly bracket:

```
  fill(0);      //black
  textAlign(CENTER);
  text("Light: " + light,150,325);
  text("Sound: " + sound,350,325);
  text("Temperature: " + temp,550,325);
```

FIGURE 13-17:

Graphing sensor values
(from left to right:
light, sound, and
temperature)

This code displays the variable name and the live mapped sensor value underneath the bar graph. You now have a completed live dashboard for visualizing data coming in through your serial port connection. Save your sketch and run it, and you should see something like Figure 13-18.

FIGURE 13-18:

Sensor graph with
printed values

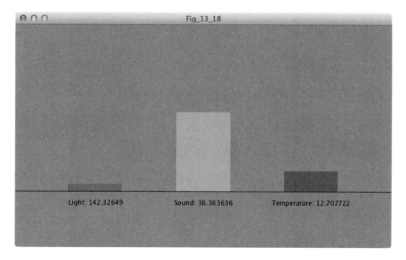

Light: 142.32649 Sound: 36.363636 Temperature: 12.707722

The sky is the limit in terms of what data you can collect using Arduino and then visualize it with Processing!

There are a number of applications for this project in industry, science, and even in your house. In home automation, the ability to collect information about a specific room and display it on a phone or central monitor is a must, and this project is a great foundation for doing that.

If you want to save all of this data and experiment with those kinds of applications later, you simply write the data to a text file. You can do that next.

LOGGING SENSOR DATA WITH PROCESSING

Processing's `PrintWriter` class allows you to save data to a text file in your sketch folder, so you can use it to save your sensor data for future use.

First, create a `PrintWriter` object in your graph project sketch; I called it `output`:

```
PrintWriter output;
```

Then, initialize `output` in your setup:

```
void setup()
{
  size(700,400);
  output = createWriter("DSInput.txt");
//the rest of your setup goes here
}
```

Set `output` with a call to the `createWriter()` function; then, pass the function a string specifying the name of the text file you want to create. Note the *.txt* extension in my example, *DSInput.txt*. You can initialize `output` anywhere in your `setup()` function, as long as you do so before you add anything to the text file.

A SERIAL COMMUNICATION TIP FOR WINDOWS USERS

Now that you've used the Serial library the hard way, I want to share some useful code I created to make serial communication dead-simple on the Processing end. The resource files for this book include a file called *autoConnect.pde*, which contains a custom function, `autoConnect()`, that figures out which COM port your Arduino is on and connects to it for you! Just include the code at the bottom of a sketch or in a new tab and then add a call to `autoConnect()` in your setup, and you are done!

To add information to your text file, print to it with a slightly different `println()` function. Add the following line to the end of your `draw()` loop:

```
//print variables to text
output.println(light + "," + sound + "," + temp);
```

This function acts like the `println()` function you've used already, but instead of printing to the console window of the IDE, it prints the data to a text file.

There are a few things you need to do to make this new `println()` function useful. First, Processing needs to know when you are done printing information so it can *flush the buffer*, or get rid of the information that is backed up. To tell Processing when you are finished logging data, add a `keyPressed()` event function after the `draw()` loop:

```
void keyPressed()
{
  if(keyCode == UP)
  {
    output.flush();   //flush the buffer and
                      //collect what data is on its way
    output.close();   //close the text file
  }
}
```

When you press the up arrow, this event function tells Processing to flush the buffer and close the text file. The `close()` function is the most important part. If you never close the text file, it will never be saved or even created in the first place! Checking for a specific key here allows you to add responses to other keys in the future without triggering Processing to close the text file.

With that, you can visualize your data in real time, stockpile it, and analyze and interpret it en masse later. Save your sketch, click **Run**, allow the sketch to run for a while, and play with the sensors. After about a minute, press the up arrow. Close your sketch window, and open your sketch folder. You will see a text file with the name you passed to `createWriter()`. Open it, and you will see a list of comma-separated values. These values are the logged values from the time that you ran your sketch. The only caveat to this technique is that every time you run this sketch, use the `createWriter()` function, and save the text file, it writes over the previous file.

TAKING IT FURTHER

This project was huge in terms of expanding the usefulness of
Processing! You learned how to send data to Processing from other
devices over a serial connection. You also learned how to log data
and save it to a text file. Both of these skills are invaluable, and at
SparkFun, we use them on a regular basis.

Try adding an Arduino to another Processing sketch, or modify
this one to visualize the data in a more creative way. Look into the
other information you can get from the Digital Sandbox; there are a
few other inputs you can add, including a button and a switch. How
could you harness those in Processing?

One great extension of using the Serial library with Processing
is to send data from Processing to a microcontroller, the opposite of
what this project did. In this final "Taking It Further," I'll give you some
Processing code to control the RGB LED on the Digital Sandbox.
The RGB is three LEDs in one: a red, green, and blue LED. You can
control each individually to do some really cool color mixing and build
something like an interactive lamp or light sculpture.

Sending Data from Processing to Arduino

Open a new Processing sketch, and write the following sketch:

NOTE

*You can also just download
the Processing and Arduino
sketches for this section,
along with the rest of the
source code for this book,
at* http://www.nostarch
.com/sparkfunprocessing/.
Open the Project 13 *folder,
and load* RGB.pde *in
Processing and* RGB.ino
in Arduino.

```
import processing.serial.*;

Serial myPort;     //create object from Serial class

❶ int r = 0;        //data received from the serial port
   int g = 0;
   int b = 0;

   void setup()
   {
     size(200,200);
     String portName = Serial.list()[0];
     myPort = new Serial(this,portName,9600);
   }

   void draw()
   {
❷    background(r,g,b);
❸    String outString = str(r) + ',' + str(g) + ',' + str(b) + ↵
     '\n';
❹    myPort.write(outString);
❺    println(outString);
   }
```

```
void keyPressed()
{
  if(key == 'r')
  {
    r++;
    key = ' ';

    if(r > 255)
    {
      r = 0;
    }
  }
  else if((key == 'g') && (g <= 255))
  {
    g++;
    key = ' ';

    if(g > 255)
    {
      g = 0;
    }
  }
  else if((key == 'b') && (b <= 255))
  {
    b++;
    key = ' ';

    if(b > 255)
    {
      b = 0;
    }
  }
}
```

This sketch uses the same keyPressed() event function that you used in "Creating a Color-Changing Feedback Box" on page 141, where you changed the color of the lines you drew with your mouse to create a basic graphics application. But instead of using those variables in Processing, this sketch writes r, g, and b across the serial port from Processing to the Arduino.

The sketch follows the same basic structure as the other Serial library sketches you created in this project. The magic happens in the keyPressed() event function and the draw() loop. There are three global variables r, g, and b ❶ (color variables as in Project 8). The setup() function follows the same pattern as in "Preparing Processing for Serial Communication" on page 251.

The draw() loop sets the sketch window background to an RGB setting of r, g, and b ❷, which starts out black. Next, you build a comma-separated string of values (r,g,b) by creating a string called outString. Convert the value of each color variable into a string using the str() function, concatenate the stringified values with comma characters, and finish with a carriage return ❸. Then, write your outString over the serial port ❹. To help you debug your outString, add a println() function that prints the string in the Processing console ❺.

The keyPressed() event function simply reads the key pressed, and if the key is R, G, or B, it increments the appropriate variable. If a variable runs over 255, it is reset to 0. Save your work in Processing, and now let's work on the Arduino side.

Receiving Processing Data on an Arduino

Open a new Arduino IDE window, select the Fio as your board, and use the same serial port you did in "An Arduino Hello World" on page 243. From this point, copy the following code into the Arduino code window, and upload it to your Digital Sandbox.

```
❶  int r = 0;
   int g = 0;
   int b = 0;

   void setup()
   {
❷    Serial.begin(9600);
❸    pinMode(9,OUTPUT);
     pinMode(10,OUTPUT);
     pinMode(11,OUTPUT);
   }

   void loop()
   {
❹    analogWrite(9,r);
     analogWrite(10,g);
     analogWrite(11,b);
❺    if(Serial.available() > 0)
     {
❻      r = Serial.parseInt();
       g = Serial.parseInt();
       b = Serial.parseInt();
     }
   }
```

First, create three global variables for the red, green, and blue values ❶ that you will later capture from the serial port. At this point, set all three of them to 0.

Next comes the setup() function. Start the Serial library by calling the begin() function, and pass it the baud rate, which is the speed at which the Digital Sandbox will communicate with your Processing sketch ❷. Set pins 9, 10, and 11 as output by passing the pinMode() function the pin numbers and the state at which you will want the pins ❸.

The loop() uses the analogWrite() function to write the three color values, which range from 0 to 255 for each appropriate pin: red is pin 9, green is 10, and blue is 11 ❹. The first time through the loop, these values should all be 0, and the RGB LED should be off.

Next comes an if() statement ❺ that uses Serial.available() to check if there's anything on the serial port. If there is, this parameter will return 1, so check if it's greater than 0. If the statement is true, call the Serial.parseInt() function for each color variable. This function reads incoming values as integers until it sees a non-numeric value. In this case, your values are comma-separated, so it will split the values at the comma. Since there are three values, use parseInt() three times to capture each value and set the variables to those values.

Upload this code to your Digital Sandbox, keep the Sandbox plugged in to your computer, run the Processing sketch, and press R, G, or B repeatedly. The Processing sketch window should change color, and the RGB LED on your Digital Sandbox should show a similar color, like in Figure 13-19.

This project was the tip of the iceberg when it comes to devices you can connect to Processing through a serial communication port. For example, I'm a huge fan of DIY identification, and one of my favorite applications is an RFID reader kit we sell (KIT-13198). This kit reads the unique ID string for a card and prints it over the serial port. The uses for RFID are endless, from identifying specific objects and assigning each a different function to personal identification and security.

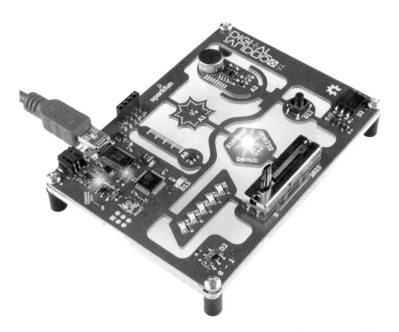

FIGURE 13-19:
The magic RGB LED that
you can color-mix to your
heart's content

Now, I send you off into the wild blue yonder of Processing! With
the completion of this chapter and this book, you're well on your
way to becoming a full-fledged software developer, digital artist, or
interface designer. I hope that this final chapter inspires you to further
explore Processing and all the different rabbit holes that you can
go down to make useful, beautiful projects. When you need more
inspiration, check out the Reference page at Processing.org, look
at different libraries, or simply google "Processing projects." Create
something cool and share it with others!

INDEX

Symbols

&& (AND logical operator), 55
* (asterisk), Loop sketch example, 169–170
{ } (curly brackets), 12–13, 53, 210
% (modulo function), 181
! (NOT logical operator), 55
|| (OR logical operator), 55, 58
() (parentheses), 13
; (semicolon), 13
[] (square brackets)
 arrays, 175
 JSON arrays, 213, 214

A

abs() function, 201
absolute value, for sound
 visualization, 201
abstract clock project
 combining with pixel art, 90
 general discussion, 71–75
Add File option, 94, 100, 155, 172, 188
Add Library option, 168
Add Mode option, 76
add-on header, Digital Sandbox, 236
Add Tool option, 125
advanced data types, 111
album() method, 198
alert bar
 Arduino IDE, 241
 Processing, 7, 8–9
alligator clips, 160, 161, 162
American Standard Code for
 Information Interchange
 (ASCII), 149–151
amplitude, sound, 198, 199–202
analog data, 246
analogRead() function, 247

analogWrite() function, 247, 264
AND logical operator (&&), 55
Android mode, 6
animation
 basic, 55–59
 with matrices, 88–90
API menu, OpenWeatherMap, 215
Arduino 233–234. *See also* sensor data
 dashboard
 analog versus digital data, 246
 blinking LED project, 243–245
 defined, 235
 experimenting with, 261–265
 Fio board, 242
 IDE, 240–241
 Serial Monitor, 248, 249, 250
 installing software, 237–240
 logging sensor data, 259–260
 and MaKey MaKey, 160
 microcontroller, 234–235
 and Processing, 5
 reading data from sensors, 247–250
 reading versus writing data, 246–247
 receiving Processing data on,
 263–265
 RGB LED, controlling, 261–265
 selecting board and
 choosing port, 242
 sending data from Processing to,
 261–263
 serial ports, 242, 251, 255
 sketches, 243
 and SparkFun Digital Sandbox,
 235–237
 SparkFun Redboard, 235
 Uno, 235
arrays
 general discussion, 175–177
 JSON, 213–215, 225–226

ABOUT THE SPARKFUN GUIDE SERIES

The *SparkFun Guide* series is a collaboration between No Starch Press and SparkFun Electronics, an online retailer that sells bits and pieces to make your own electronics projects possible. Each title in the series is written by an experienced maker on the SparkFun staff and edited by the folks at No Starch Press. The result? The book you're reading now.

COMING SOON

The SparkFun Guide to Arduino will teach you how to use the open source Arduino hardware platform to explore electronics. With the help of 13 hands-on projects like a robot that draws, a servo-controlled balance beam, and even a digital Etch-a-Sketch, you'll learn to build circuits, write programs, collect sensor data, and control motors, as well as other skills essential for any aspiring maker.

The SparkFun Guide to Processing is set in Gauge, Helvetica Neue, Montserrat, and TheSansMono Condensed. The book was printed and bound by Lake Book Manufacturing in Melrose Park, Illinois. The paper is 70# Husky Opaque Offset, which is certified by the Sustainable Forestry Initiative (SFI).

The book uses a layflat binding, in which the pages are bound together with a cold-set, flexible glue and the first and last pages of the resulting book block are attached to the cover. The cover is not actually glued to the book's spine, and when open, the book lies flat and the spine doesn't crack.